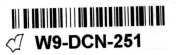

How to Read Chinese Paintings

How to Read
Chinese Paintings

Maxwell K. Hearn

The Metropolitan Museum of Art, New York

Yale University Press, New Haven and London

For Wen Fong
Scholar, Teacher, Curator, Mentor, Friend

This volume is published in conjunction with the exhibition "Anatomy of a Masterpiece: How to Read Chinese Paintings," organized by The Metropolitan Museum of Art, New York, and held there from March 1 through August 10, 2008.

The exhibition is made possible by The Miriam and Ira D. Wallach Foundation.

Published by The Metropolitan Museum of Art, New York

John P. O'Neill, Publisher and Editor in Chief
Gwen Roginsky, General Manager of Publications
Margaret Rennolds Chace, Managing Editor
Margaret Donovan, Editor
Bruce Campbell, Designer
Christopher Zichello and Paula Torres, Production Managers
Robert Weisberg, Assistant Managing Editor
Jayne Kuchna, Bibliographer

New photography by Oi-Cheong Lee, The Photograph Studio, The Metropolitan Museum of Art

Typeset in Monotype Bembo Std and LTC Deepdene; DF Kai Shu HK (Chinese characters)
Printed on Gardapat Kiara 135gsm
Separations by Professional Graphics Inc., Rockford, Illinois
Printed and bound by Arnoldo Mondadori Editore S.p.A., Verona

Cover illustrations: *front,* Han Gan (active ca. 742–56). *Night-Shining White.* Handscroll, ink on paper. Purchase, The Dillon Fund Gift, 1977 (1977.78) (detail, no. 1); *back,* Qian Xuan (ca. 1235–before 1307). *Wang Xizhi Watching Geese,* ca. 1295. Handscroll, ink, color, and gold on paper. Gift of The Dillon Fund, 1973 (1973.120.6)

Frontispiece: Zhao Mengfu (1254–1322). *Twin Pines, Level Distance,* ca. 1300. Handscroll, ink on paper. Gift of The Dillon Fund, 1973 (1973.120.5) (detail, no. 17)

Library of Congress Cataloguing-in-Publication Data

Hearn, Maxwell K.
 How to read Chinese paintings / Maxwell K. Hearn.
 p. cm.
 Includes bibliographical references.
 ISBN 978-1-58839-281-7 (Metropolitan Museum of Art [pb]) -- ISBN 978-0-300-14187-0 (Yale University Press [pb])
 1. Painting, Chinese. I. Metropolitan Museum of Art (New York, N.Y.) II. Title.
 ND1040.H43 2008
 759.951--dc22
 2008006480

Contents

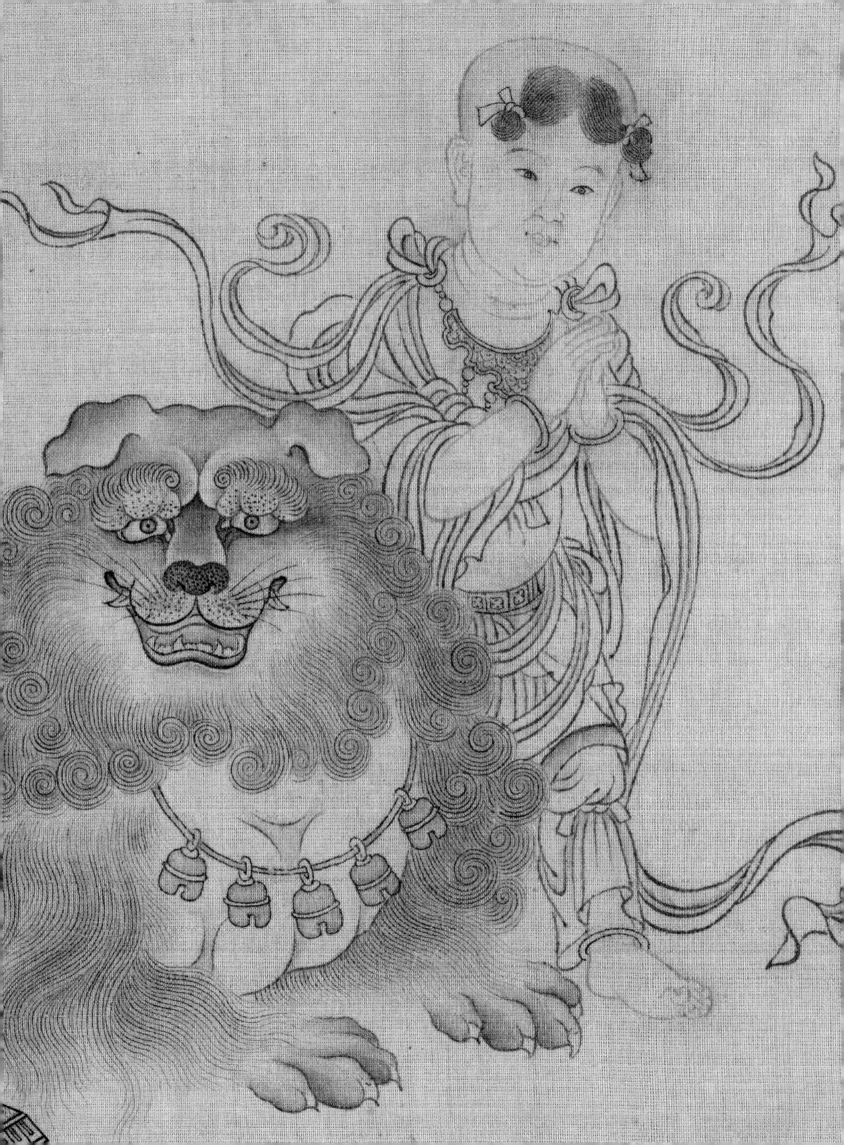

Acknowledgments

This book is dedicated to Wen Fong.

From 1971 to 2000 Wen served as chairman of the Metropolitan Museum's Department of Asian Art while concomitantly holding the Edwards S. Sanford Professorship of Art History at Princeton University. It was Wen's commitment to teaching and his conviction that students can learn only from actual objects that led him to take up the role of curator. During his tenure at the Metropolitan, the staff, collections, and exhibition space of the department were transformed. In 1971, when I joined the Department of Far Eastern Art, as it was then called, the staff numbered six, with only two permanent galleries (the Great Hall Balcony and Early Buddhist Sculpture Gallery) and an uneven collection. Today, under Brooke Russell Astor Chair James C. Y. Watt, the staff numbers thirty, with twelve curators and three conservators; its fifty galleries hold one of the world's most comprehensive collections of Asian art.

Wen Fong's area of expertise is Chinese calligraphy and painting, and the timing of his arrival at the Metropolitan was propitious. New York in the 1970s and 1980s was not only the center of the Chinese painting market but also the home of numerous world-class private collectors, including John M. Crawford, Jr., C. C. Wang, Earl Morse, Ernest Erickson, John B. Elliott, Robert H. Ellsworth, Wan-go Weng, Florence and Herbert Irving, Marie-Hélène and Guy Weill, and Oscar Tang. Important works from each of these individuals have helped to transform the Met into a major center for the study and appreciation of this art form.

Douglas Dillon, longtime trustee and board president of the Metropolitan, was the catalyst for this transformation. Convinced of Asia's growing importance on the world stage, in 1970, at the time of the Metropolitan's centennial, he rededicated the Museum to pursuing the founders' goal of building an encyclopedic collection. Mr. Dillon personally committed himself to rebuilding the Department of Asian Art and helped the Metropolitan acquire 133 major Chinese paintings. The magnitude of his contribution is clear from the seventeen works in this publication acquired with his generous support and that of the Dillon Fund.

Together, Wen Fong and Douglas Dillon brought a sense of mission and optimism to the task of enlarging the Metropolitan's holdings. In 1981, when the Douglas Dillon Galleries for Chinese Calligraphy and Painting were opened, the Museum did not own enough high-quality works to fill a second rotation. Sixteen years later, the galleries needed to be expanded. In the present publication, only two works were acquired prior to 1971.

As the collection has grown and been exhibited, it has been enriched by much valuable scholarship thanks to its close proximity to a constellation of colleges and research universities with graduate programs in Chinese art. Professors and students have shed fresh perspectives on these works, and I have personally benefited from the privilege of working with the talented scholars who have served as visiting fellows, interns, or participants in seminars that I have offered over the years as an adjunct professor at Yale, Columbia, Princeton, and New York University's Institute of Fine Arts.

If artworks are the lifeblood of a museum, then its heart is its curators, conservators, and professionals. It has been an enormous privilege to work on this collection as a member of the Metropolitan's unparalleled staff. In addition to his steadfast support over the years, Director Philippe de Montebello not only endorsed this publication when it was little more than a pile of scanned images, but also offered numerous helpful suggestions regarding both the title and the text. The Museum's editorial team led by Publisher and Editor in Chief John P. O'Neill

<
Wang Zhenpeng (active ca. 1280–1329). *Vimalakirti and the Doctrine of Nonduality*, dated 1308. Handscroll, ink on silk. Purchase, The Dillon Fund Gift, 1980 (1980.276) (detail, no. 19)

helped transform that pile into the present book. Bruce Campbell crafted the handsome design, Margaret Donovan expertly edited the unruly text, Jayne Kuchna conducted bibliographic research, Robert Weisberg composed the type, Christopher Zichello and Paula Torres guided materials through production, and General Manager of Publications Gwen Roginsky oversaw the color correction and printing. The Museum's Photograph Studio under Barbara Bridgers dedicated many hours to this project. Photographer Oi-Cheong Lee captured with luminous clarity the beauty of the artworks, while Jillian Schultz in the Department of Asian Art tirelessly translated my sketched requests into proper photo orders. In the larger Museum community, my dear friends Marie-Hélène Weill, Kit Luce, Oscar and Argie Tang, Shau-Wai and Marie Lam, Michael Feng, John and Julia Curtis, and Eliot Nolen have offered many encouraging words along the way. Finally, my wife, Vera, and our sons Garrett and Alex, who have given me so much love and inspiration over the years, were most understanding and supportive during the many weekends and late nights in the office that this project required. Vera even permitted a draft copy of the manuscript to accompany us on our twentieth anniversary celebration! My heartfelt thanks to all.

But my deepest gratitude goes to Wen Fong. This book rests on the foundation of scholarship that he built through his many publications on the collection, as well as on the countless hours we worked together in the 1980s crafting the object labels upon which much of the present text is based. I am privileged to have him as both mentor and friend.

While none of the errors and omissions that remain belong to these many collaborators, the credit for bringing this book into the light of day is entirely theirs.

<div style="text-align: right">

Maxwell K. Hearn
Douglas Dillon Curator
Department of Asian Art
The Metropolitan Museum of Art

</div>

Dynastic Chronology

XIA	ca. 2100–ca. 1600 B.C. (unconfirmed)
SHANG	ca. 1600–1046 B.C.
ZHOU	1046–256 B.C.
Western Zhou	1046–771 B.C.
Eastern Zhou	770–256 B.C.
Spring and Autumn period	770–476 B.C.
Warring States period	475–221 B.C.
QIN	221–207 B.C.
HAN	206 B.C.–A.D. 220
Western (Former) Han	206 B.C.–A.D. 9
Eastern (Later) Han	A.D. 25–220
SIX DYNASTIES	220–589
Three Kingdoms	220–265
Western Jin	265–316
Eastern Jin	317–420
Northern and Southern Dynasties	420–589
SUI	581–618
TANG	618–907
FIVE DYNASTIES	907–960
LIAO	916–1125
SONG	960–1279
Northern Song	960–1127
Southern Song	1127–1279
JIN	1115–1234
YUAN	1271–1368
MING	1368–1644
QING	1644–1911

China's Cultural Heartland

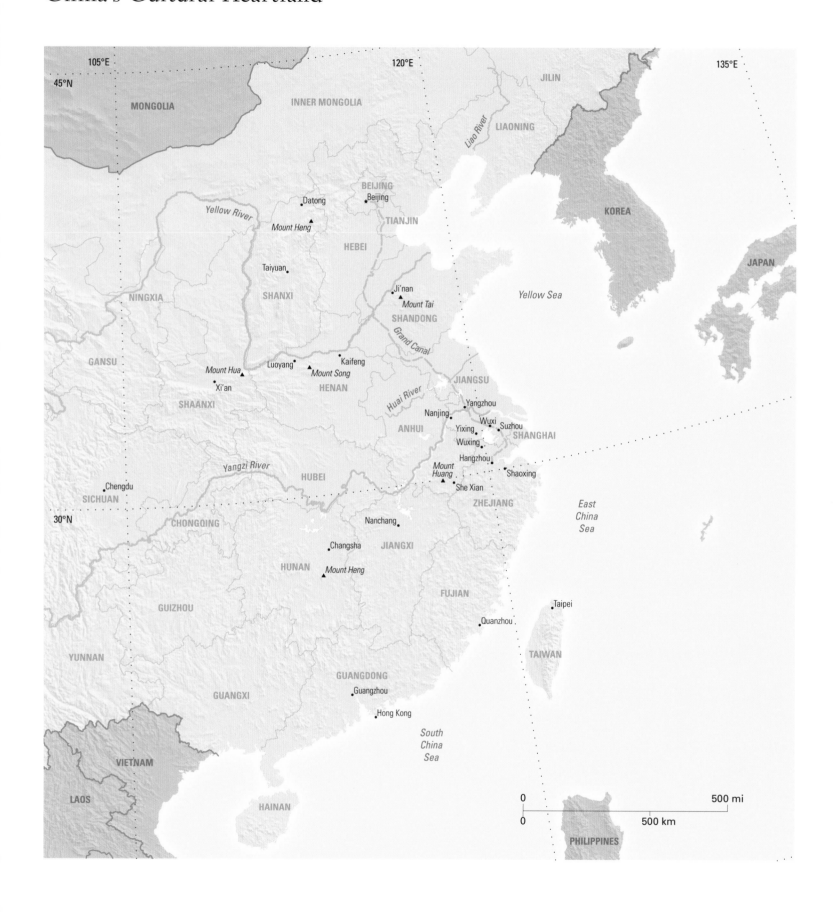

MONGOLIA

INNER MONGOLIA

JILIN

105°E

120°E

135°E

45°N

Liao River

LIAONING

KOREA

•Datong

BEIJING

Yellow River

★Beijing

JAPAN

▲Mount Heng

TIANJIN

HEBEI

Taiyuan•

Ji'nan•

Yellow Sea

SHANXI

▲Mount Tai

SHANDONG

Grand Canal

GANSU

NINGXIA

▲Mount Hua Luoyang• •Kaifeng

Xi'an• ▲Mount Song

JIANGSU

HENAN

Huai River

Yangzhou

SHAANXI

Nanjing• •Yangzhou

ANHUI

•Yixing •Wuxi •Suzhou

•Wuxing SHANGHAI

Yangzi River

HUBEI

Mount
Huang ▲ •Hangzhou

•Shaoxing

Chengdu•

She Xian▲

ZHEJIANG

East
China
Sea

SICHUAN

30°N

CHONGQING

Nanchang•

•Changsha

JIANGXI

HUNAN ▲Mount Heng

FUJIAN

GUIZHOU

•Taipei

YUNNAN

•Quanzhou

TAIWAN

GUANGDONG

GUANGXI •Guangzhou

•Hong Kong

VIETNAM

South
China
Sea

LAOS

HAINAN

0 500 mi

0 500 km

PHILIPPINES

How to Read Chinese Paintings

Introduction

The Chinese way of appreciating a painting is often expressed by the words *du hua*, "to read a painting." How does one do that?

The first work in this book, *Night-Shining White* by Han Gan (no. 1), is an image of a horse. Originally little more than a foot square, it is now mounted as a handscroll that is twenty feet long as a result of the myriad inscriptions and seals (marks of ownership) that have been added over the centuries, some directly on the painted surface, so that the horse is all but overwhelmed by this enthusiastic display of appreciation. Miraculously, the animal's energy shines through. It does so because the artist has managed to distill his observations of both living horses and earlier depictions to create an image that embodies the vitality and form of an iconic "dragon steed." He has achieved this with only the most economical of means: brush and ink on paper.

This is the aim of the traditional Chinese painter: to capture not only the outer appearance of a subject but its inner essence as well—its energy, life force, spirit. To accomplish his goal, the Chinese painter more often than not rejected the use of color. Like the photographer who prefers to work in black and white, the Chinese artist regarded color as a distraction. He also rejected the changeable qualities of light and shadow as a means of modeling, along with opaque pigments to conceal mistakes. Instead, he relied on line—the indelible mark of the inked brush.

The discipline that this kind of mastery requires derives from the practice of calligraphy. Traditionally, every literate person in China learned as a child to write by copying the standard forms of Chinese ideographs. The student was gradually exposed to different stylistic interpretations of these characters. He copied the great calligraphers' manuscripts, which were often preserved on carved stones so that rubbings could be made. He was also exposed to the way in which the forms of the ideographs had evolved: their earliest appearance on bronzes, stones, and bones about 1300 B.C. (known today as "seal" script, after its use on the red seals of ownership); their gradual regularization, culminating with the bureaucratic proliferation of documents by government clerks during the second century A.D. ("clerical" script); their artful simplification into abbreviated forms ("running" and "cursive" scripts); and the fusion of these form-types into "standard" script, in which the individually articulated brushstrokes that make up each character are integrated into a dynamically balanced whole. Over time the practitioner evolved his own personal style, one that was a distillation and reinterpretation of earlier models.

The practice of calligraphy became high art with the innovations of Wang Xizhi in the fourth century (page 19, *center*). By the eleventh century, a good hand was one criterion—together with a command of history and literary style—that determined who was recruited into the government through civil service examinations. Those who succeeded came to regard themselves as a new kind of elite, a meritocracy of "scholar-officials" responsible for maintaining the moral and aesthetic standards established by the political and cultural paragons of the past. It was their command of history and its precedents that enabled them to influence current events. It was their interpretations of the past that established the strictures by which an emperor might be constrained. And it was their poetry, diaries, and commentaries that constituted the accounts by which a ruler would one day be judged.

These were the men who covered *Night-Shining White* with inscriptions and seals. Their knowledge of art enabled them to determine that the image was a portrait of an imperial

3

stallion by a master of the eighth century. They recognized that the horse was meant as an emblem of China's military strength and, by extension, as a symbol of China itself. And they understood the poignancy of the image. Night-Shining White was the favorite steed of an emperor who led his dynasty to the height of its glory but who, tethered by his infatuation with a concubine, neglected his charge and eventually lost his throne.

The emperor's failure to put his stallion to good use may be understood as a metaphor for a ruler's failure to properly value his officials. This is undoubtedly how the retired scholar-official Zhao Mengfu intended his image of a stallion, painted six hundred years later (no. 2), to be interpreted. Expertise in judging fine horses had long been a metaphor for the ability to recognize men of talent. Zhao's portrait of the horse and groom may be read as an admonition to those in power to heed the abilities of those in their command and to conscientiously employ their talents in the governance of their people.

When an emperor neglected the advice of his officials, was unjust or immoral, scholar-officials not infrequently resigned from government and chose to live in retirement. Such an action had long been understood as a withdrawal of support, a kind of silent protest in circumstances deemed intolerable. Times of dynastic change were especially fraught, and loyalists of a fallen dynasty usually refused service under a new regime (nos. 16, 29). Scholar-officials were at times also forced out of office, banished as a result of factionalism among those in power. In such cases, the alienated individual might turn to art to express his beliefs. But even when concealed in symbolic language, beliefs could incite reprisals: the eleventh-century official Su Shi, for example, was nearly put to death for writing poems that were deemed seditious. As a result, these men honed their skills in the art of indirection. In their hands the transcription of a historical text could be transformed into a strident protest against factional politics (no. 8), illustrations to a Confucian classic become a stinging indictment of sanctimonious or irresponsible behavior (no. 7). Because of their highly personal nature, such works were almost always dedicated to a close friend or kindred spirit and would have been viewed only by a select circle of like-minded individuals. But since these men acted both as policymakers and as the moral conscience of society, their art was highly influential.

Scholar-official painters most often worked in ink on paper and chose subjects—bamboo, old trees, rocks—that could be drawn using the same kind of disciplined brush skills required for calligraphy. This immediately distinguished their art from the colorful, illusionistic style of painting preferred by court artists and professionals. Proud of their status as amateurs, they created a new, distinctly personal form of painting in which expressive calligraphic brush lines were the chief means employed to animate their subjects. Another distinguishing feature of what came to be known as scholar-amateur painting is its learned references to the past. The choice of a particular antique style immediately linked a work to the personality and ideals of an earlier painter or calligrapher. Style became a language by which to convey one's beliefs.

Zhao Mengfu epitomized the new artistic paradigm of the scholar-amateur. A scholar-official by training, he was also a brilliant calligrapher (no. 18) who applied his skill with a brush to painting. Intent on distinguishing his kind of scholar-painting from the work of professional craftsmen, Zhao defined his art by using the verb "to write" rather than "to paint." In so doing, he underscored not only its basis in calligraphy but also the fact that painting was not merely about representation—a point he emphasized in his *Twin Pines, Level Distance* (no. 17) by adding his inscription directly over the landscape. Zhao was a consummate scholar, and his choice of subject and painting style was carefully considered. Because the pine tree remains green through the winter, it is a symbol of survival. Because its outstretched boughs offer protection to the lesser trees of the forest, it is an emblem of the princely gentleman. For recluse artists of the tenth century the pine had signified the moral character of the virtuous man. Zhao, having recently withdrawn from government service under the Mongols, must have chosen to "write" pines in a tenth-century style as a way to express his innermost feelings

to a friend. His painting may be read as a double portrait—a depiction of himself and also of the person to whom it was dedicated.

Since scholar-artists employed symbolism, style, and calligraphic brushwork to express their beliefs and feelings, they left the craft of formal portraiture to professional artisans. Such craftsmen might be skilled in capturing an individual's likeness (no. 31), but they could never hope to convey the deeper aspects of a man's character.

Integrating calligraphy, poetry, and painting, scholar-artists for the first time combined the "three perfections" in a single work (no. 21). In such paintings, poetic and pictorial imagery and energized calligraphic lines work in tandem to express the mind and emotions of the artist (nos. 22, 23). Once poetic inscriptions had become an integral part of a composition, the recipient of the painting or a later appreciator would often add an inscription as his own "response." Thus, a painting was not finalized when an artist set down his brush, but it would continue to evolve as later owners and admirers appended their own inscriptions or seals. Most such inscriptions take the form of colophons placed on the borders of a painting or on the endpapers of a handscroll or album; others might be added directly onto the painting. In this way, *Night-Shining White* (no. 1) was embellished with a record of its transmission that spans more than a thousand years.

As the arbiters of history and aesthetic values, scholars had an immense impact on taste. Even emperors came to embrace scholarly ideals. Although some became talented calligraphers and painters (no. 6), more often they recruited artists whose images magnified the virtues of their rule. Both the court professional and the scholar-amateur made use of symbolism, but often to very different ends. While Zhao Mengfu's pines may reflect the artist's determination to preserve his political integrity (no. 17), a landscape painting by a court painter might be read as the celebration of a well-ordered empire (no. 4). A scholar-painting of narcissus reflects the artist's identification with the pure fragrance of the flower, a symbol of loyalty (no. 15), while a court painter's lush depiction of orchids was probably intended to evoke the sensuous pleasures of the harem (no. 14). The key distinction between scholar-amateur and professional painting is in the realization of the image: through calligraphically abbreviated monochrome drawing on paper or through the highly illusionistic use of mineral pigments on silk.

Amateur and professional alike shared a reverence for the past. Artists would manipulate antique styles (no. 16) and reinterpret ancient subjects (no. 2) to lend historical resonance to their work. But the weight of past precedents was also a heavy burden that could make painters acutely self-conscious. Sometimes their solutions were eccentric and challenged the viewer's ability to judge them by what had preceded them (no. 32). At other times, a knowledge of past models made them keenly aware of the illusionistic power of art, the capacity to mimic reality (no. 34) as well as to distort it (no. 12).

To "read" a Chinese painting is to enter into a dialogue with the past; the act of unrolling a scroll or leafing through an album provides a further, physical connection to the work. An intimate experience, it is one that has been shared and repeated over the centuries. And it is through such readings, enjoyed alone or in the company of friends, that meaning is gradually revealed.

1 | Dragon Steed

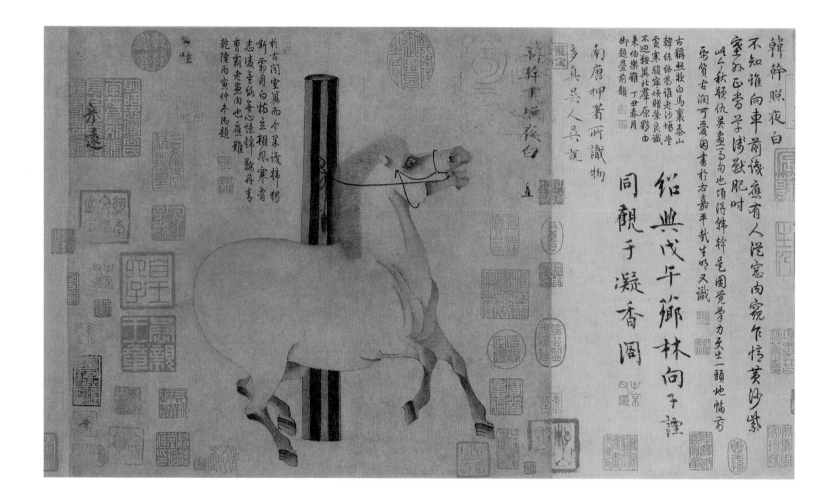

唐　韓幹　照夜白圖　卷

Han Gan (active ca. 742–56)
Night-Shining White

Handscroll, ink on paper, 12⅛ × 13⅜ in. (30.8 × 34 cm)
Ex coll.: Sir Percival David
Purchase, The Dillon Fund Gift, 1977 (1977.78)

Han Gan, a leading horse painter of the Tang dynasty (618–907), was known for portraying not only the physical likeness of a horse but also its spirit. This painting, the most famous of the works attributed to the artist, is a portrait of Night-Shining White, a favorite charger of the emperor Xuanzong (r. 712–56). With its burning eye, flaring nostrils, and dancing hoofs, the fiery-tempered steed epitomizes Chinese myths about Central Asian "celestial steeds" that "sweated blood" and were really dragons in disguise.

The sensitive and precise drawing, reinforced by delicate shading in ink, is an example of *baihua,* or "white painting," a term used in Tang texts to describe monochrome painting with ink shading, as opposed to painting in full color. The later term *baimiao,* or "plain drawing," denotes line drawing without shading, as seen in the paintings of Li Gonglin (ca. 1041–1106; no. 7).

The addition of numerous seals and inscriptions to the painting and its borders by those who later owned and appreciated it is a distinctive feature of Chinese collecting and connoisseurship.

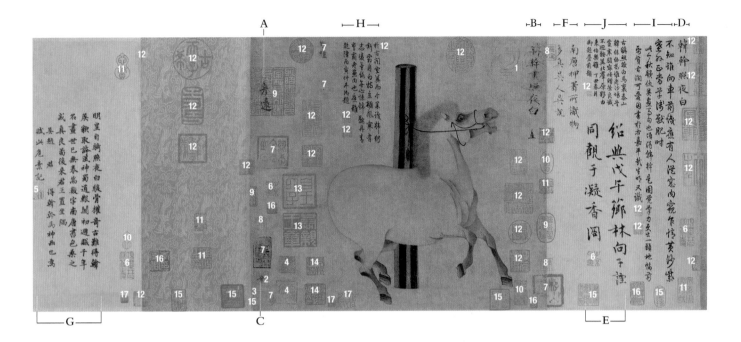

This detail of *Night-Shining White* shows a portion of its twenty-foot-long handscroll mounting with some of the seals and appended inscriptions. These record the transmission of the painting over more than a thousand years as well as its continuing impact on later generations.

Inscriptions (in the approximate order in which they were added)

A. Zhang Yanyuan 張彥遠 (9th century)
B. Southern Tang emperor Li Yu 李煜, 南唐後主 (r. 961–75)
C. Mi Fu 米芾 (1051–1107)
D. Song emperor Gaozong? 宋高宗 (r. 1127–62)
E. Xiang Ziyin 向子諲 (1086–1153), dated 1138
F. Wu Yue 吳說 (12th century)
G. Wei Su 危素 (1303–1372)
H. Qing emperor Qianlong 清帝乾隆 (r. 1736–95), dated 1746
I. Qing emperor Qianlong (r. 1736–95)
J. Qing emperor Qianlong (r. 1736–95), dated 1757

Collectors' seals (in the approximate order in which they were added)

1. Southern Tang emperor Li Yu 李煜, 南唐後主 (r. 961–75)
2. Mi Fu 米芾 (1051–1107)
3. Li Junxi 李君錫 (11th century)
4. Jia Sidao 賈似道 (1213–1275)
5. Wei Su 危素 (1303–1372)
6. Xiang Yuanbian 項元汴 (1525–1590)
7. Unidentified seals (16th century?)
8. Fan Xizhi 蕃希之 (16th century?)
9. Geng Zhaozhong 耿昭忠 (1640–1686)
10. Unidentified seals (pre-18th century)
11. An Qi 安岐 (1683–after 1742)
12. Qing emperor Qianlong 清帝乾隆 (r. 1736–95)
13. Yixin, Prince Gongqin 恭親王奕訢 (1833–1898)
14. Zaiying 載瀅 (Yixin's son, 1861–1909)
15. Pu Ru 溥儒 (Zaiying's son, 1896–1963)
16. Li Xuanti 李宣倜 (1883–1961)
17. Unidentified seals (20th century)

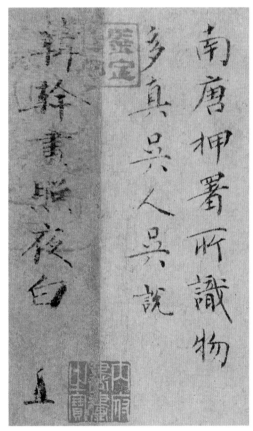

Han Gan's authorship comes from a title and cipher (*left*) of Li Yu: "Han Gan's painting of Night-Shining White." Confirmation comes from the inscription (*right*) by Wu Yue (12th century): "Most works bearing the cipher of the Southern Tang are genuine."

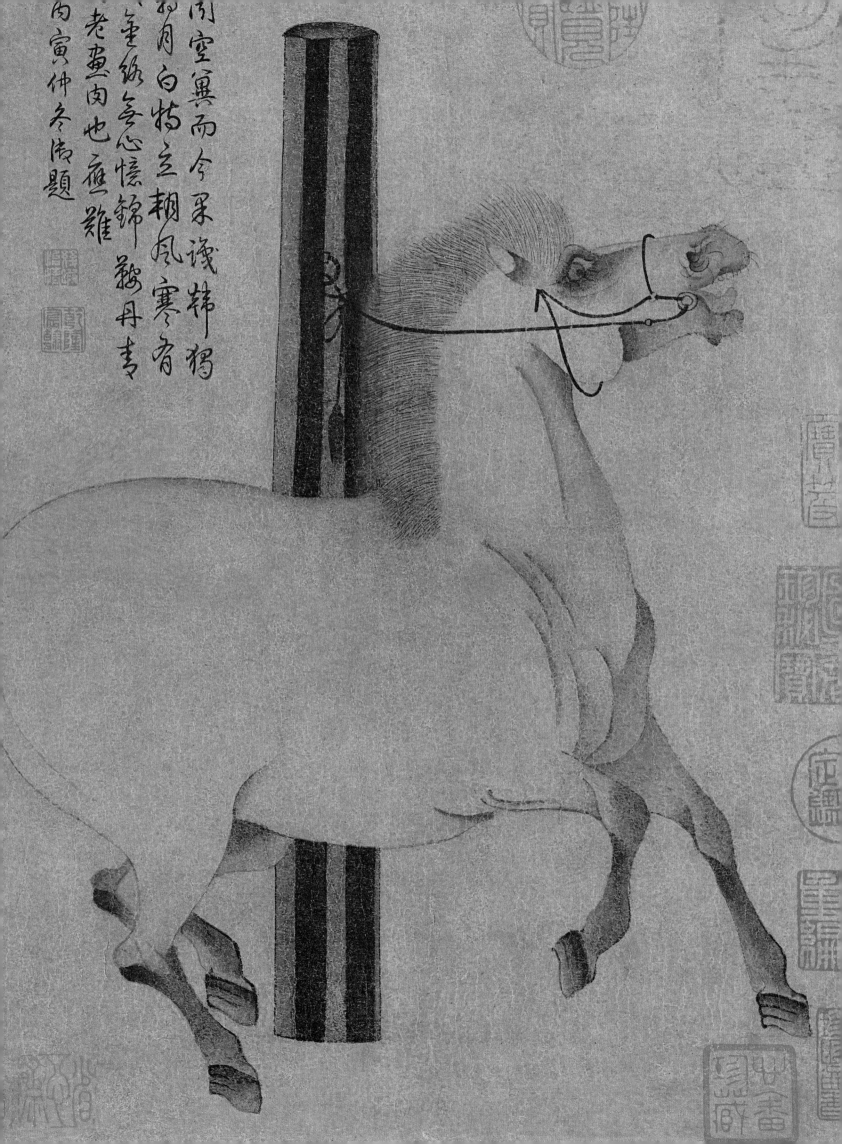

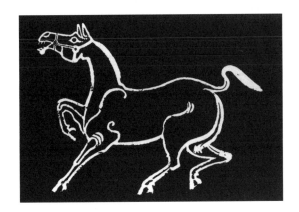

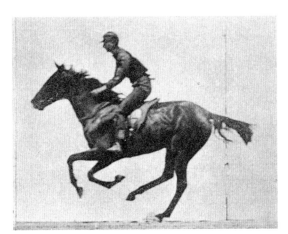

Han Gan is said to have preferred visits to the stables over the study of earlier paintings of horses. The artist's keen observation of living animals is confirmed by his accurate rendering of equine movement, which did not occur in Western art until a thousand years later, when Edgar Degas made use of photographic studies, such as those by Eadweard Muybridge (*at left, below* and *bottom*), in his depictions of horses.

But Han Gan's largely profile image and his reduction of the animal's anatomy to a series of abstract curves clearly derive from ancient prototypes, including the Western Han *Prancing Horse* (*at left, above*), that transform Night-Shining White into an archetypal "dragon steed." The addition of pale shading softens the geometry of these arcs, however, changing flat lines into three-dimensional horseflesh.

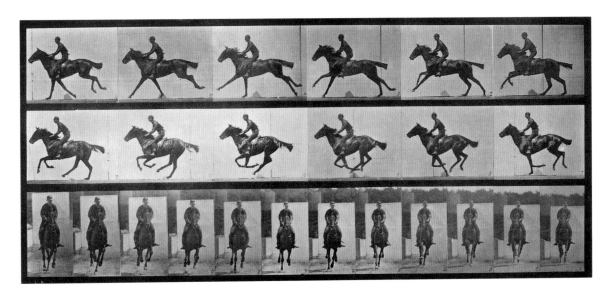

<

Much of the stallion's fiery temperament is conveyed through the rendering of its head: the swept-back, seemingly electrified mane, flared nostril, open mouth, and wide, rolling eye.

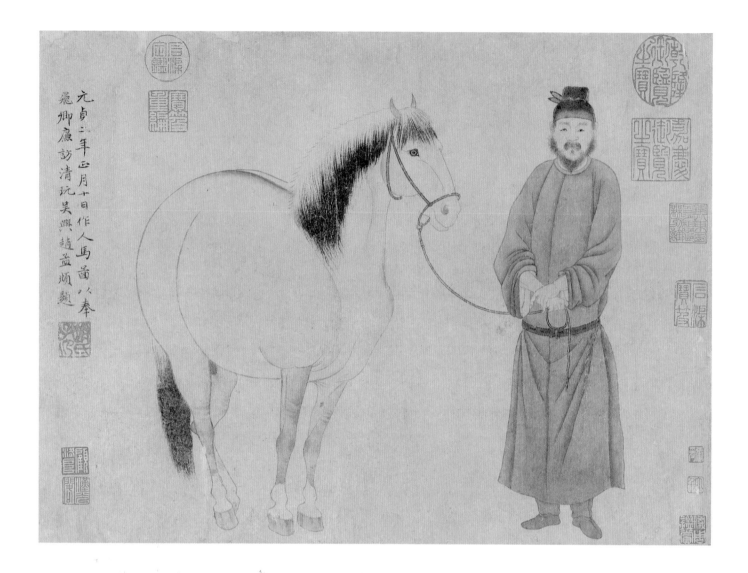

元　趙孟頫　人馬圖　卷

Zhao Mengfu (1254–1322)
Groom and Horse, dated 1296

Handscroll, ink and color on paper, 11 ⅞ × 17 ⅛ in. (30.3 × 43.5 cm)
Gift of John M. Crawford Jr., 1988 (1988.135)

The imported "celestial steed," treasured by early emperors and noble warriors, was a subject favored by such leading painters as Han Gan (active ca. 742–56; no. 1) and Li Gonglin (ca. 1041–1106; no. 7). In the early Yuan period (1271–1368), when alien Mongol rulers curtailed the employment of Chinese scholar-officials, the theme of "groom and horse" became a metaphor adopted to plead for the proper use of scholarly talent, and the famous saying of the Tang essayist Han Yu (762–824) was frequently quoted: "There are always excellent steeds, but not always a Bole, the excellent judge of horses." In Zhao Mengfu's painting, executed in early 1296, when Zhao had recently retired from serving under Khubilai Khan (r. 1260–94), the circular, abstract form of the horse serves as a deliberate foil to the sensitively rendered figure of the groom—a portrait, perhaps, of the painting's recipient (identified in Zhao's dedication at left), who may have been a government recruiter.

Although Zhao Mengfu's horse recalls *Night-Shining White* (no. 1), Zhao has radically transformed eighth-century precedents. His foreshortened three-quarter view appears more naturalistic than the earlier profile image, while his disciplined brushstrokes, particularly the parallel arcs defining the hindquarters, are more self-consciously calligraphic.

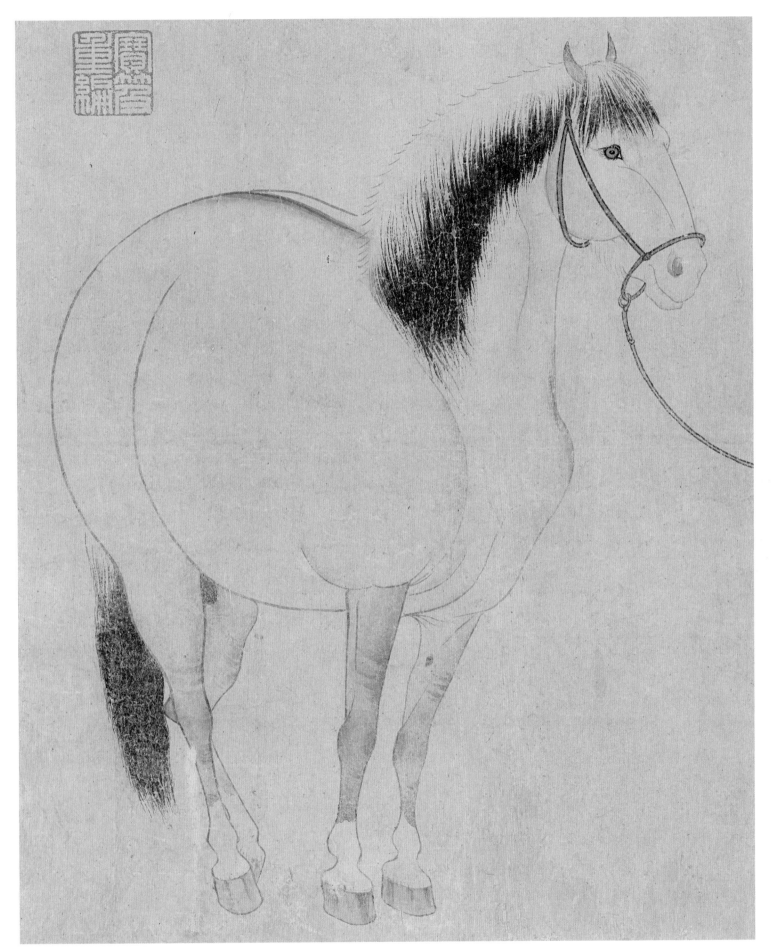

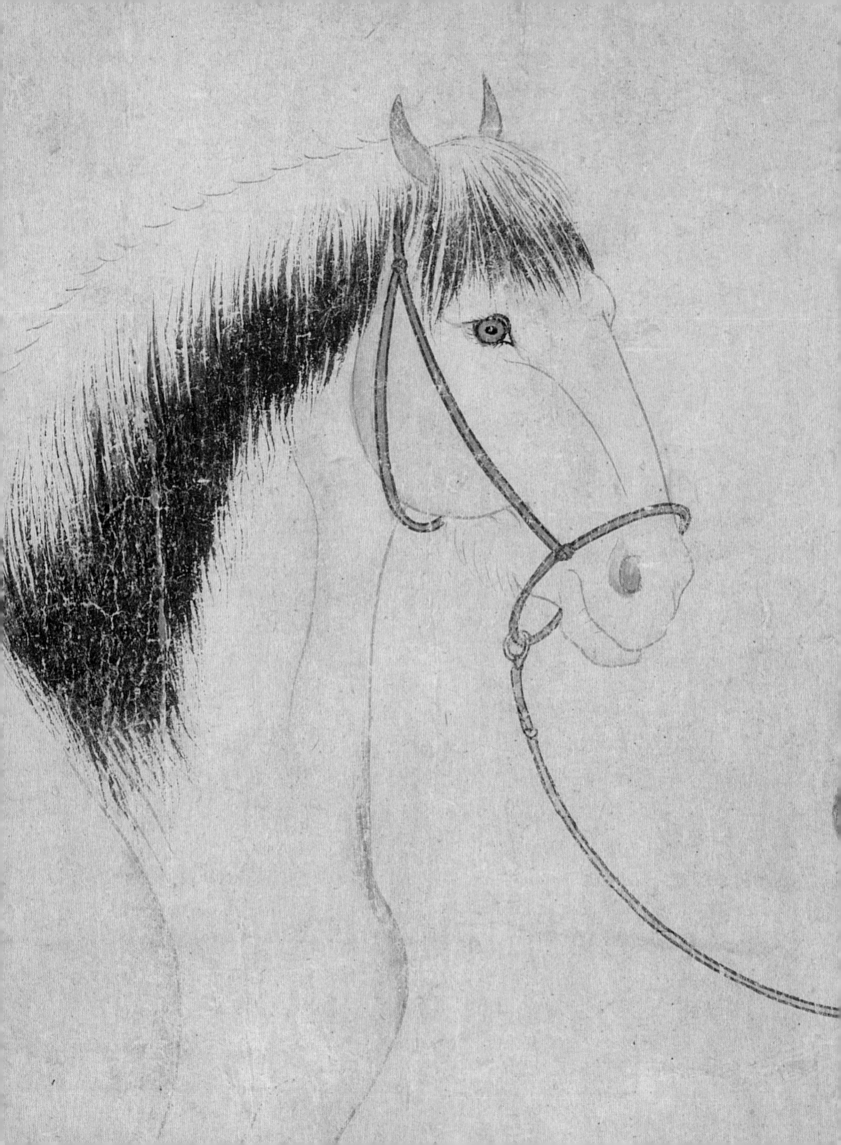

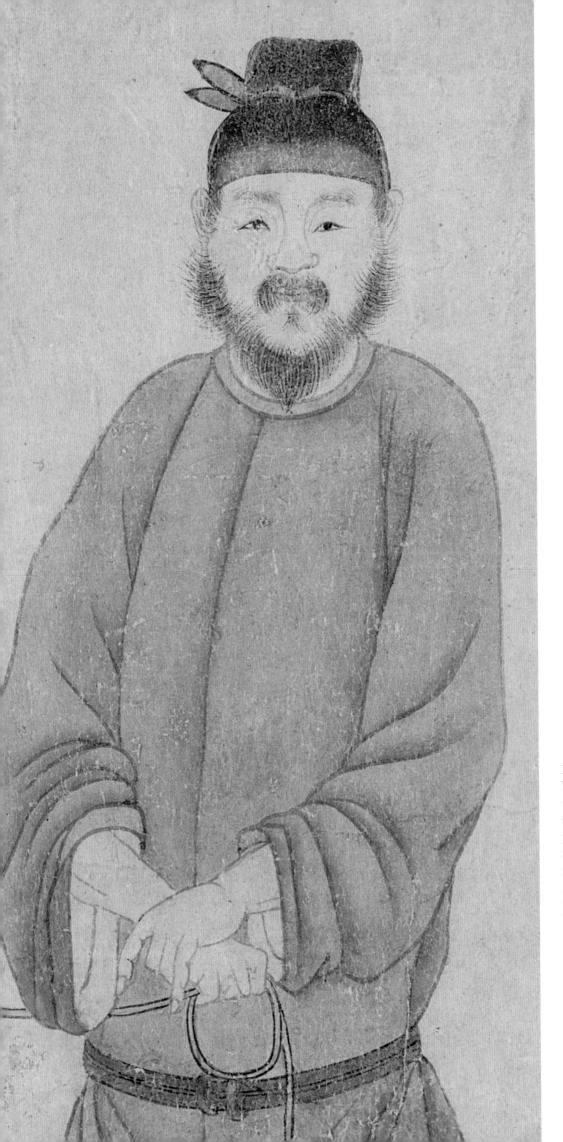

Expertise in judging fine horses has long been a metaphor in China for the ability to recognize men of talent, while superior steeds have often been likened to accomplished scholars. In this work, painted for a man who may have been a government official, Zhao's sensitively portrayed groom may allude to the recipient's talent for recruiting able men, but might also be read as a subtle reference to the artist's own abilities.

Zhao Mengfu's drawing balances representational concerns—evident in his subtle use of ink wash along the horse's contours—with a desire to inflect each line with calligraphic nuances.

13

3 | Exquisite Discipline

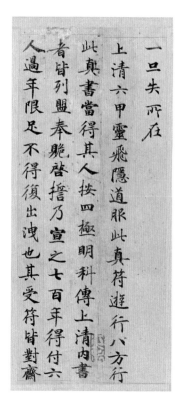

唐 傳鍾紹京 楷書靈飛經 冊

Attributed to Zhong Shaoqing (active ca. 713–41)
Spiritual Flight Sutra, ca. 738

Album of nine leaves (four above), ink on paper, each leaf 8¼ × 3½ in. (20.8 × 8.9 cm)
Ex coll.: Weng Tonghe (1830–1904)
Purchase, The Dillon Fund Gift, 1989 (1989.141.1)

The copying of sutras, the sacred texts of Buddhism and Daoism (Taoism), was an act of devotion as well as a means of propagating the faith. It required a special brush, paper of a conventional size with a vertical grid, and the use of the strictest, most formal type of calligraphy, known as standard script. This hallowed fragment of a Daoist religious text meets all those requirements yet has an elegance and fluency that elevate it beyond normal sutra writing. Wen Fong has described the sutra as follows:

> Commissioned in 738 by the princess Yuzhen, a daughter of the emperor Xuanzong [r. 712–56], [it] exemplifies the highly sophisticated court style of the High Tang period. The small-size standard script . . . is balanced and harmonious, with every stroke, hook, and dot perfectly defined and executed. Applied with a stiff, long-pointed brush, each stroke shows clean, crisp movements, with graceful, saber-sharp turns. Individual characters are straight and upright, firmly built and with a rectangular frame of supports and walls. The construction of the characters reveals an analytical process, whereby different types of brushstrokes are seen as "forces" (*shi*) of a dynamic composition, each having a perfect form and "method" (*fa*) of interacting with another stroke, and each character, with its elegant, carefully considered deployment of these forces, exemplifying a model of physical equilibrium and spiritual repose.

In the early seventeenth century this sutra was acquired by the influential painter, calligrapher, and theorist Dong Qichang (1555–1636), who regarded it as one of the finest extant examples of Tang dynasty small writing.

Detail, third leaf
from right, above

上清六甲靈飛隱道

此真書當得其人楼

者皆列盟奉貽啓

入過年限足不得

Traditional Chinese texts are generally written in columns that are read from right to left. Each column is written from top to bottom, and each character is also written according to a fixed stroke order that proceeds from top to bottom and from left to right. In standard script, characters are composed within an imaginary grid. Thus, while characters may be denser or more open depending upon their number of brushstrokes, each occupies the same amount of space.

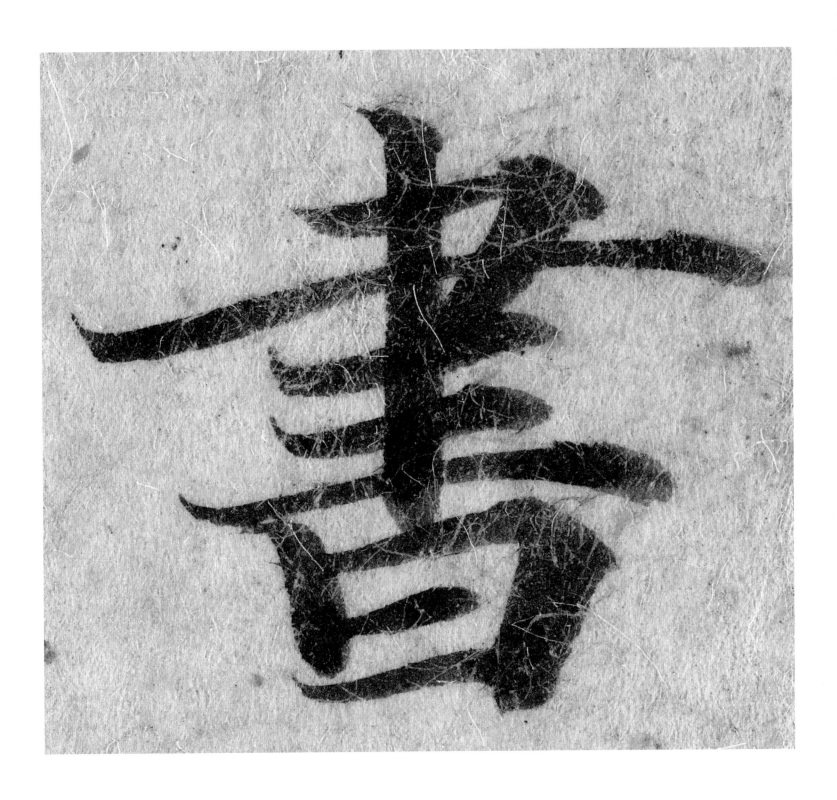

The character for "writing" or "book," 書 (*shu*),
exemplifies the disciplined grace of the finest
standard-script calligraphy. The actual character is
barely the size of a fingernail, but each line is
composed of a distinct beginning, middle, and
end that reflect subtle shifts in the pressure and
direction of the brush. By varying the length
and thickness of each brushstroke, the calligra-
pher integrates these lines into a rhythmically
coherent whole with countervailing energies held
in dynamic equilibrium.

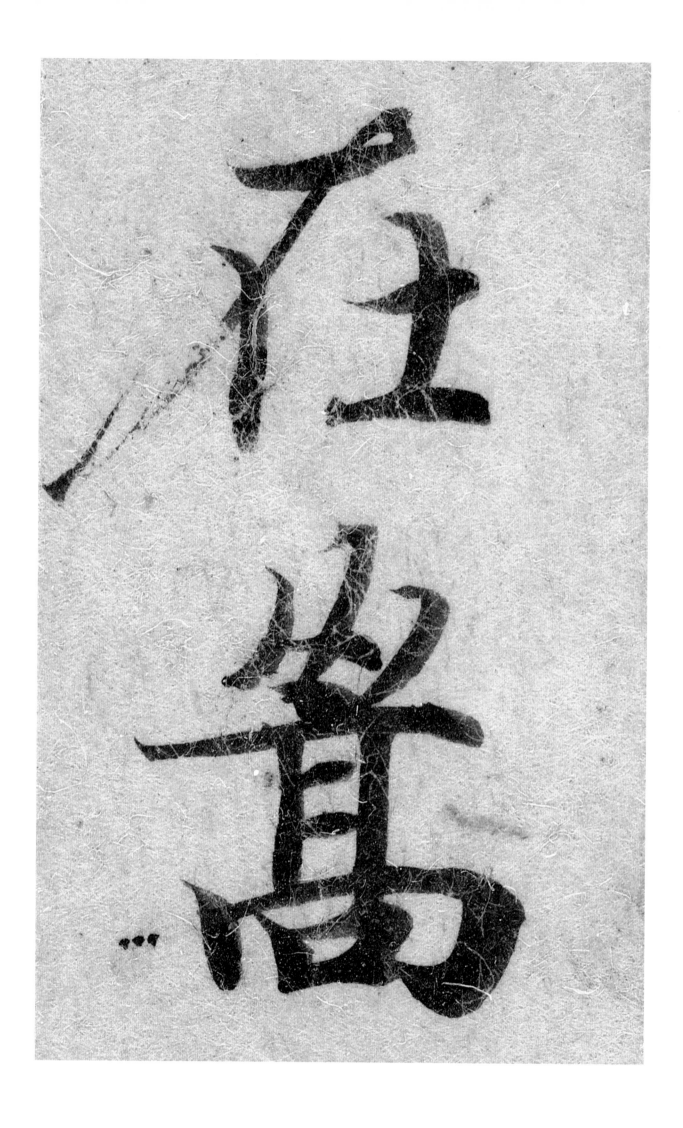

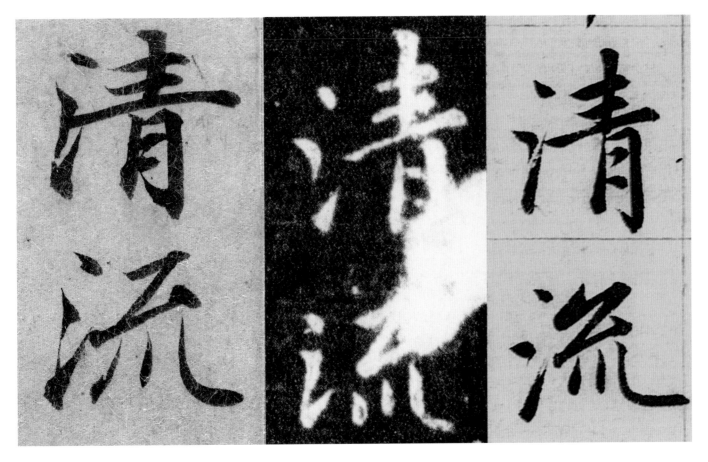

An appreciation of calligraphy entails a careful examination of how individual brushstrokes are integrated to form a character. A comparison of the *Spiritual Flight Sutra* (*left*) with a rubbing of Wang Xizhi's *Orchid Pavilion Preface* of A.D. 359 (*center*) and Zhao Mengfu's revival of Wang's style in his *Record of the Miaoyan Temple* of about 1310 (*right*) reveals that the brushstrokes of the sutra's characters are more relaxed and lack the dynamic interaction seen in the other two works—in part because of their smaller size and in part because the writer was less concerned with emulating classical prototypes. Note in Wang's and Zhao's writing the rakish angle of horizontal strokes and the alignment of vertical strokes in 清 (*qing,* "pure") as well as the progressively larger size of the three verticals in 流 (*liu,* "flow"), with the third vertical ending in a sharp right-angle turn.

<

In standard script, the individual lines that compose each character are formed of distinct brushstrokes, but occasionally this writer adopts a more cursive form of a character by merging two lines into a single movement, as in the first two strokes of 在 (*zai,* "in"). The tilting 山 component of the character 嵩 (*song,* "lofty"), which evokes an earlier clerical-script form of the character, is another example of creative license.

Because it is not possible to erase mistakes, three dots are used to indicate an error; the small ones to the left of the character here indicate that it was mistranscribed. The correct character, 高 (*gao,* "high"), follows.

4 | The Vastness and Multiplicity of Creation

北宋　傳屈鼎　夏山圖　卷

Attributed to Qu Ding (active ca. 1023–ca. 1056)
Summer Mountains

Handscroll, ink and pale color on silk, 17⅞ × 45⅜ in. (45.3 × 115.2 cm)
Ex coll.: C. C. Wang Family
Gift of The Dillon Fund, 1973 (1973.120.1)

Between the years 900 and 1100, Chinese painters created visions of landscape that "depicted the vastness and multiplicity of creation itself." Viewers of these works are meant to identify with the human figures in the painting, to "travel . . . dwell or ramble" in the landscape.

In *Summer Mountains,* lush forests suffused with mist identify the time as a midsummer evening. Moving from right to left, travelers make their way toward a temple retreat where vacationers are seated together enjoying the view. Above the temple roofs, the central mountain sits in commanding majesty, like an emperor among his subjects, the culmination of nature's hierarchy.

The advanced use of texture strokes and ink wash suggests that *Summer Mountains,* formerly attributed to Yan Wengui (active ca. 970–1030), is by a master working in the Yan idiom about 1050. This early date is corroborated by the presence of collectors' seals belonging to the Song emperor Huizong (r. 1101–25). Although there is no record of any paintings by Yan Wengui in Huizong's collection, three works entitled *Summer Scenery* by Yan's eleventh-century follower Qu Ding are listed in the emperor's painting catalogue.

Like many early paintings, *Summer Mountains* was executed on finely woven silk that has darkened with age, but its otherwise pristine condition is likely due to its careful transmission through imperial collections. In addition to the seals of Emperor Huizong, on the left-hand corners of the painting, it bears a Ming palace inventory half-seal (ca. 1373–84) along its bottom right margin as well as Qing dynasty imperial seals that include those of the Qianlong emperor (r. 1736–95), who also added a poetic inscription in the right-hand corner of the composition.

The awesome central peak towers above a temple nestled in a high valley and swathed in a cloud formation that recalls the shape of a magic *lingzhi* mushroom.

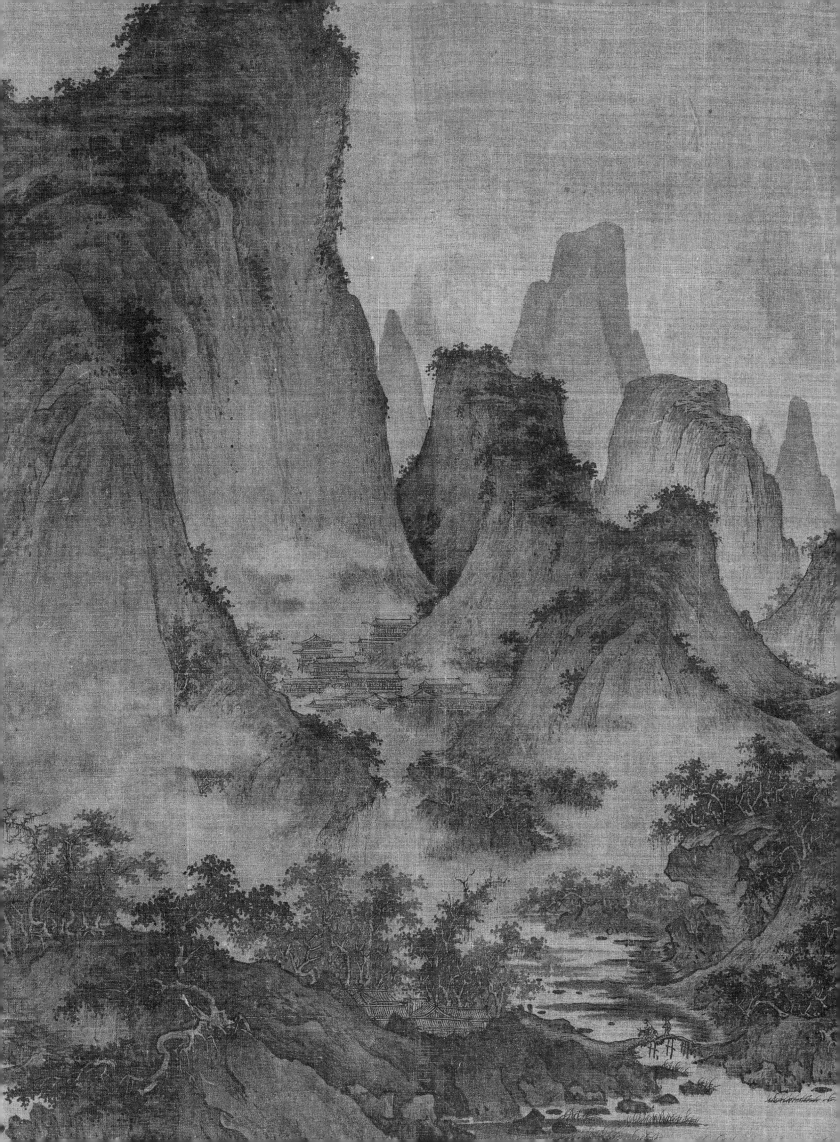

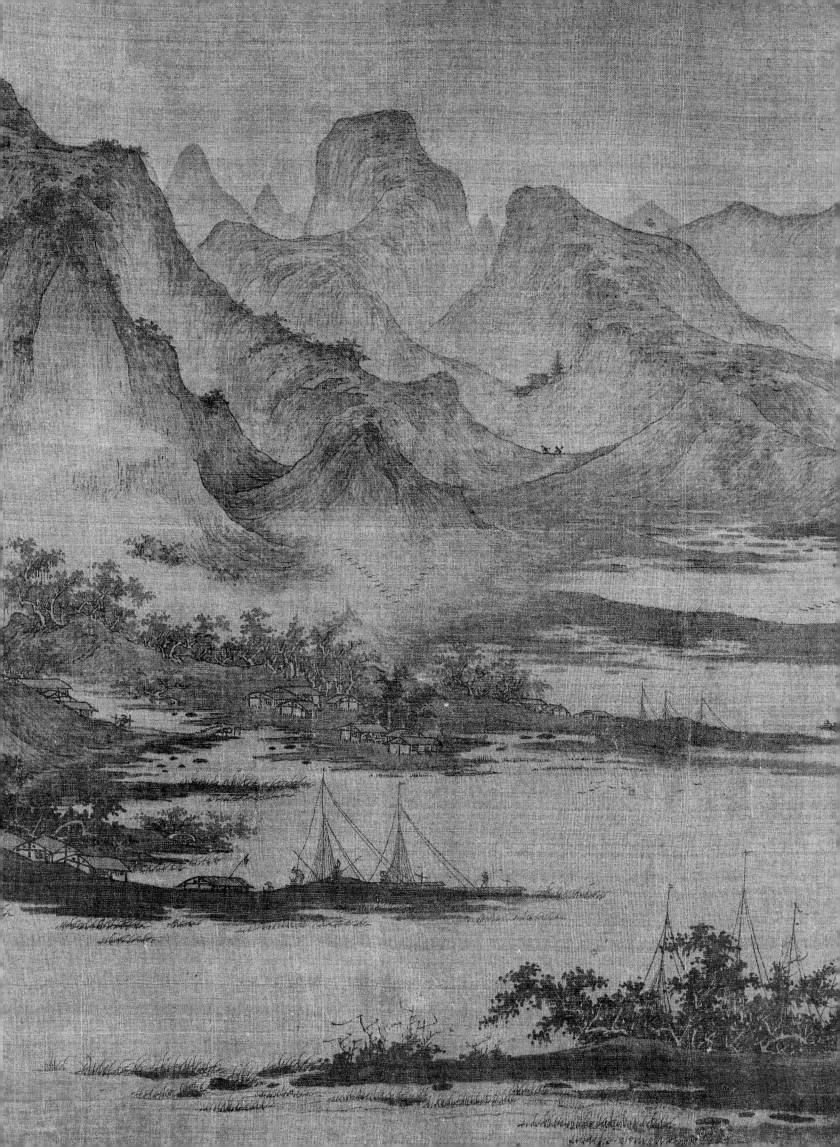

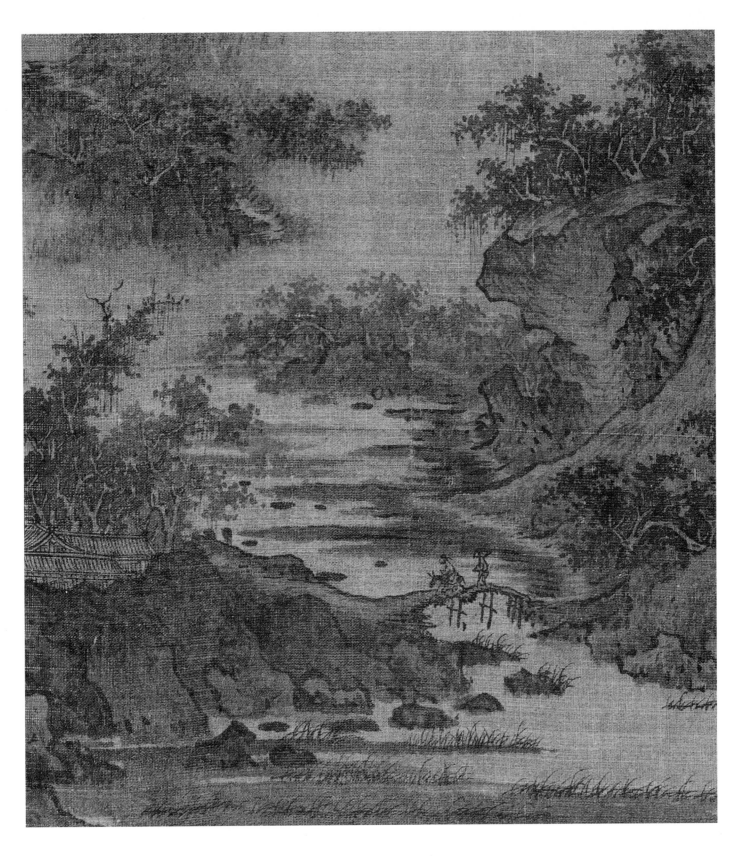

∧
A traveler on his donkey and a porter carrying
his zither make their way from the landing.

<
As the diagonal line of the river draws the
viewer into the foreground, circling geese,
returning fishermen, and mist rising through
lush foliage mark the time and season:
a summer evening.

Overleaf: In the gathering dusk, travelers hasten
along a plank road as a fisherman draws in his net
for the last time. A temple, perched on a rocky
outcrop overlooking a stream, offers a haven for
contemplation and renewal.

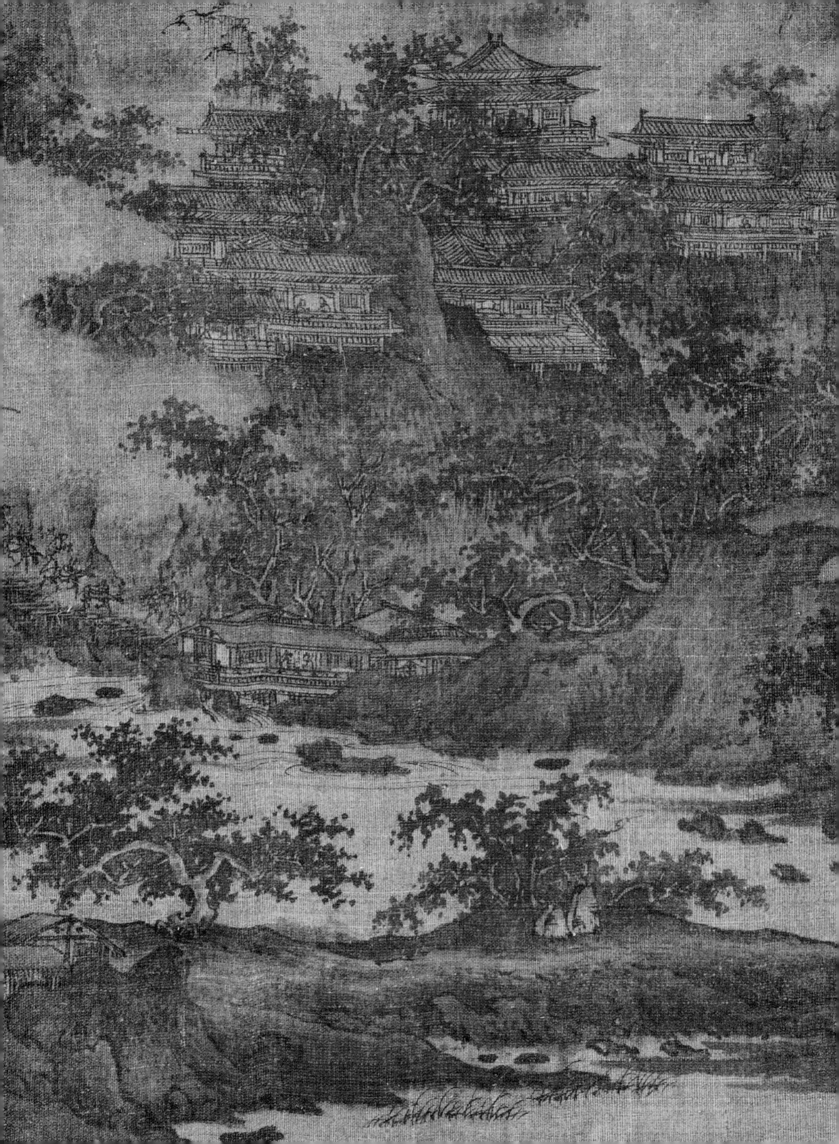

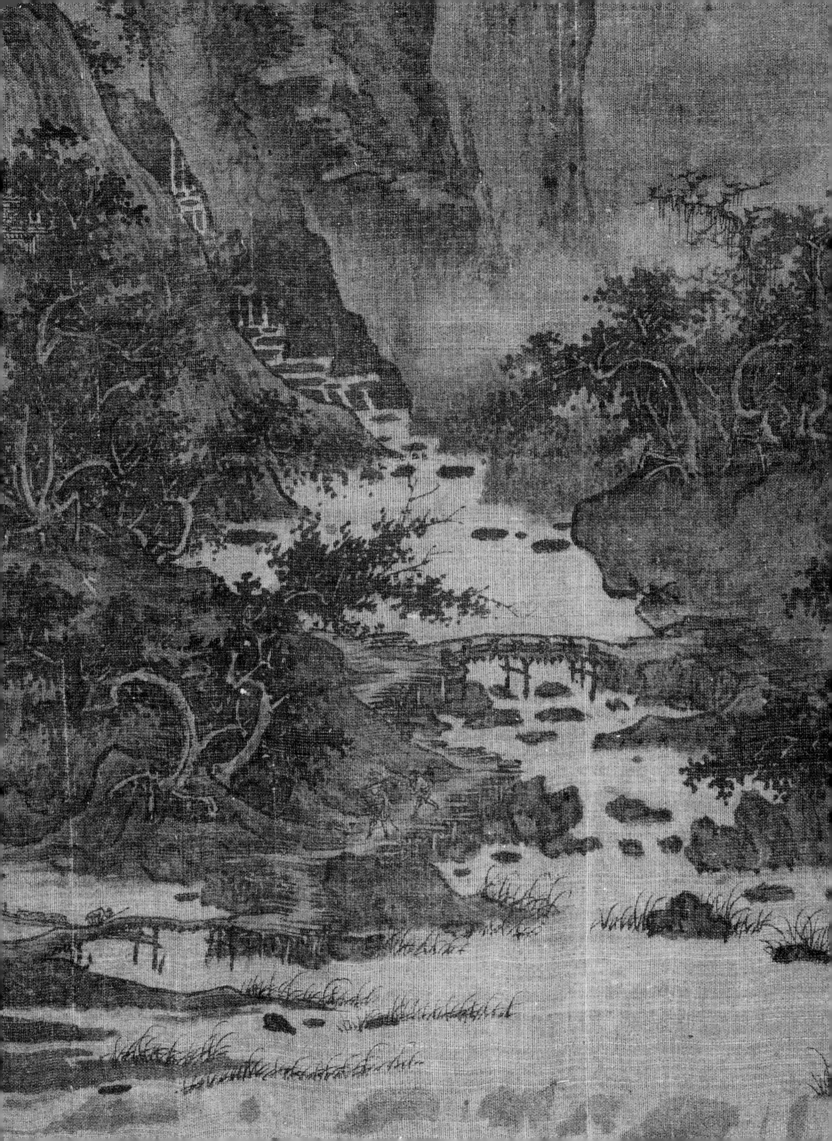

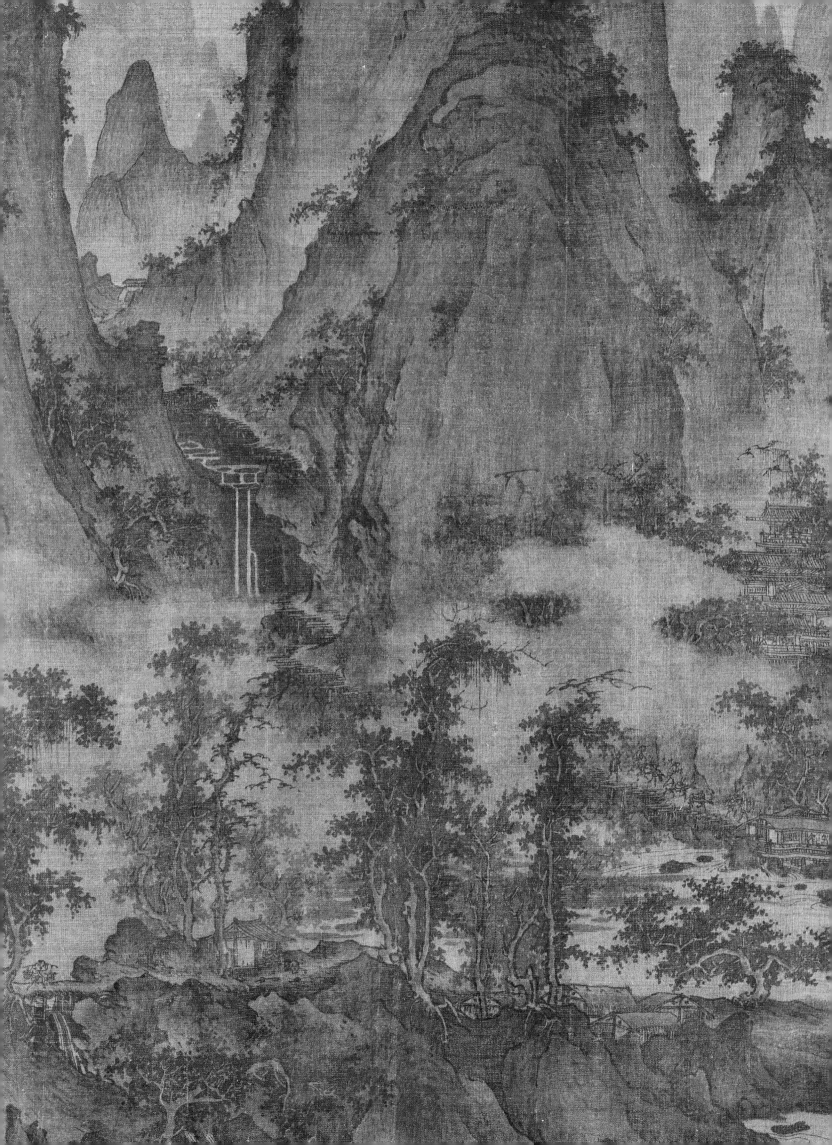

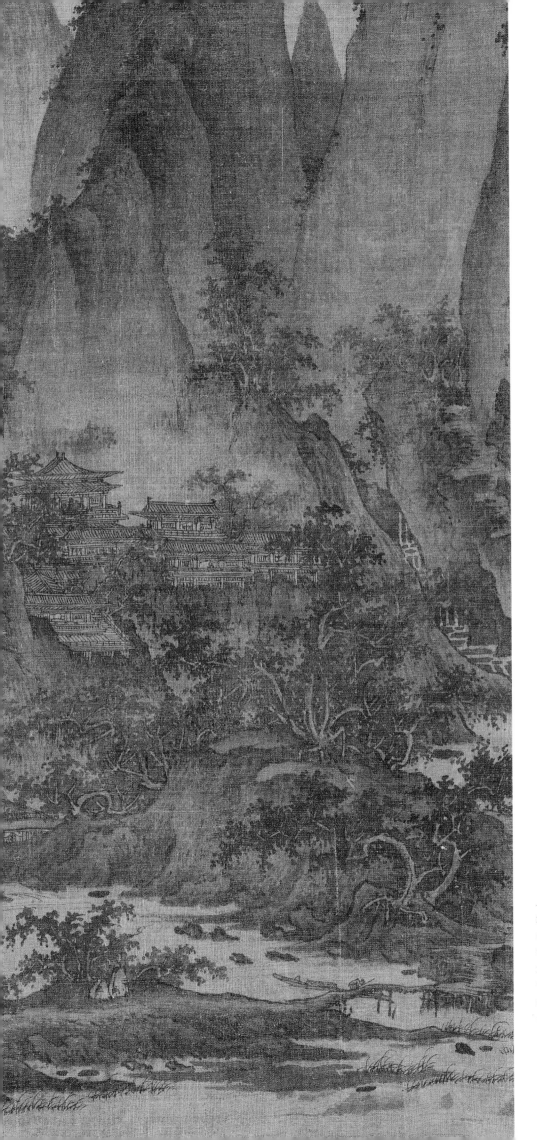

At the scroll's end, the rightward movement of a lone porter crossing a bridge and a mule train descending from a gated mountain pass signals an end to the leftward unrolling of the scroll and leads the viewer back into the composition.

5 | Landscape of Emotion

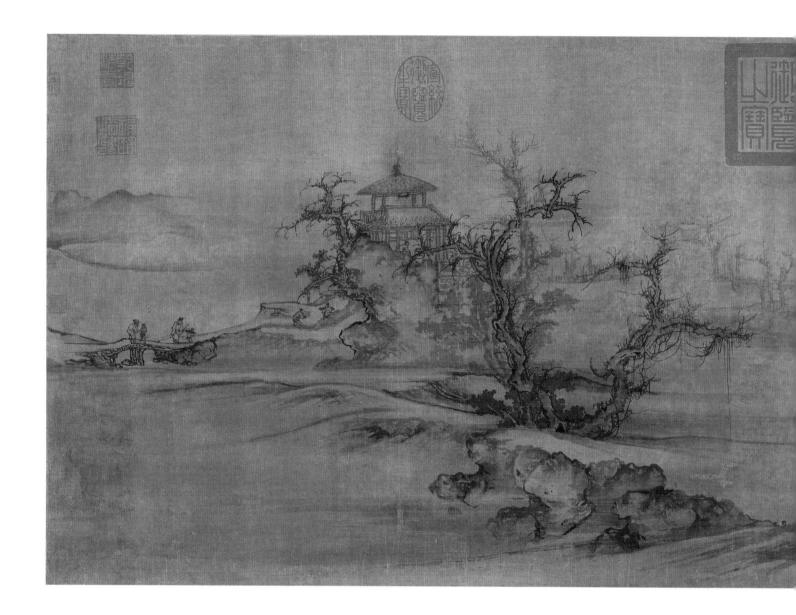

北宋 郭熙 樹色平遠圖 卷

Guo Xi (ca. 1000–ca. 1090)
Old Trees, Level Distance

Handscroll, ink and color on silk, 14 ⅛ × 41 ¼ in. (35.9 × 104.8 cm)
Gift of John M. Crawford, Jr., in honor of Douglas Dillon, 1981 (1981.276)

Guo Xi was the preeminent landscape painter of the late eleventh century. Although he continued the idiom of "crab-claw" (*xiezhao*) trees and "devil-face" (*guimian*) rocks developed by Li Cheng (919–967), his innovative brushwork and use of ink are rich, almost extravagant, in contrast with the earlier master's severe, sparing style.

The brushwork and forms of *Old Trees, Level Distance* compare closely to those of *Early Spring*, Guo Xi's masterpiece, dated 1072 (National Palace Museum, Taipei). In both paintings, landscape forms simultaneously emerge from and recede into a dense, moisture-laden atmosphere: rocks and distant mountains are suggested by outlines, texture strokes, and ink washes that run into each other to create an impression of wet, blurry surfaces. Guo Xi describes his technique in

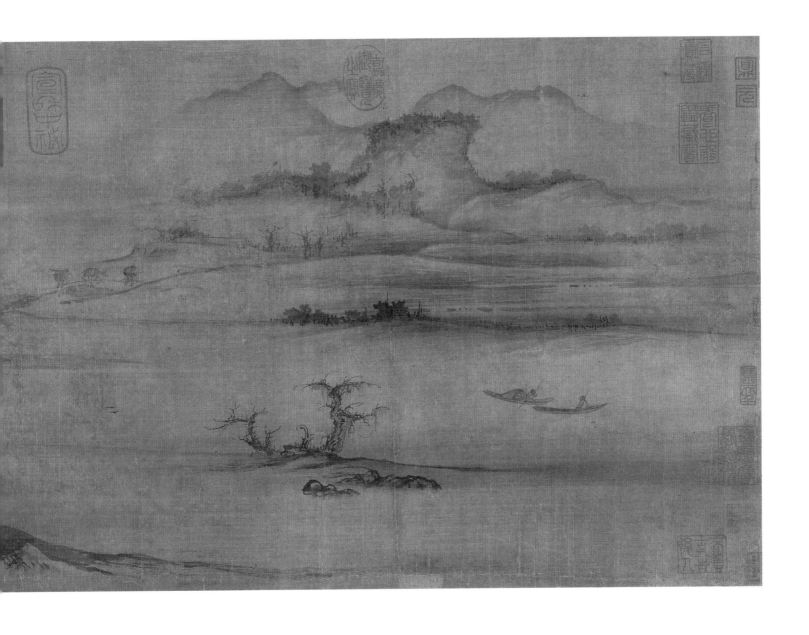

his painting treatise *Linquan gaozhi* (*Lofty Ambitions in Forests and Streams*): "After the outlines are made in dark inkstrokes, I trace the outlines repeatedly with ink wash mixed with blue, so that even when the outlines remain visible, the forms appear as if emerging from the mist and dew."

The "level-distance" (*pingyuan*) composition, a view across a broad lowland expanse, is one of the three traditional ways in which Chinese artists conceptualized landscape. The other two are "high distance" (*gaoyuan*), a view of towering mountains (see no. 4), and "deep distance" (*shenyuan*), a view past tall mountains into the distance. Guo Xi's painting is a variation on the classical level-distance formula originated by Li Cheng—tall foreground trees set against a wide river valley (see also no. 17).

Friends with many leading scholar-officials, including the poets Su Shi (1036–1101) and Huang Tingjian (1045–1105; no. 8), Guo Xi sought to give form to poetic images and emotions rather than to the "principles" (*li*) of nature. He was particularly interested in conveying nuances of season and time of day.

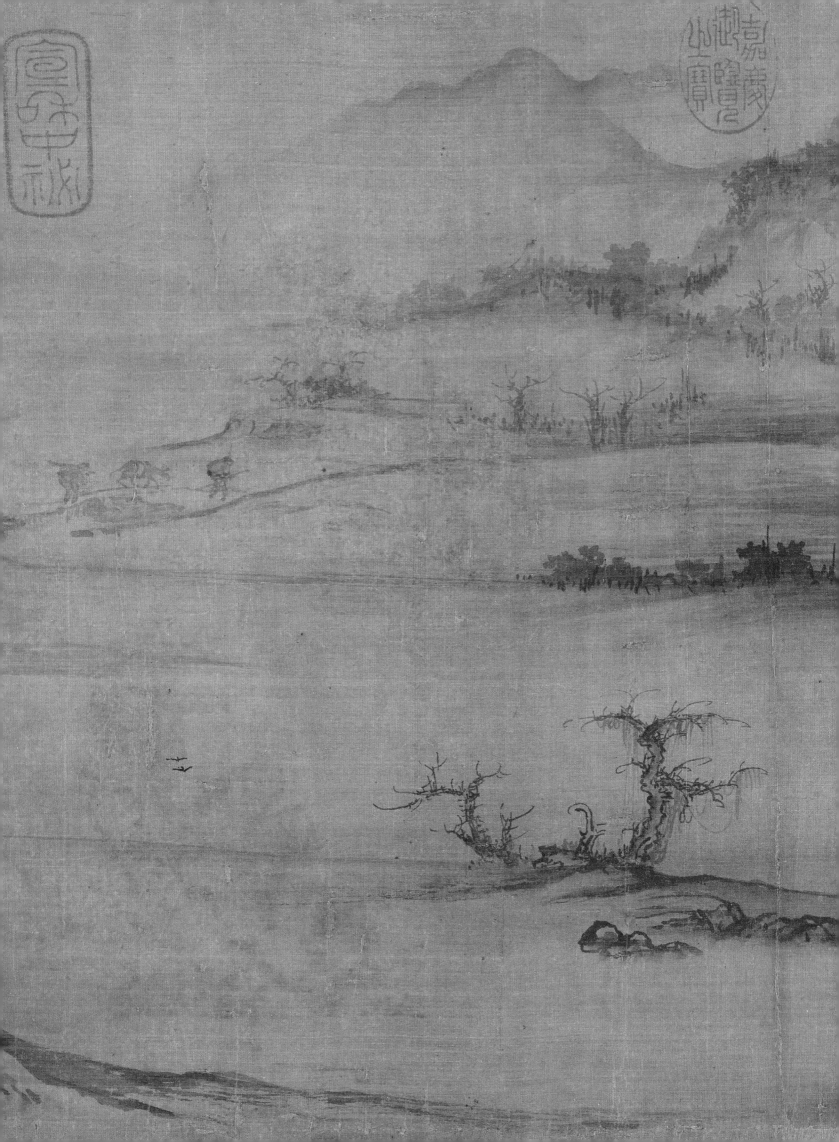

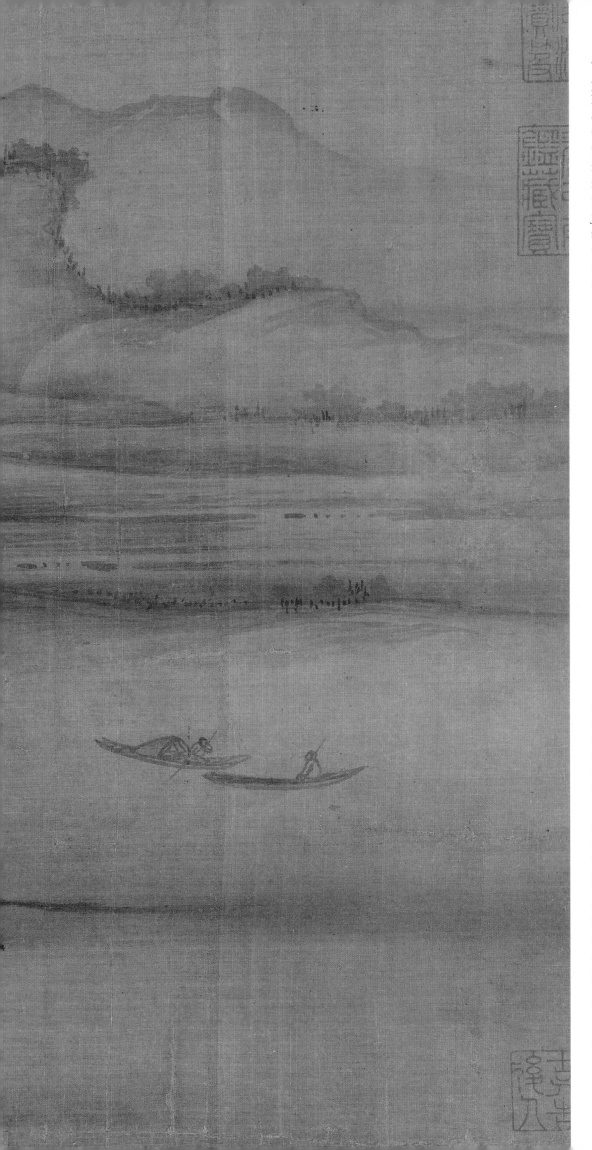

This intimately scaled painting is probably a late work done for a fellow government official on the eve of his retirement and departure from the capital. The opening section of the handscroll sets the mood. Two fishermen in their boats and travelers moving toward the distant mountains are harbingers of an imminent journey into retirement and the final stage of life, waiting at the end of the road. The leafless trees and deepening mist impart a forlorn, autumnal air to the scene.

Overleaf: The second half of the scroll narrows the focus. A diagonal embankment draws the eye leftward to a bridge where two elderly figures—perhaps the artist (who may have been close to eighty at the time) and his friend—make their way toward a pavilion. Their stooped forms are echoed by the two craggy foreground trees, seemingly connected at the root. The pavilion may represent one of the kiosks built on the outskirts of the capital where colleagues might gather to bid farewell to a departing friend. Several attendants with food baskets and a zither have gone ahead to prepare a simple meal. Given the advanced age of the two gentlemen, it is likely that this meeting will be their last. The intense emotions of the moment are subtly conveyed by the landscape.

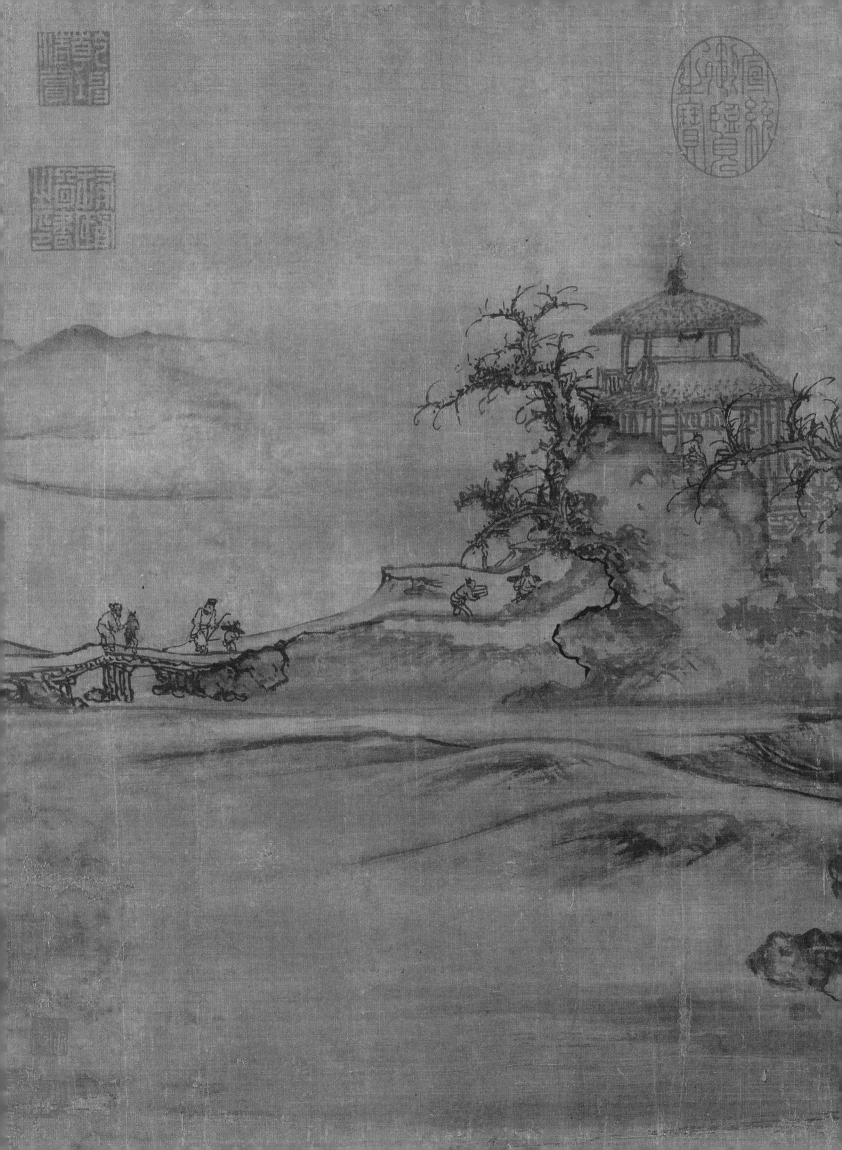

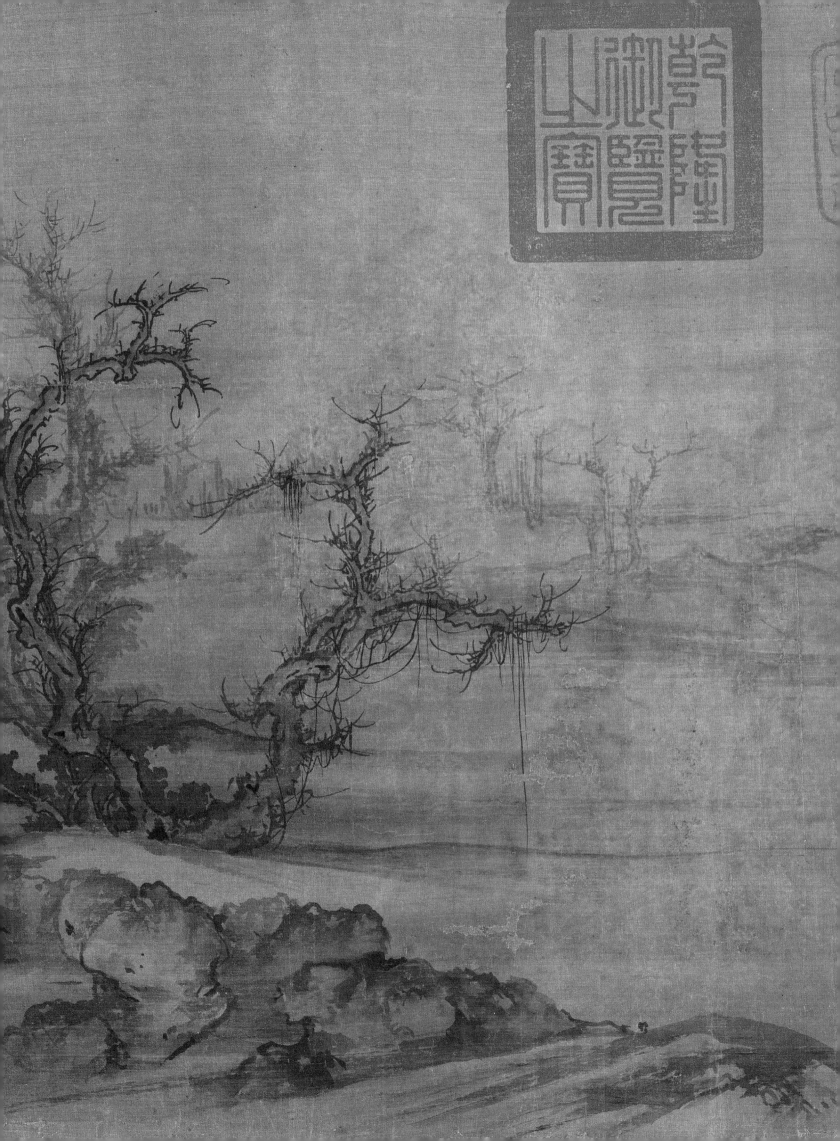

北宋　徽宗　竹禽圖　卷

Emperor Huizong (1082–1135, r. 1101–25)
Finches and Bamboo

Handscroll, ink, color, and lacquer on silk, painting 11 × 18 in. (27.9 × 45.7 cm)
John M. Crawford Jr. Collection,
Purchase, Douglas Dillon Gift, 1981 (1981.278)

Huizong, the eighth Song emperor and a rapacious collector of art objects, was a painter and calligrapher of great talent. In 1127 Huizong's capital at Kaifeng, Henan Province, was sacked by the Jurchen, and the emperor was carried off to the north; he died in captivity in 1135.

Finches and Bamboo illustrates the suprarealistic style of flower-and-bird painting preferred by the artists of Huizong's Imperial Painting Academy. In such works, the painter displayed

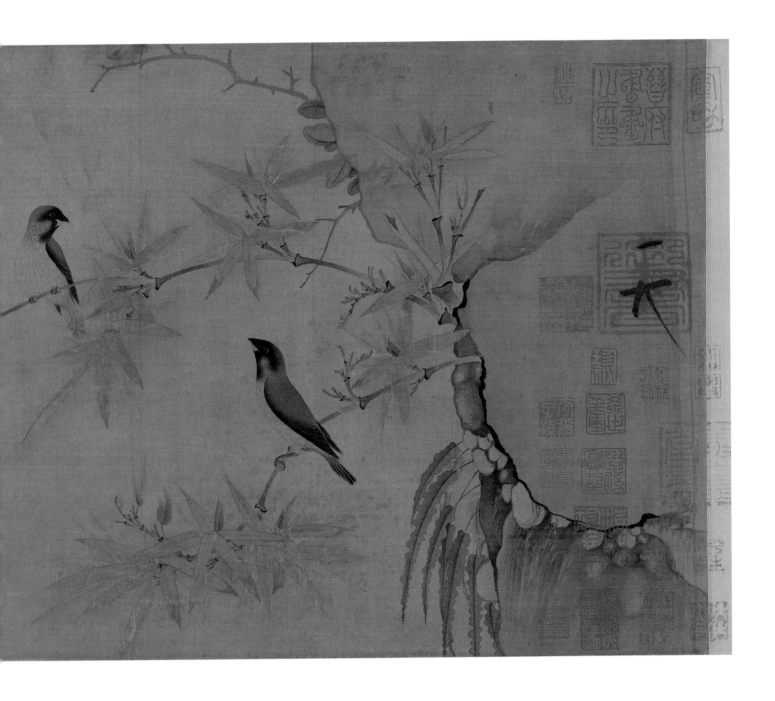

both his intimate knowledge of plants and his ability to render accurately the movements of birds as they hop about or stand poised ready for flight. Whether making a study from nature or illustrating a line of poetry, however, the artist valued capturing the spirit of the subject more than mere literal representation. Here, the minutely observed finches are imbued with the alertness and sprightly vitality of their living counterparts. Drops of lacquer added to the birds' eyes impart a final lifelike touch.

In his colophon to the painting, the scholar-artist Zhao Mengfu (1254–1322; nos. 2, 17, 18) offers an amusing commentary on Huizong's creation: "The prince of the Dao was gifted and wise by nature. In the art of painting he attained the ultimate in subtlety. With ability almost beyond anything human, he could depict the essential character of plants and animals so that they were as though created by nature. In this scroll he has not labored much with ink and colors, yet all is spontaneous and right. It is proper that generations have treasured it. What good fortune for these insignificant birds to have been painted by this sage."

When the painting was remounted, one of its framing borders of yellow brocade was moved to the left of Zhao Mengfu's colophon as a way of highlighting this important inscription. This rearrangement was probably done at the command of the Ming prince Zhu Gang (1358–1398), whose large seals are impressed on the paper-silk seams to either side of the colophon.

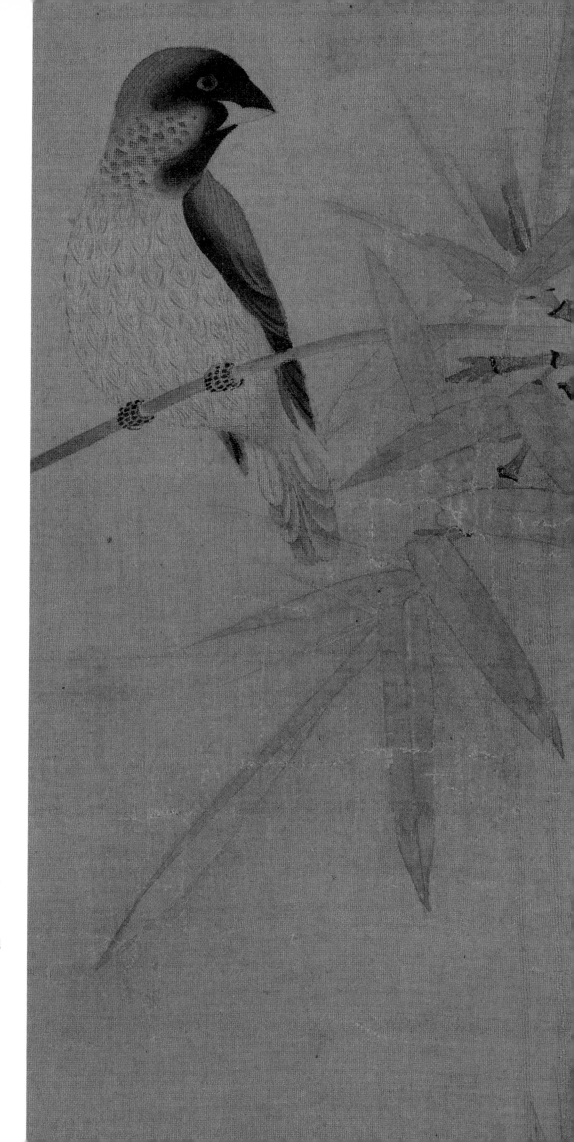

Emperor Huizong stressed keen obser-
vation and telling details as keys to
capturing a subject's inner spirit as well
as its outer appearance. He has created
a wonderful sense of psychological
interaction between these two small
creatures. Beyond their lively poses and
naturalistic plumage, these finches are
animated by the addition of dots of
lacquer to their eyes, imparting a luster
and three-dimensionality that paint
alone cannot convey.

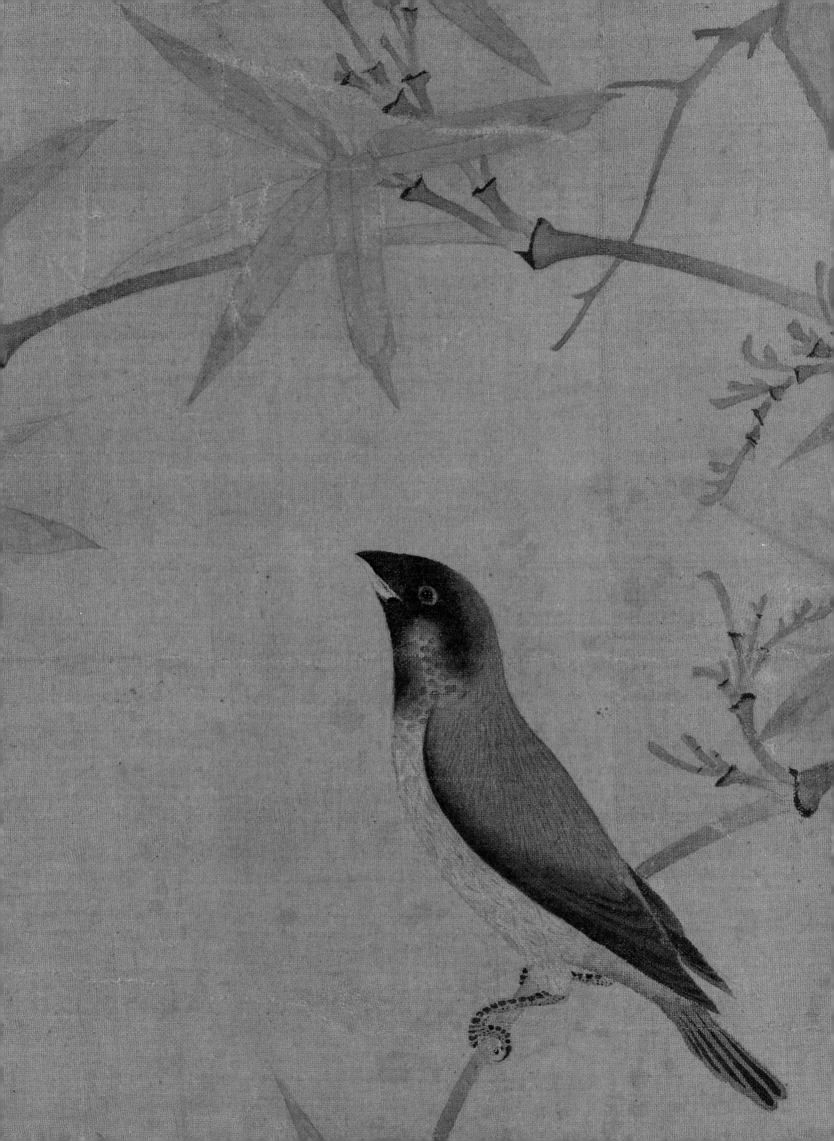

7 | The Subtle Subversive

北宋　李公麟　孝經圖　卷

Li Gonglin (ca. 1041–1106)
The Classic of Filial Piety, ca. 1085

Handscroll (detail above), ink on silk, 8⅝ in. × 15 ft. 7¼ in. (21.9 × 475.5 cm)
Ex coll.: C. C. Wang Family
From the P. Y. and Kinmay W. Tang Family Collection,
Gift of the Oscar L. Tang Family, 1996 (1996.479a–c)

Scholar-artists of the Song dynasty (960–1279) believed that painting was not just a record of sensory experience but also a reflection of the artist's mind, a revelation of his personality, and an expression of deeply held values. In giving form to this ideal, Li Gonglin fundamentally transformed Chinese art. Prior to Li's time, painting served a public function and was primarily decorative or didactic in intent. With Li, painting joined music, poetry, and calligraphy as a medium of self-expression. His revolutionary new style established the three essential desiderata of scholar painting: moral purpose, learned stylistic references to the past, and expressive calligraphic brushwork.

The Classic of Filial Piety, composed between 350 and 200 B.C., teaches a simple but all-embracing lesson: beginning humbly at home, filial piety not only ensures success in an individual's life but also brings peace and harmony to the world at large. During the Song dynasty, the text became one of the thirteen classics of the Neo-Confucian canon, and it remained a cornerstone of traditional Chinese moral teaching until modern times. The images accompanying Li's transcription of the *Classic* do more than illustrate the text, however. Using his art to criticize, exhort, or subvert, Li presents subtle commentaries on the *Classic*'s moral relevance to the Song world.

Purposefully restrained and without the decorative appeal of color, the paintings alternate with transcriptions of brief chapters from the *Classic*. Like the paintings, the calligraphy is executed in an archaic style instantly recognizable to the connoisseur as a sophisticated plea for a return to simple virtues and plain-living rectitude.

In his standard-script calligraphy, Li eschewed the suave elegance and meticulously formed characters of eighth-century examples (see no. 3). Instead, he developed an unadorned and highly individualistic style derived from archaic models that features characters with stubby squat forms, rectilinear configurations, or exaggerated components, including elongated horizontals and compressed thick verticals.

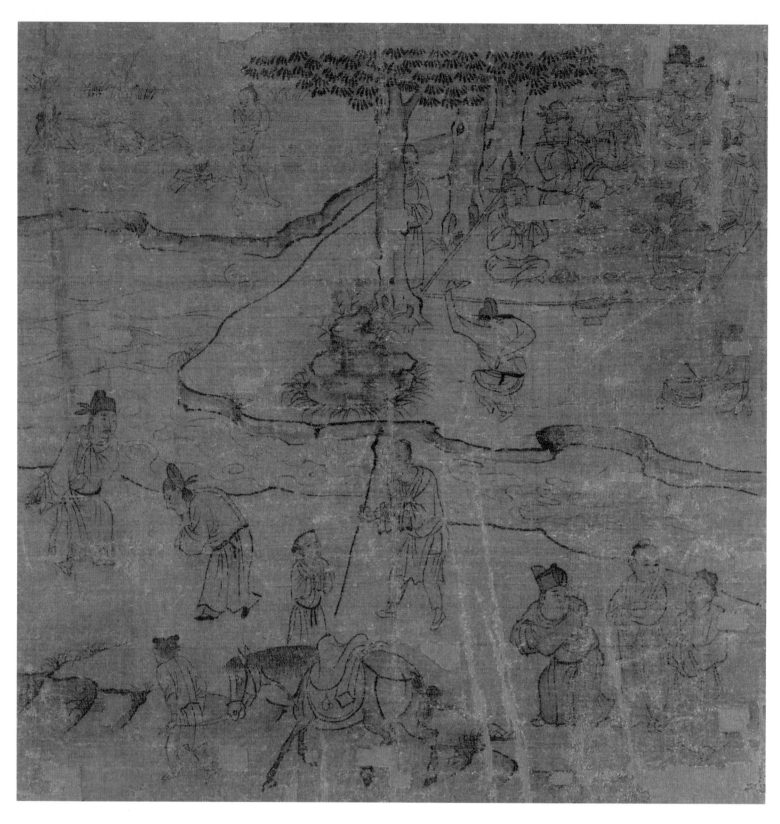

This scene focuses on filial relationships at all levels of contemporary society: a son takes leave of his parents before mounting his horse; a youth pays his respects to an elder; a gentleman yields the path to a second man, who bows in appreciation. An elegant gathering in the background suggests the harmonious influence of music, but two half-naked figures nearby offer a trenchant commentary on society's failure to succor the needy.

Li's illustration of filial piety in government focuses on the passage that declares, "The rulers of states did not dare to slight wifeless men and widows. How much less would they slight their officers and subjects!" The painting, which depicts an audience between the emperor and a group of aged men and women, seems to laud the emperor's humane treatment of his subjects, but the contrast between the ruler—who stands on a platform surrounded by his courtiers and is protected by cudgel-wielding guards— and the stooped elders implies that this encounter is only a hollow formality.

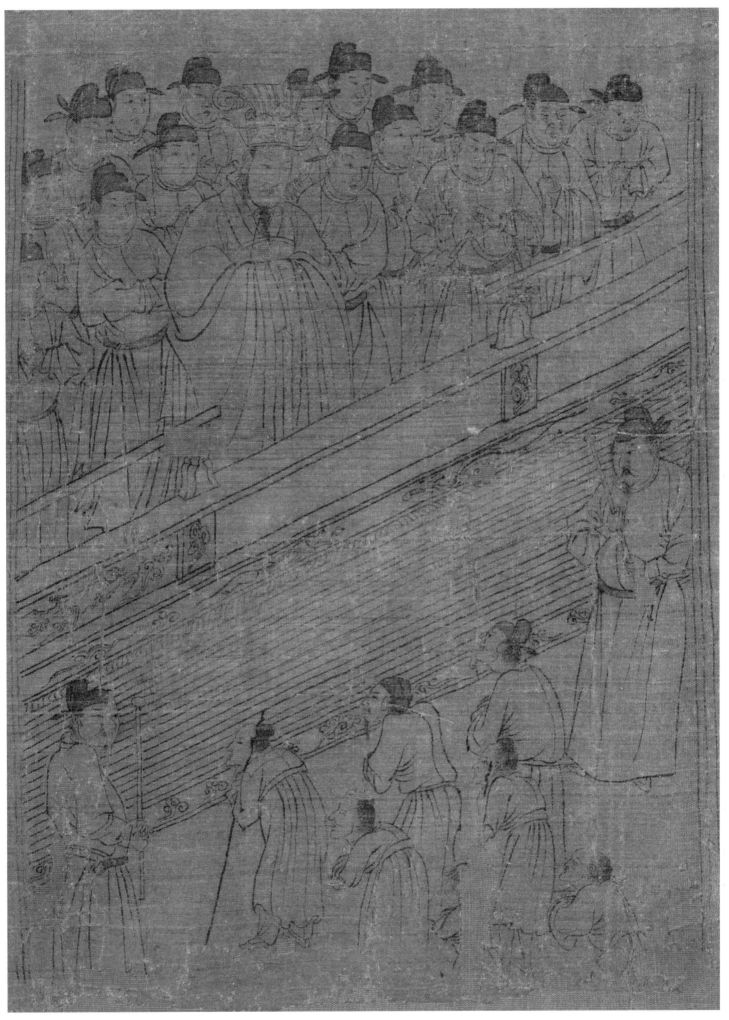

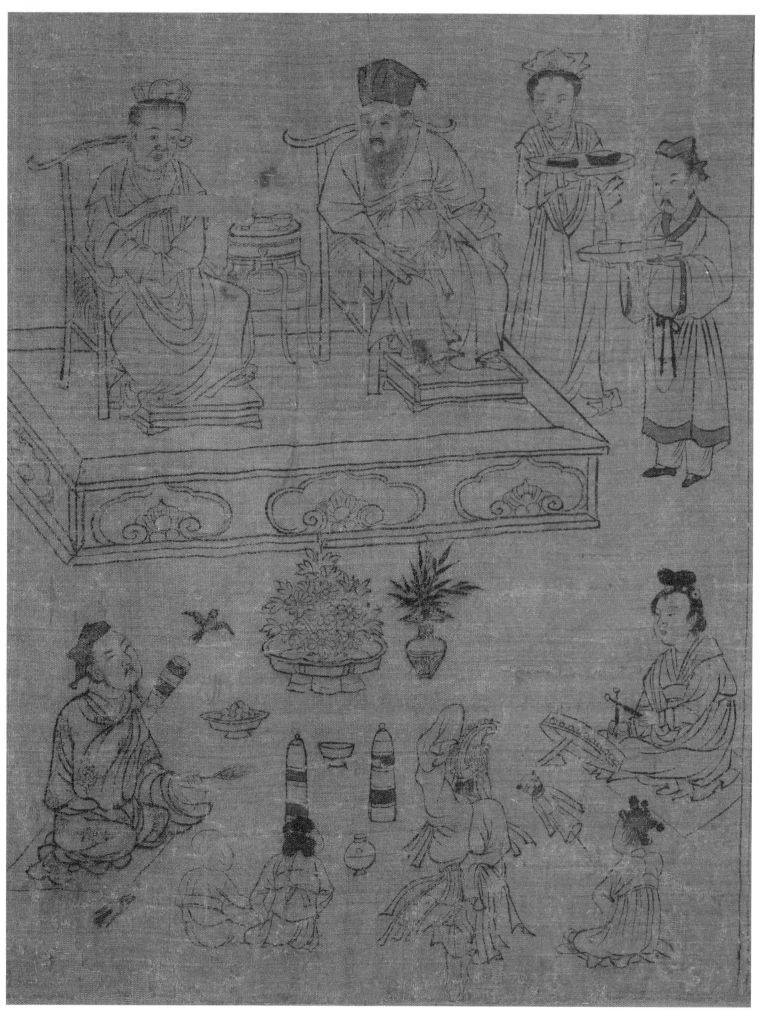

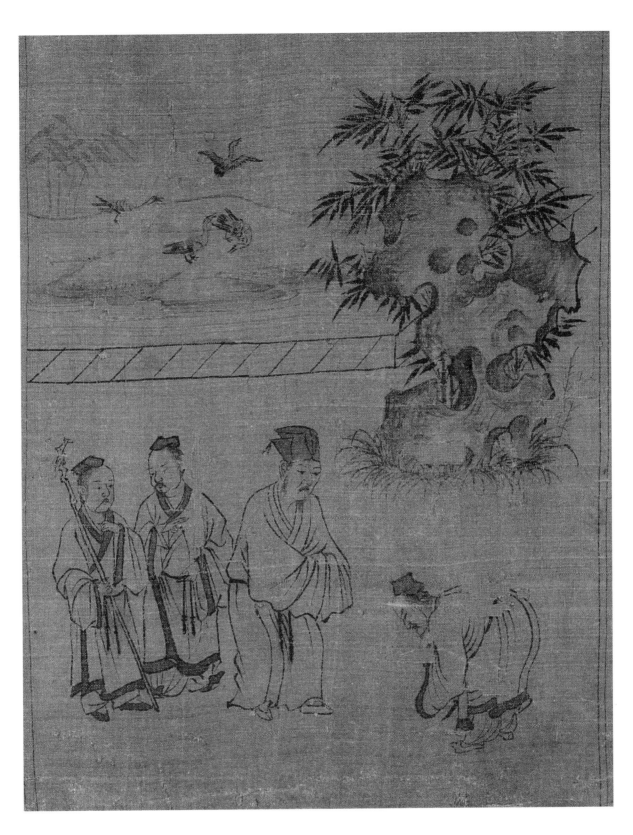

<

This chapter reads in part, "The service which a son renders to
his parents is as follows. In his general conduct toward them he
manifests the utmost reverence. In his nourishing of them, his
endeavor is to give them the utmost pleasure." Li Gonglin per-
sonalizes the text by conjuring up a delightful family scene in
which an elderly couple is entertained by a magician, a musi-
cian, and a dancer while their dutiful son and his wife prepare
to serve them. The patriarch, like his son and daughter-in-law,
is mesmerized by the conjuring of a bird, but his wife appears
more interested in her grandchildren, who are seated among
the entertainers.

∧

This chapter instructs readers, "For securing the repose of
superiors and the good order of the people there is nothing
better than propriety. Propriety is simply respect." Li visual-
izes this abstract concept by depicting the deferential behav-
ior of two men—even in the informal setting of a garden.
Their upright nature is underscored by the rock and bam-
boo, symbols of fortitude and moral virtue.

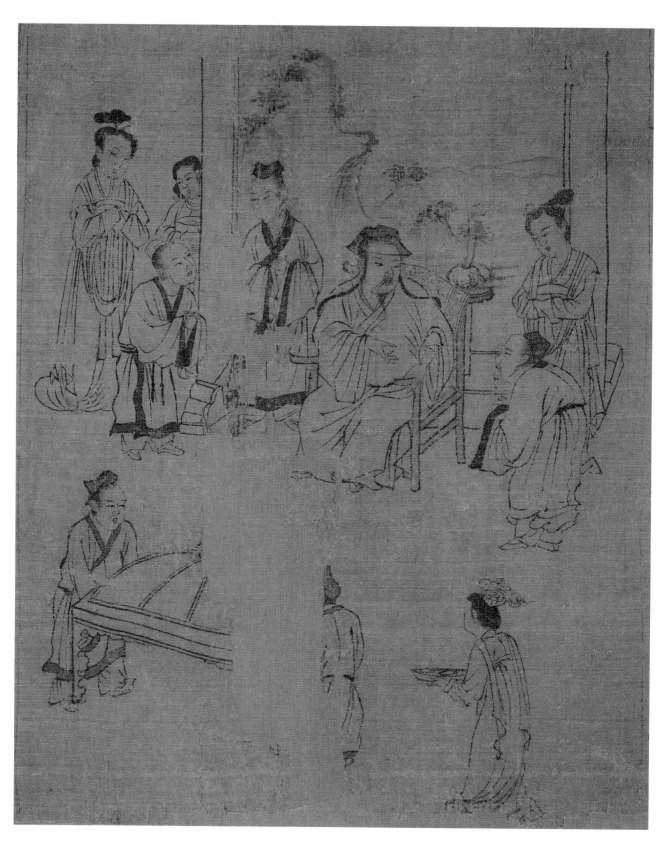

To illustrate the practice of filial piety at home, Li depicts a family patriarch ensuring harmony between two generations by inviting them to partake of a meal together.

Serious matters of law were the responsibility of the local magistrate, who served both as administrator and judge. Seated by a table with his assistants, the official listens to a dispute between three men and a woman as the guilty parties in a previous case are being led away by two bailiffs. Li's unflinching depiction of the harsh consequences of illegal behavior is a powerful reminder of the text's admonition that "there are three thousand offenses against which the five punishments are directed, and there is not one of them greater than being unfilial."

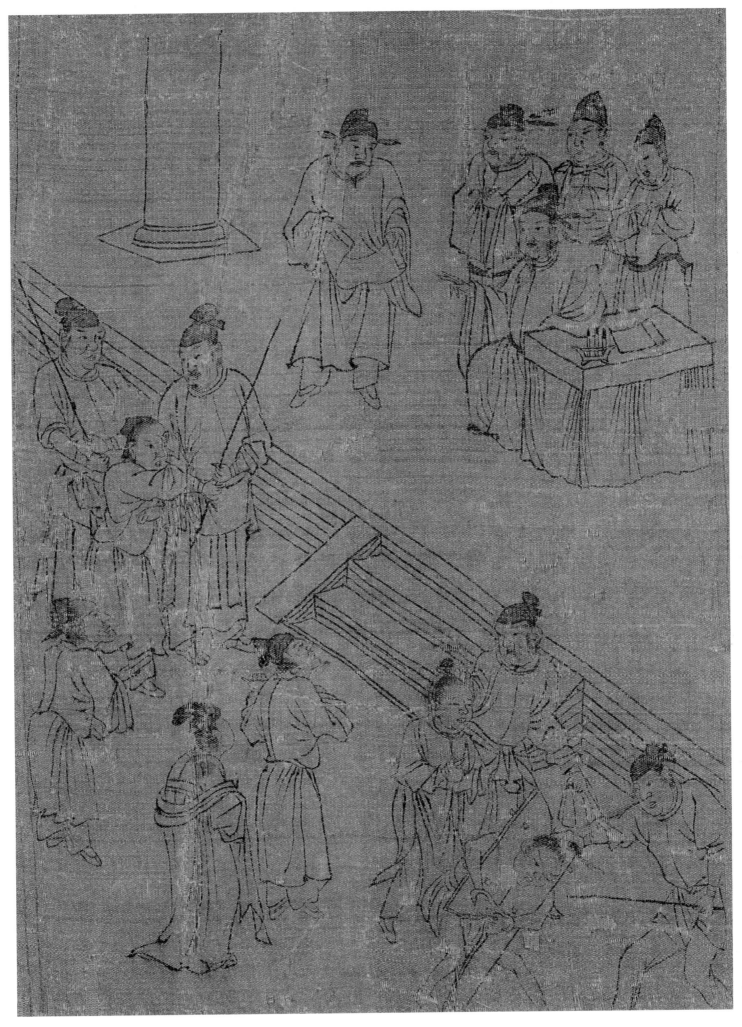

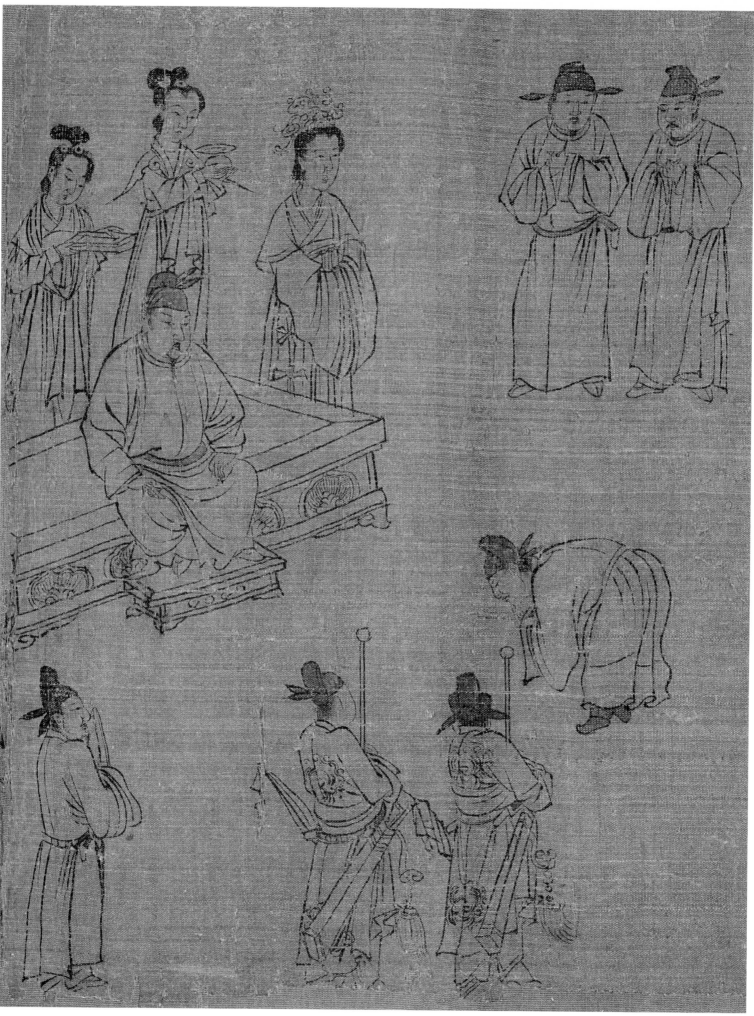

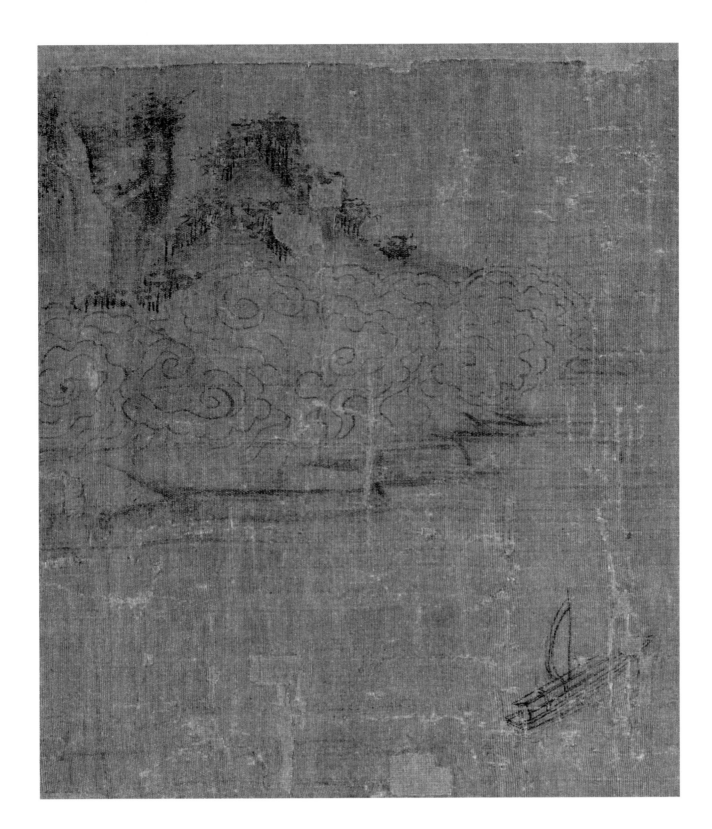

<

The emperor is the supreme authority figure to whom
obedience and respect are due. But the ultimate act of loy-
alty for ensuring good government is an official's honest
remonstration and constructive criticism of the ruler's
shortcomings. Li vividly evokes the tension of such a
moment. The emperor, accompanied by his empress and
courtiers, sits on the edge of his throne. His evident dis-
comfort is conveyed by the flicking brushstrokes that
describe his robe. Two cudgel-bearing guards suggest the
dire consequences of imperial displeasure, while the
seriousness of the moment is conveyed by the worried
expressions of two bystanders.

∧

To accompany the text on the death of a parent, Li does
not refer to the *Classic*'s descriptions of mourning, burial,
and sacrifice. Instead, he depicts a lone boat sailing along
a range of mountains half concealed by clouds. The image
may have been suggested by an ancient poem of mourning
for one's parents from the *Book of Songs* that reads in part,
"The two of you went off in a boat, / Floating, floating
far away. / Longingly I think of you; / My heart within
is pained."

8 | Expressive Freedom in Banishment

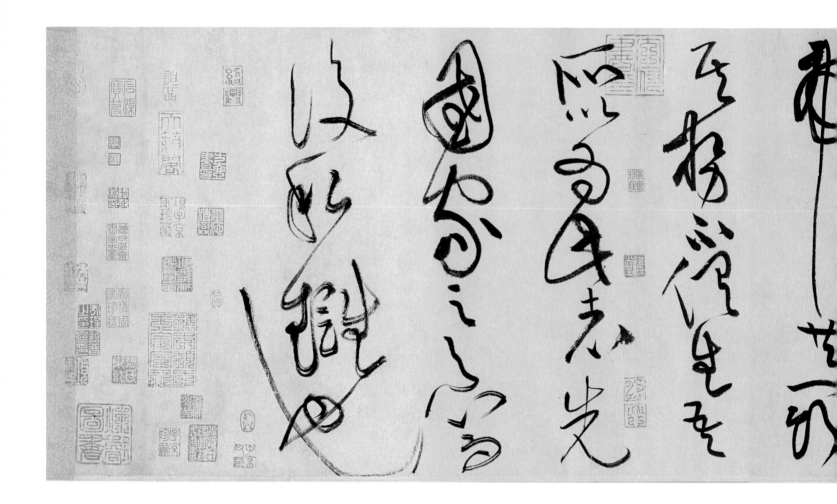

北宋　黄庭堅　草書廉頗藺相如傳　卷

Huang Tingjian (1045–1105)
Biographies of Lian Po and Lin Xiangru, ca. 1095

Handscroll (detail above), ink on paper, 12¾ in. × 59 ft. 9 in. (32.5 × 1,822.4 cm)
Bequest of John M. Crawford Jr., 1988 (1989.363.4)

Poet, calligrapher, and Chan (Zen) Buddhist adept, Huang Tingjian shared the view of his contemporary Su Shi (1037–1101) that calligraphy should be spontaneous and self-expressive—"a picture of the mind."

Biographies, measuring almost sixty feet in length and containing nearly twelve hundred characters, is Huang Tingjian's longest extant work and one of the longest calligraphy hand-scrolls ever executed. This masterpiece of cursive-script writing displays a sustained energy, exuberant curvilinear forms, and round brush lines that show a clear indebtedness to the "wild cursive" manner of the "mad monk" Huaisu (ca. 735–?800), whose *Autobiography* Huang saw in 1094.

Biographies transcribes an account from the *Records of the Historian (Shi ji)* by Sima Qian (145–86 B.C.) that describes the rivalry of two officials in the state of Zhao who served King Huiwen (r. 298–266 B.C.): Lian Po, a distinguished general, and Lin Xiangru, who began his career as steward to the chief eunuch, but whose skill as a strategist in dealing with the more powerful state of Qin led to his being promoted to a rank superior to that of the general. Insulted by this apparent snub, Lian Po resolved to humiliate Lin, but Lin avoided a

The stirring finale of Huang's scroll begins with the dramatic character for "tiger," 虎 (*hu*), at the start of the eighth column from the right, and culminates in the final column with four emphatic characters that he wrote out without pausing to reink his brush.

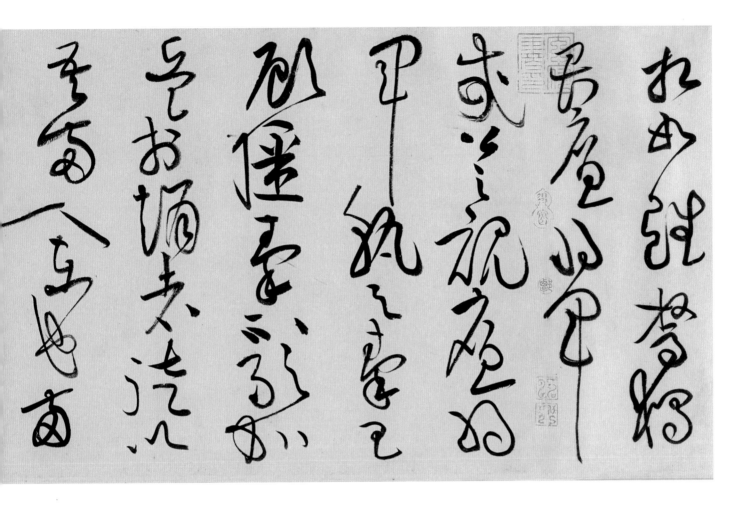

confrontation and eventually won Lian's support by placing the well-being of the state above private grievances. Huang's transcription edits the historical text to focus on this key event, ending abruptly with Lin's words: "[When] two tigers fight, one must perish. I behave as I do because I put our country's fate before private feuds." Read in the context of Northern Song factional politics, Huang's transcription becomes a powerful indictment of the partisanship that led to his own banishment to Qianzhou, in Sichuan Province, in 1094.

Huang once boasted that he could write several thousand characters without tiring, and *Biographies* substantiates that claim. While changes in the consistency and tonality of the ink show that Huang replenished his ink supply several times, there is no obvious change in the momentum of his writing. Instead, shifts in the spacing, scale, and tonality of the characters primarily reflect Huang's emotional response to the text. In writing Lin's final words (*seen above*), Huang permits his emotions to pour out, scarcely lifting the brush from the paper until the last stroke—the grandly sweeping diagonal of the final particle 也 (*ye*)—which embodies Huang's fierce determination to rise above factional politics. The historical text does not end here, but Huang's decision to stop his transcription at this juncture underscores his intention to use this ancient text as a critical commentary on contemporary politics.

Huang probably elected to leave his work unsigned in order to safeguard both himself and the scroll's recipient from possible political reprisal for either creating or possessing such an inflammatory text brushed by a prominent banished official. A generation later, however, the scroll became a treasured work in the Song imperial collection, as confirmed by the seals of Emperor Gaozong (r. 1127–62) placed over the paper joins as a kind of inventory mark to prevent the removal of a portion of the scroll.

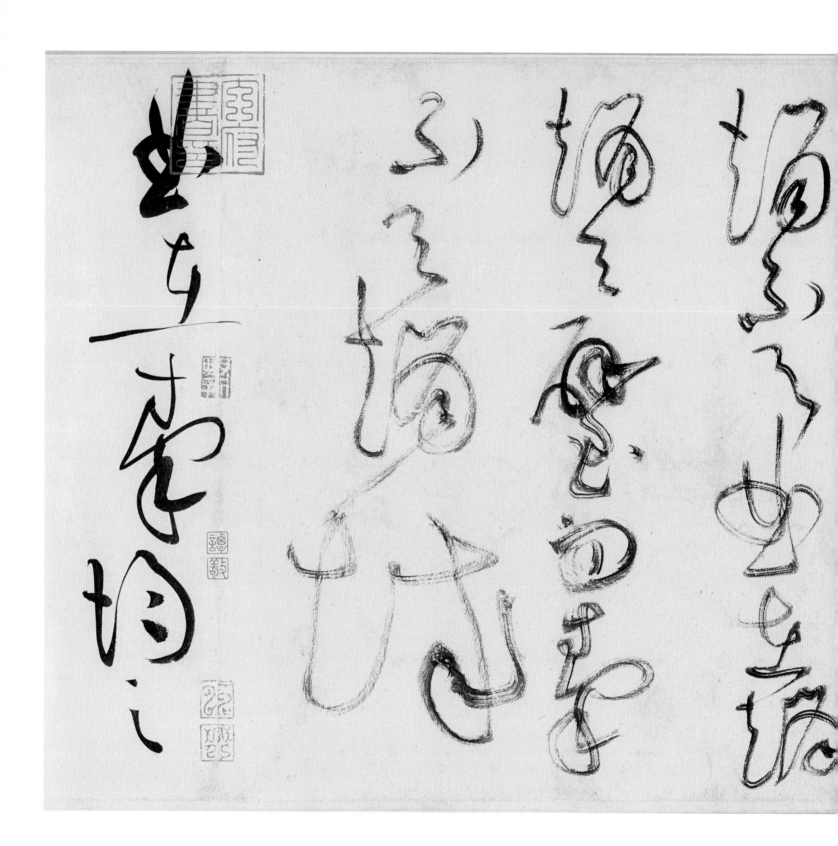

For the first eighteen feet of the scroll, the ink tone of Huang's writing is uniformly dark. In this dramatic passage, Huang's excitement propels him forward, and he continues without pausing to regularly reink his brush. The text recounts the king of Zhao's interview with Lin Xiangru concerning the state of Qin's demand to exchange cities for a precious jade disk (*bi*): "The king said, 'If Qin takes my jade but does not give me cities, then what?' Xiangru replied: 'If we refuse Qin's offer of cities in exchange for the jade, that puts us in the wrong; but if we give up the jade and no cities are given, that puts Qin in the wrong.'" The enlarged character 何 (*he*, "what?") at the top of the third column from the right acts as an exclamation point. Huang wrote the last three characters in the seventh line, 予趙城 (*yu Zhao cheng*, "give Zhao cities"), without once lifting his brush from the paper.

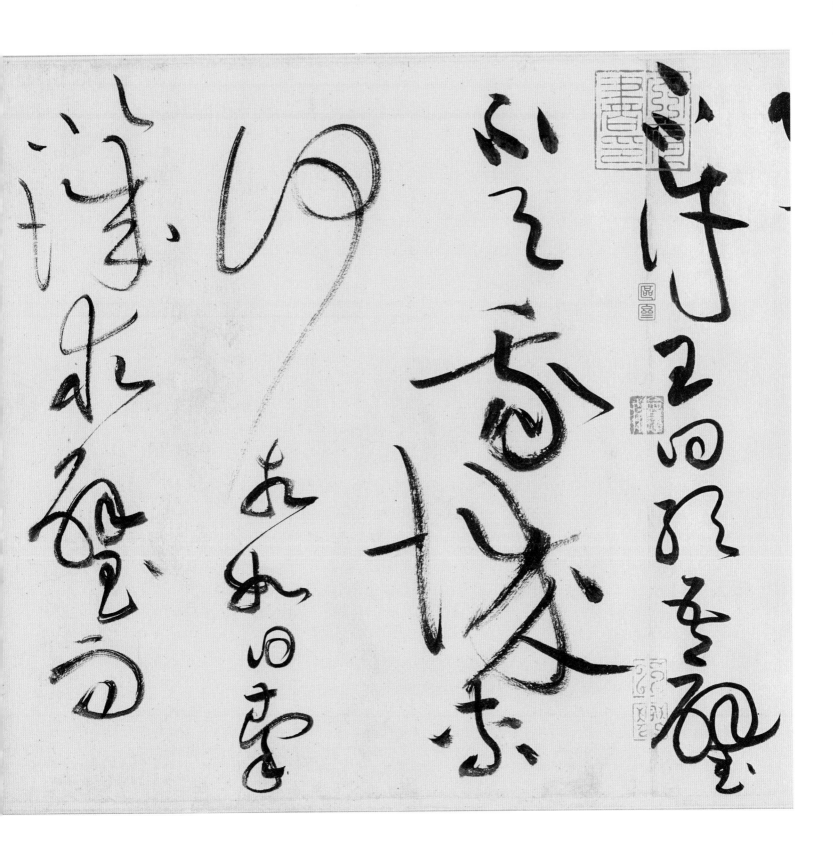

The character for "jade disk," 璧 (*bi*), appears frequently in the text (three times in the detail above), but Huang avoids monotonous repetition by changing the pattern of strokes or by varying the form from squat to elongated, stable to imbalanced.

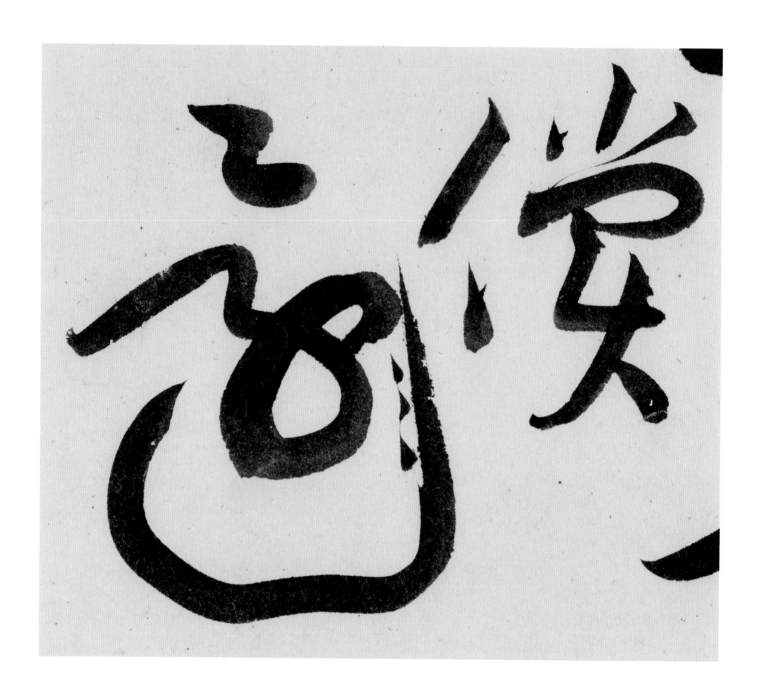

Three dots indicate a mistranscribed character. Its replacement is sometimes written, as here, at a smaller scale to its right. Huang first wrote 還 (*huan*), "to give back," then realized the text used 償 (*chang*), which has the same meaning.

Calligraphy can have a three-dimensional appearance. In the two characters 怒髮 (*nu fa*, "[so] angry his hair [bristled]") the last stroke of the top character appears to wrap around the first stroke of the next.

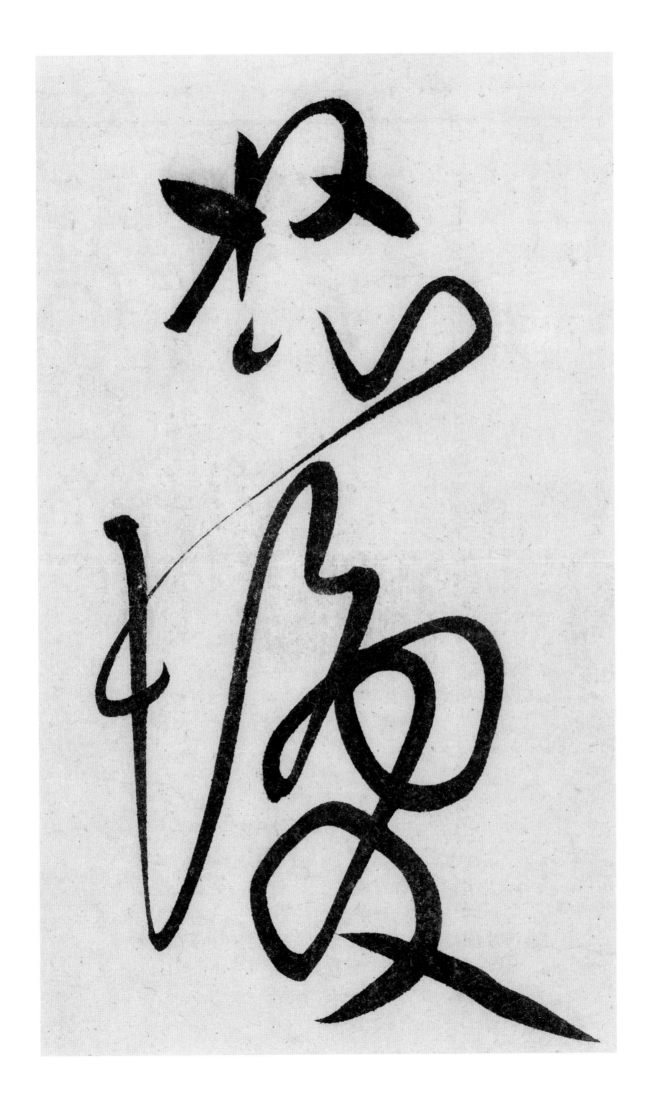

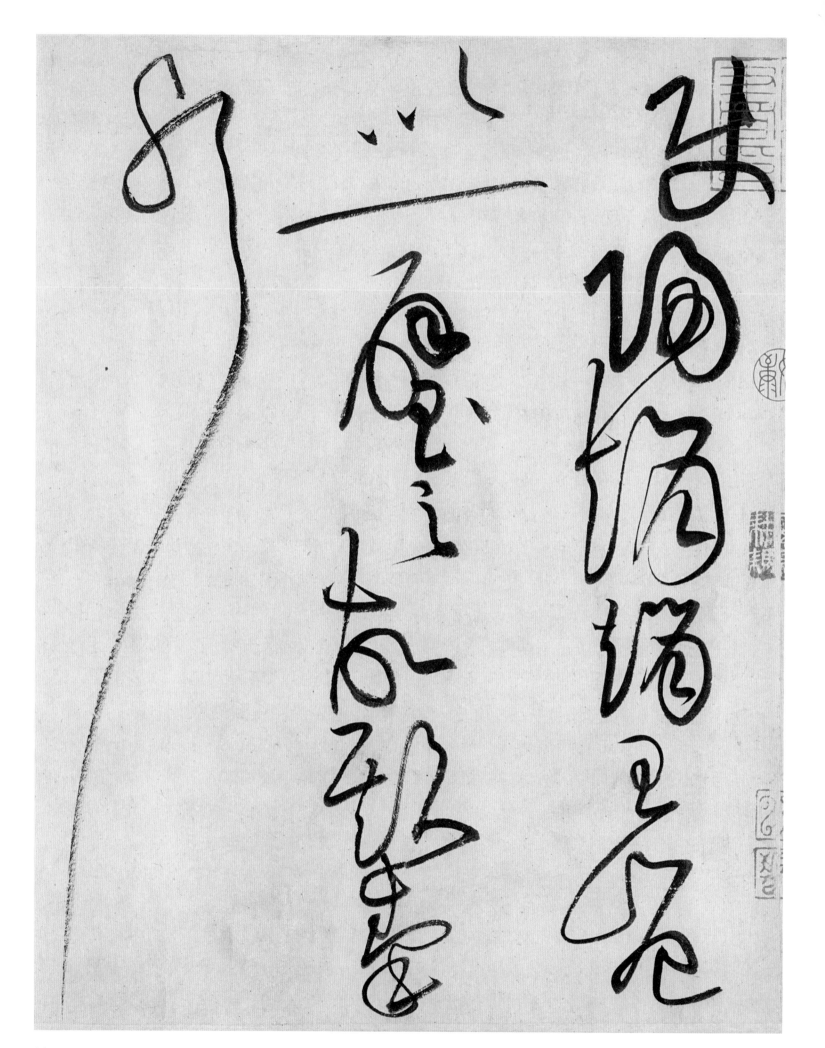

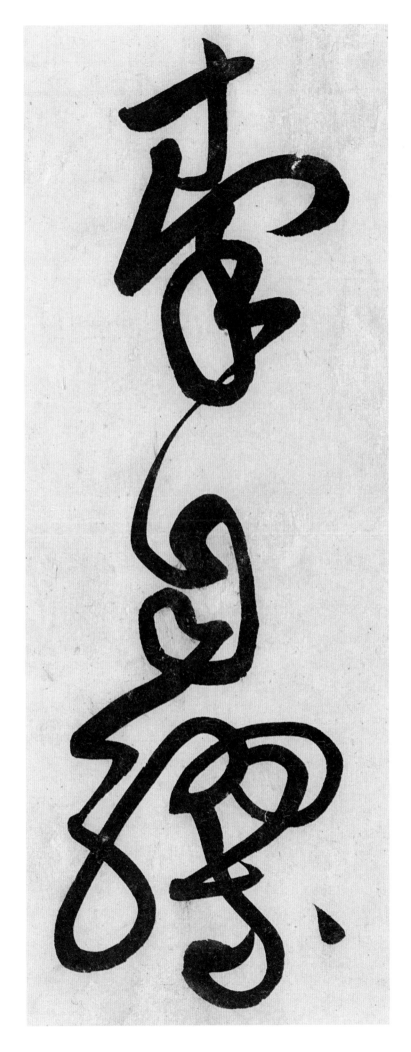

<

The section of the text illustrated here (italicized in the translation below) is from a passage quoting the king of Qin's words upon discovering that Lin Xiangru has outwitted him by sending the jade disk that he coveted back to Zhao: "Killing Xiangru now will not get us the jade but would spoil our relations with Zhao. Better treat him handsomely and *send him back. How could the king of Zhao, for the sake of a piece of jade, risk offending Qin so!*"

 The extreme elongation of the character 邪 (*ya*, "so"), serves as an exclamation point and indicates Huang's intense engagement with the narrative. Of the nearly twelve hundred characters in the text, this is the only one that stretches the entire height of a column.

Cursive script appears to be written swiftly, but the brush actually moves with great deliberation, even when several characters are linked together in an unbroken sequence of movements.

9 | Envisioning Introspection

南宋　馬遠　高士觀瀑圖　冊頁

Ma Yuan (active ca. 1190–1225)
Scholar by a Waterfall

Album leaf, ink and color on silk, 9¾ × 10¼ in. (24.9 × 26 cm)
Ex coll.: C. C. Wang Family
Gift of The Dillon Fund, 1973 (1973.120.9)

The monumental northern landscape style was largely abandoned in 1127, when the Song court was forced by invading Jurchen tribesmen to relocate to the south. After the establishment of the capital in Hangzhou in 1138, artists began to work in smaller formats, such as this one, and to focus intensively on intimate corners of nature. Ma Yuan, a fourth-generation member of a family of painters, was a leading artist at the Southern Song Painting Academy in the new capital. A city of unsurpassed beauty, Hangzhou was graced with pavilions, gardens, and scenic vistas.

In this album leaf, which shows a gentleman in a gardenlike setting, the jagged rhythms of the pine tree and rock contrast with the quiet mood of the scholar, who gazes pensively into the bubbling rapids of a cascade. Ma Yuan reduces nature to a poetic geometry of angular forms and emptiness. The diagonally divided "one-corner" composition leads from chiseled foreground forms to a mist-filled distance, from tactile rocks and trees to the sound of rushing water, from the sensory world to an awareness of the infinite.

The dark silhouette of a boulder presents a striking foil to the white-robed man, yet both share angular profiles and sharp contour strokes that suggest, rather than describe, mass and volume.

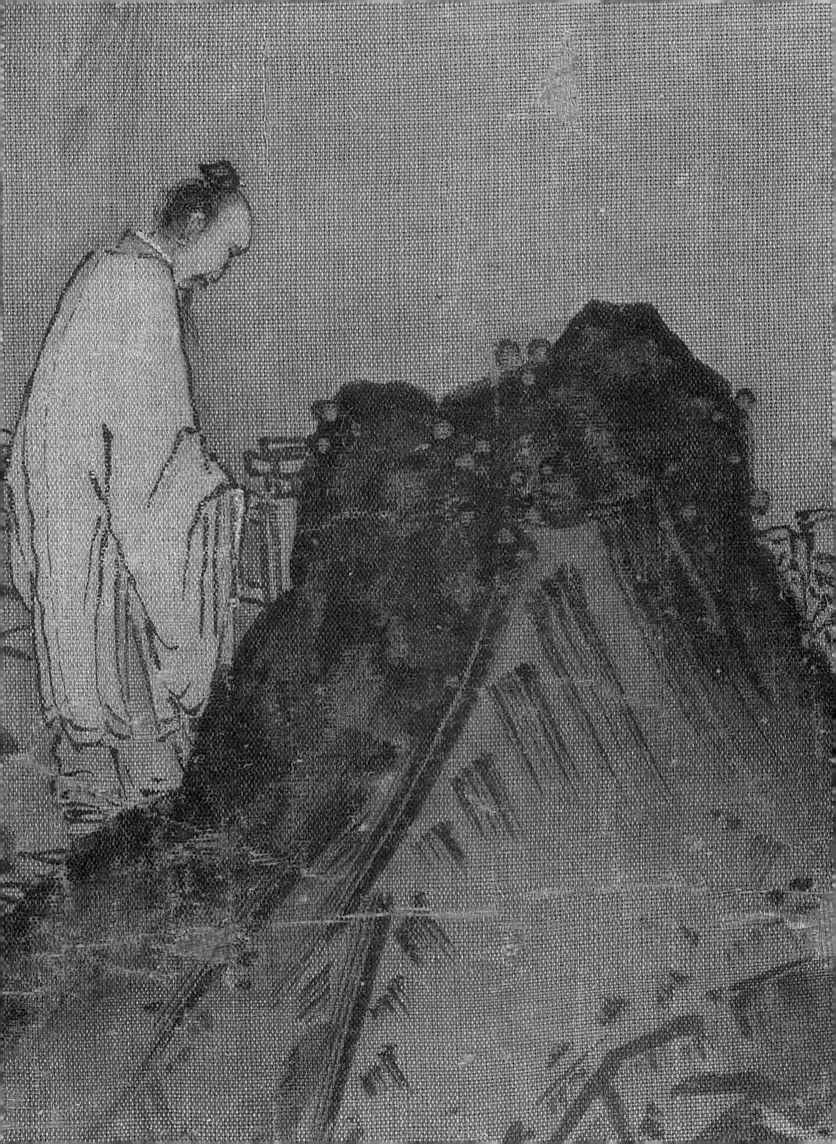

10 | Evocative Abbreviation

南宋　夏珪　山市晴嵐圖　冊頁

Xia Gui (active ca. 1195–1230)
Mountain Market, Clear with Rising Mist

Album leaf, ink on silk, 9¾ × 8⅜ in. (24.8 × 21.3 cm)
John Stewart Kennedy Fund, 1913 (13.100.102)

This album leaf presents a poetic evocation of one of the *Eight Views of the Xiao and Xiang Rivers*. The *Eight Views* became a popular subject for painters beginning in the late eleventh century after the Chan Buddhist monk Huihong (1071–1128) composed eight poems on these themes. His poem on *Mountain Market, Clear with Rising Mist* offers vividly specific images for painters to interpret:

> *Last night's rain is letting up, mountain air is heavy,*
> *Steam rising, sun and shadow, shifting light amid trees;*
> *The silkworm market comes to a close, the crowd thins out,*
> *Roadside willows by the market bridge: golden threads play;*
> *Whose house with flower-filled plot is across the valley?*
> *A smooth-tongued yellow bird calls in spring breeze;*
> *Wine flag in hazy distance—look and you can see:*
> *It's the one west of the road to Zhe Tree Ridge Valley.*

In this interpretation by Xia Gui, a master in the Southern Song Painting Academy, boldly executed brushstrokes and ink dots create an abstract language of visual signs rather than merely descriptive forms. The kinesthetic brushstrokes, which change effortlessly from outlines and foliage dots to wedge-shaped modeling strokes and ink wash, at once simplify and unify the landscape and human forms, breathing life into the moisture-drenched landscape. It was this brilliantly simplified ink wash and "ax-cut" brush idiom, which infused gesture with meaning, that prepared the way for the calligraphic revolution of expressive brushwork in the ensuing Yuan dynasty (1271–1368).

During the Song dynasty (960–1279), it became common for court artists to sign their works, but usually in an inconspicuous manner. Here, Xia Gui has embedded his signature in the landscape along the right edge of the composition.

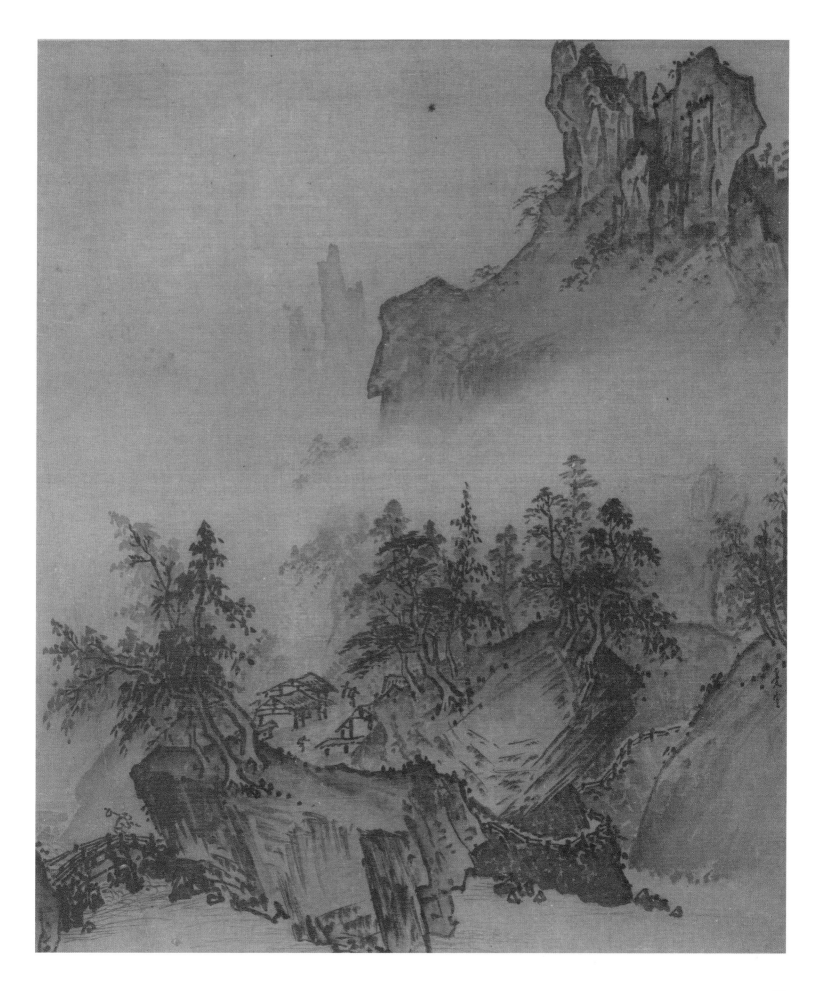

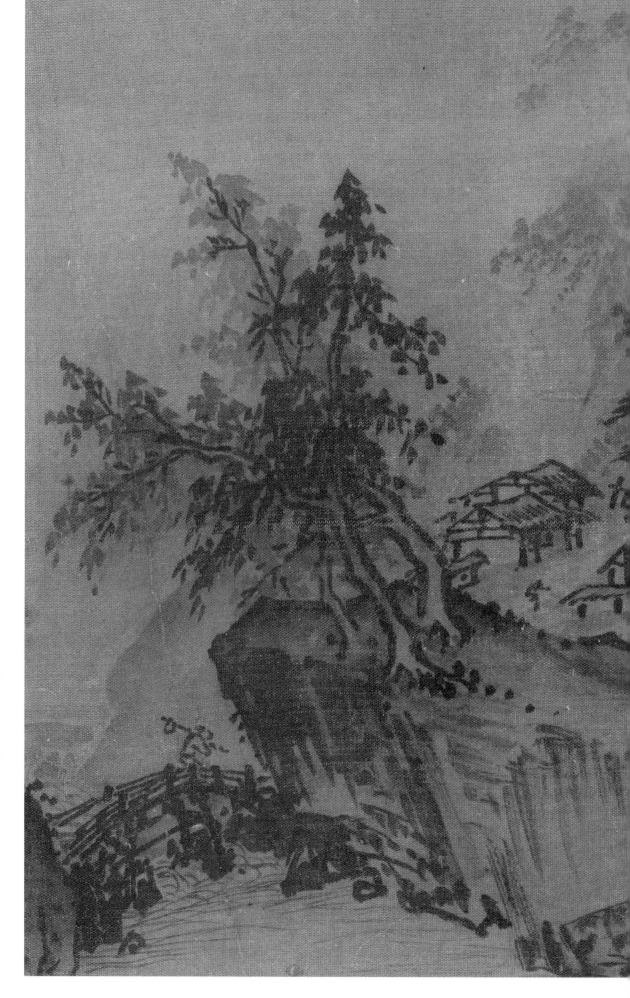

Xia Gui simplifies his rocks to a few angular outlines and "ax-cut" hatch-marks along the face of the boulder, yet the layering of contour lines and uninked passages creates a convincing evocation of depth and cubic mass. Suggesting recession through shifts in scale and increasingly paler ink, the artist leads the viewer's eye incrementally from a foreground bridge and boldly delineated rocks and trees, to a village with its receding road, to the misty wooded slopes beyond. Sketchily rendered figures enhance both the illusion of movement and the blurring effects of a moisture-laden atmosphere.

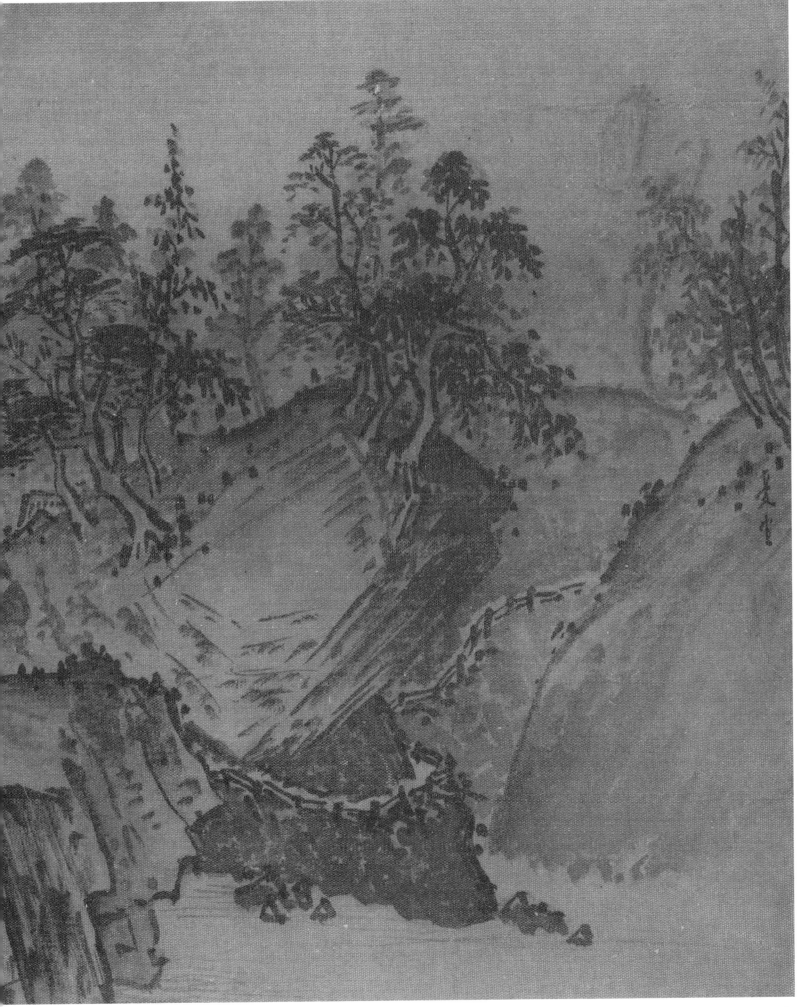

| A Private World

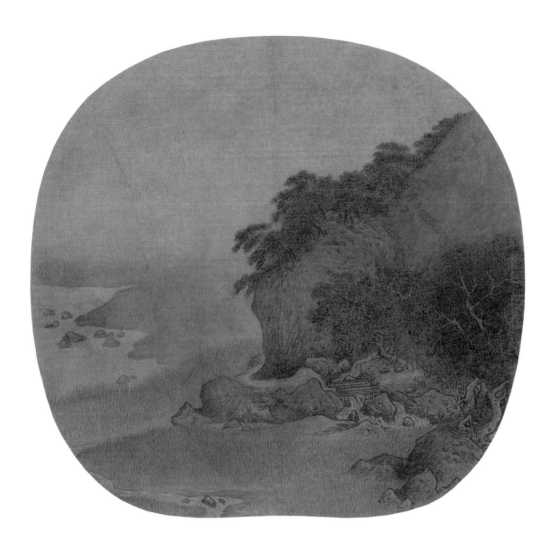

南宋 傳閻次于 松壑隱棲圖 團扇

Attributed to Yan Ciyu (active ca. 1164–81)
Hermitage by a Pine-Covered Bluff

Fan mounted as an album leaf, ink and color on silk, 8⅜ × 9 in. (21.3 × 22.8 cm)
Ex coll.: C. C. Wang Family
Purchase, Gift of Mr. and Mrs. Jeremiah Milbank and Gift of Mary Phelps Smith, in memory of Howard
Caswell Smith, by exchange, 1973 (1973.121.12)

This choice corner of nature, intimate and secluded in feeling, epitomizes the landscape painting
of the early Southern Song Painting Academy. The exacting delineation of rocks, foliage, and
gnarled tree trunks recalls Northern Song techniques, while the soft reeds of the marsh and the
misty distance display the simpler, more suggestive style of the Southern Song. Considerably
smaller than the tall hanging scrolls and large handscrolls favored by Northern Song artists, fan
paintings were ideally suited to the highly focused visions of the Southern Song period.

The painting was originally mounted as one face of a fan with a rigid frame (see p. 155) that
has left wear marks along the painting's vertical axis. The landscape was probably inspired by a
poem, now lost, which would have been mounted on the other side of the fan. Such precious
articles were often used as presentation pieces from the emperor to members of his court.

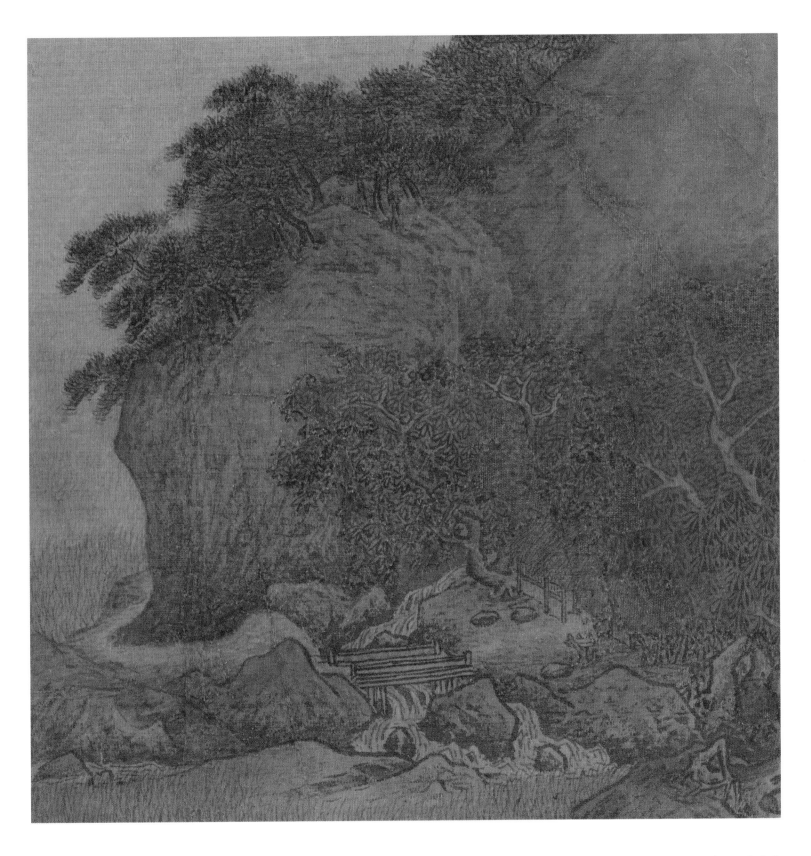

According to the geomantic principles of *fengshui,* this secluded retreat—sheltered by a cliff, shaded by tall trees, and enlivened by a mountain stream—is ideally situated. The substantial wooden bridge, large stone seats, and a water basin propped in the fork of a tree stump beside the front door all suggest that the resident "recluse" welcomes guests.

12 | Dream Vision

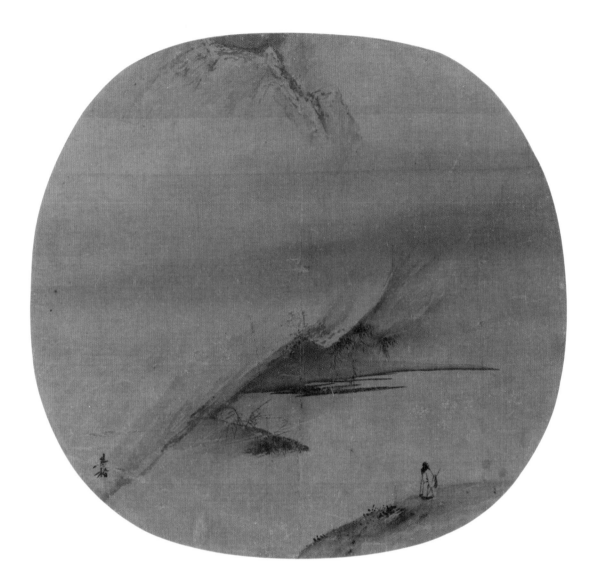

南宋　梁楷　澤畔行吟圖　團扇

Liang Kai (active first half of 13th century)
Poet Strolling by a Marshy Bank

Fan mounted as an album leaf, ink on silk, 9 × 9⅝ in. (22.9 × 24.3 cm)
Bequest of John M. Crawford Jr., 1988 (1989.363.14)

Liang Kai served as a painter-in-attendance at the Southern Song Painting Academy in
Hangzhou from about 1201 to 1204. He later relinquished that prestigious position to live
and paint at a Chan Buddhist temple.

　　This small landscape, one of the most disorienting compositions in Chinese art, challenges
our perception of reality and may reflect Chan notions of the illusory nature of existence. The
painting depicts a gentleman strolling along the bank of a stream. The far shore recedes dra-
matically, moving from a near-ground embankment dotted with reeds to marshy lowlands and
mist-enshrouded hills. But both this vista and our own vantage point are challenged by the
discordant foliage-draped underside of a rocky overhang. The looming cliff itself dissolves in a
bank of mist out of which distant peaks emerge, leaving us to wonder at what lies between.

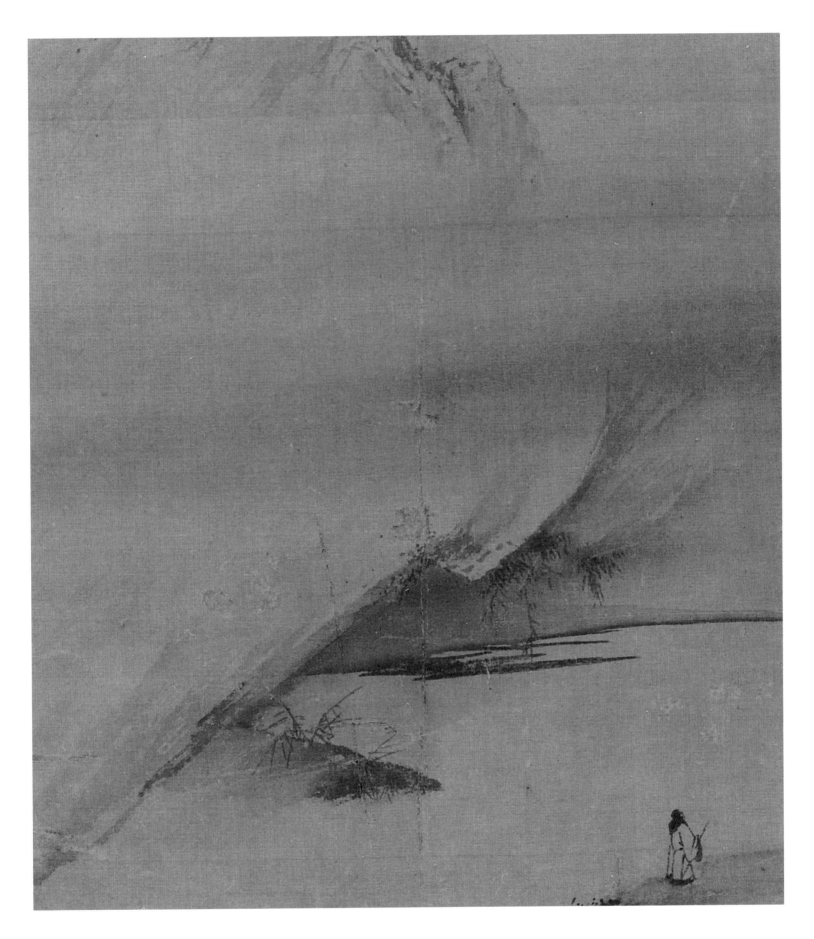

Reversing the usual "one-corner" compositional formula of the Southern Song Painting Academy, which leaves half the picture space unpainted (see no. 9), Liang Kai introduces an unsettling diagonal overhang that restricts the view and makes the landscape beyond appear even more inaccessible and illusory.

13 | The Zen of Painting

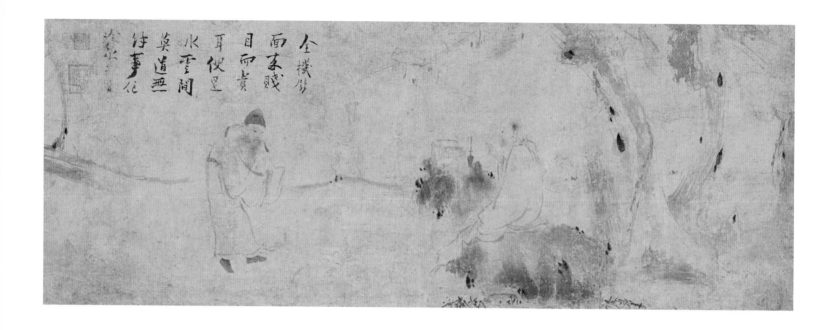

南宋　傳直翁　藥山李翱問道圖　軸

Attributed to Zhiweng (active early 13th century)
Meeting between Yaoshan and Li Ao, before 1256

Horizontal leaf mounted as a hanging scroll, ink on paper, 12 ¼ × 33 ⅛ in. (31.1 × 84.1 cm)
Edward Elliott Family Collection, Purchase, The Dillon Fund Gift, 1982 (1982.2.1)

This painting was inscribed by the well-known Chan Buddhist priest Yanxi Guangwen (1189–1263) between 1254 and 1256, while he was serving as abbot of Lingyin Temple in Hangzhou. It is an important example of early Chan Buddhist "apparition-painting," so named because of its pale, sensitive brushwork.

Depicted here is a famous encounter between the Confucian scholar Li Ao and the Chan master Yaoshan (both active ca. 840). Hearing of the master's reputation, the scholar went to see him and, disappointed at Yaoshan's appearance, remarked, "Seeing your face is not as good as hearing your name." The master replied, "Would you distrust your eye and value your ear?" Then, pointing up and down, the master indicated that the ultimate reality is in what can be seen, such as "clouds in the sky and water in a vase."

Yanxi Guangwen's inscription may be translated as follows: "All moments of enlightenment come in a flash, / Why distrust your eye and value your ear? / Just as between the water and the clouds, / Don't say there is nothing there."

The Chan master used riddles to sharpen a student's direct perception in the face of distracting hearsay; the Chan painter, a simple and spontaneous, albeit elusive, brush style to capture his fleeting vision of truth.

Like contemporary Song Academy painters, this artist focuses on a few picture elements set in a shallow foreground space, but he renders them with diffuse washes and pale brush lines that emphasize the illusory nature of human perception.

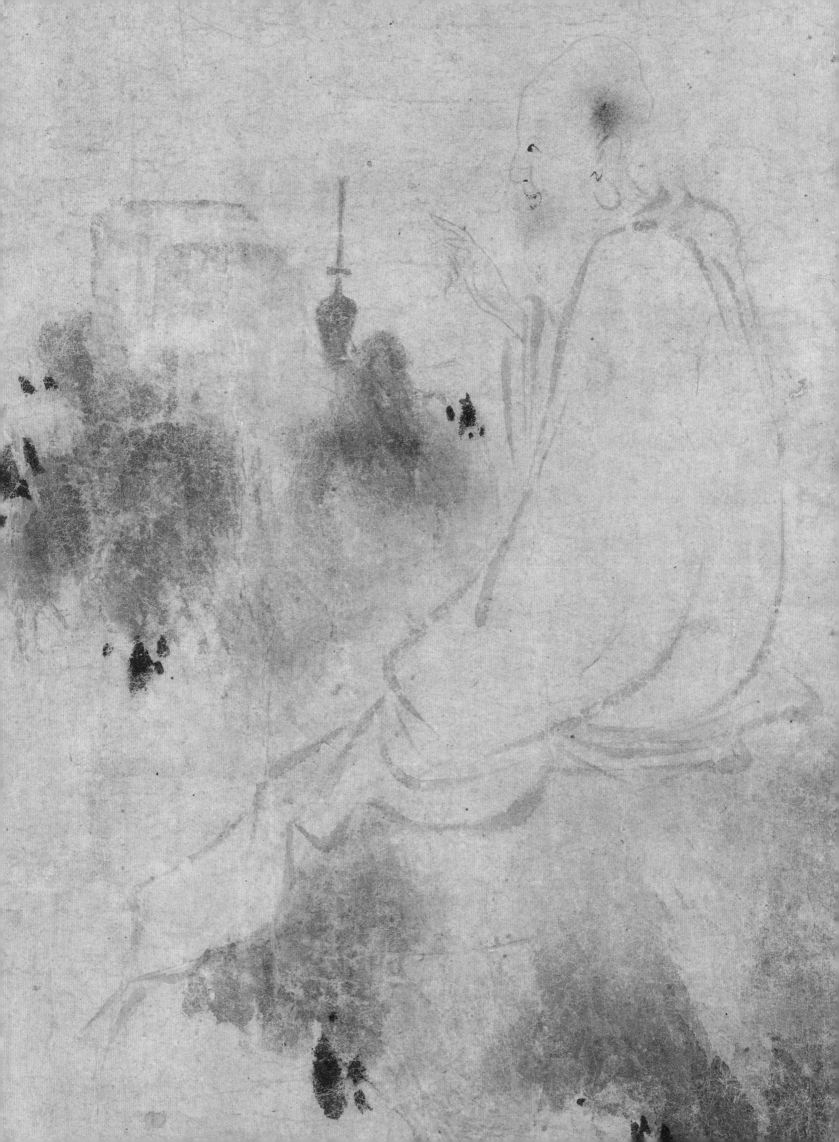

14 | The Perfection of Nature

南宋 馬麟 蘭圖 冊頁

Ma Lin (ca. 1180–after 1256)
Orchids

Album leaf, ink and color on silk, 10⅜ × 8⅞ in. (26.2 × 22.4 cm)
Ex coll.: C. C. Wang Family
Gift of the Dillon Fund, 1973 (1973.120.10)

This exquisite representation of orchids, signed by Ma Lin, son of Ma Yuan (no. 9), exemplifies the style of formal realism favored by the aristocratic Southern Song court. The simple, asymmetrical balance of the flowers and leaves, meticulously rendered in subtle shades of lavender, white, and malachite green, bespeaks a consciously aestheticizing sensibility. Such flower paintings recall the late Southern Song lyric poems about flowers: "Meeting the wind, they offer their artful charm; / Wet by the dew, they boast their pink beauty."

Ma Lin was the fifth-generation descendant of the most famous family of artists to serve at the Song court, beginning in the time of Emperor Huizong (no. 6). Like his father, Ma Lin was tremendously versatile. In addition to intimate depictions of flowers, his extant works include landscapes, large-scale imaginary portraits of Confucian sages, and depictions of figures in landscape or architectural settings. In each, Ma was able to distill his imagery to achieve the same lyrical qualities as poetry. His paintings exquisitely convey the highly aestheticized lifestyle indulged in by members of the Song court.

Focusing on a single specimen plant, Ma Lin emphasizes the sensuality of the orchid with its tender stalk, pliant blossoms, and pastel shades of lavender and chartreuse offset by the brittle sharpness of its dark green leaves.

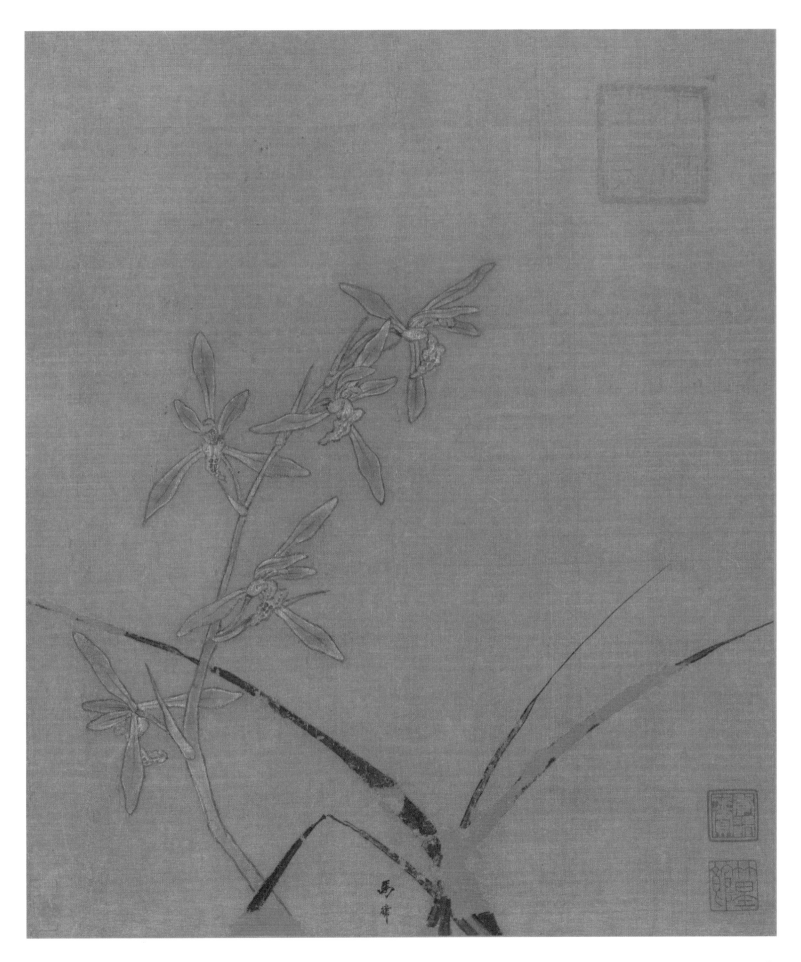

69

15 | Identification with Nature

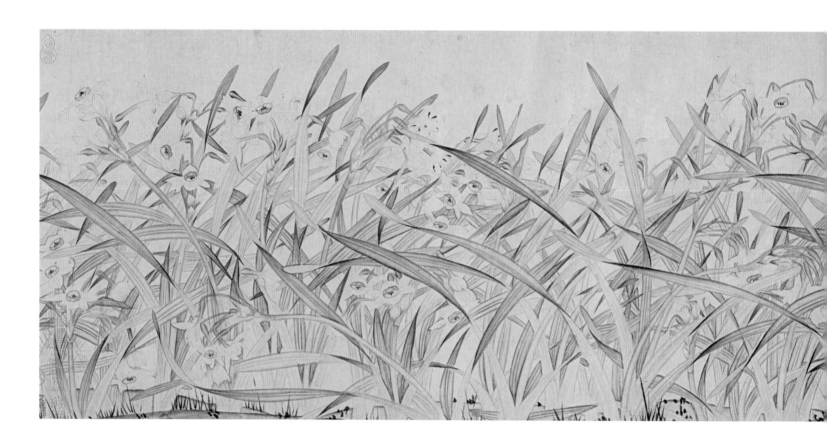

南宋　趙孟堅　水仙圖　卷

Zhao Mengjian (1199–before 1267)
Narcissus

Handscroll (detail above), ink on paper, 13 ⅛ in. × 12 ft. 2 ½ in. (33.2 × 372.2 cm)
Ex coll.: C. C. Wang Family
Gift of The Dillon Fund, 1973 (1973.120.4)

Zhao Mengjian, a member of the Song imperial family and an accomplished scholar and calligrapher, specialized in painting the narcissus and raised the flower in the esteem of scholars to the level of the orchid.

Offering the promise of spring, the narcissus is known in Chinese as "the water goddess" (*shuixian*) or "the goddess who stands above the waves" (*lingbo xianzi*). Its fragrant blossoms are associated with the two goddesses of the Xiang River and, by extension, with Qu Yuan (343–277 B.C.), author of *On Encountering Sorrow (Li sao)*. Qu Yuan, a loyal minister of the state of Chu, tied orchids around his waist and then drowned himself in a tributary of the Xiang River after failing to alert his prince to the imminent danger threatening the state.

In a poem appended to the scroll after the Mongol conquest, the Song loyalist Qiu Yuan (1247–after 1327) describes Zhao's narcissus as the only vision of life in an otherwise devastated land:

The shiny bronze vessel is overturned, and the immortal's dew spilled;
The bright jade ring is smashed, like broken corals.
How I pity the narcissus for not being the orchid,
Which at least knew the sober minister from Chu [Qu Yuan].

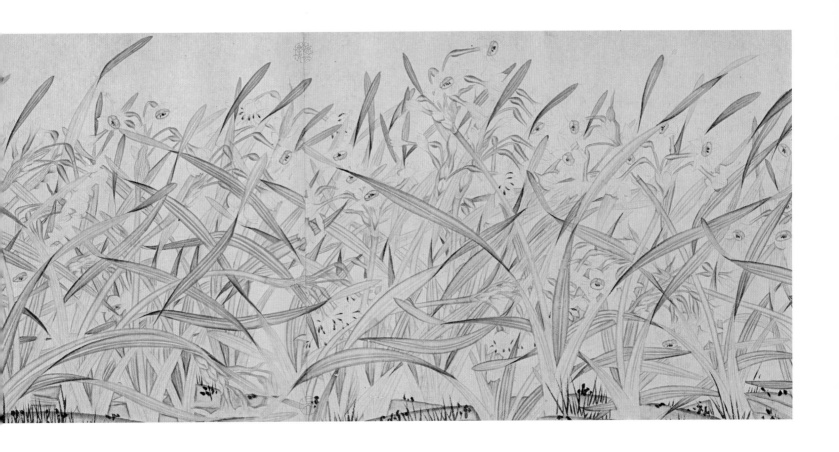

The graceful curves of the narcissus leaves contrast with the sharp thrusts of the blades of grass. That the clustered moss dots resemble the cursive form of the character 不 (*bu*, "no") emphasizes their frankly calligraphic nature.

Detail, the character 不 (*bu*, "no"), from Huang Tingjian, *Biographies of Lian Po and Lin Xiangru* (no. 8)

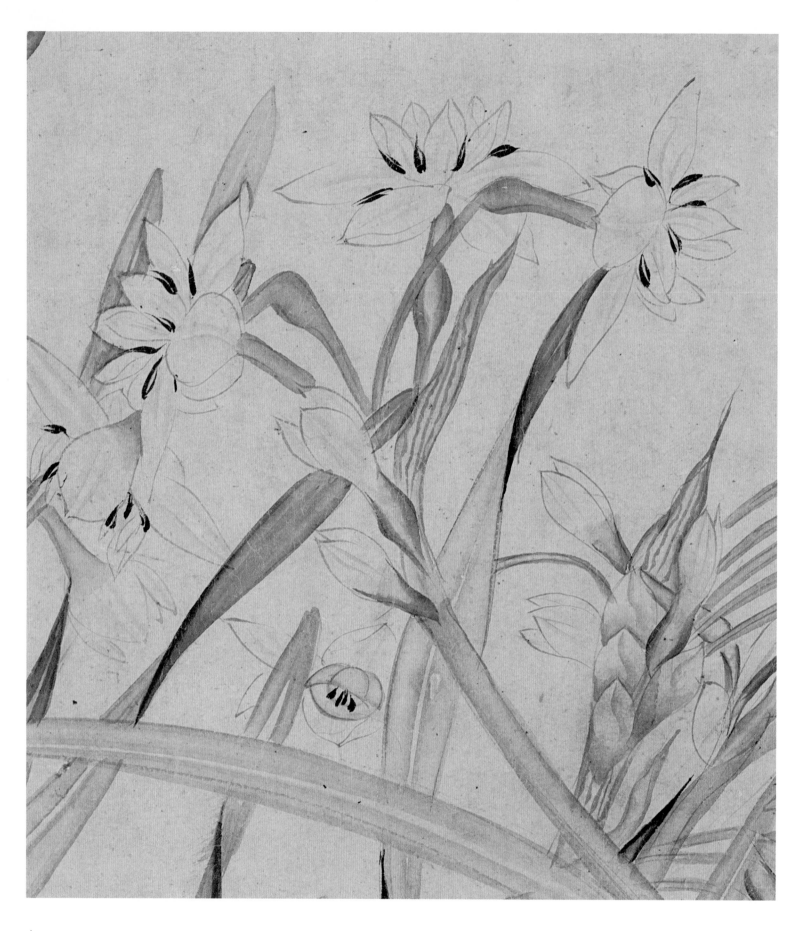

∧

Finely outlined petals are comple-
mented by dabs of pale wash to
model the belly of each petal, while
jet-black dots highlight the stamens.

>

Depicting the enormously complex interweaving
leaves required careful planning. The artist began
by drawing the leaves in pale outlines, then
reinforced these outlines with darker ink and
graded washes. The twisting and turning leaves
are especially effective in evoking movement.

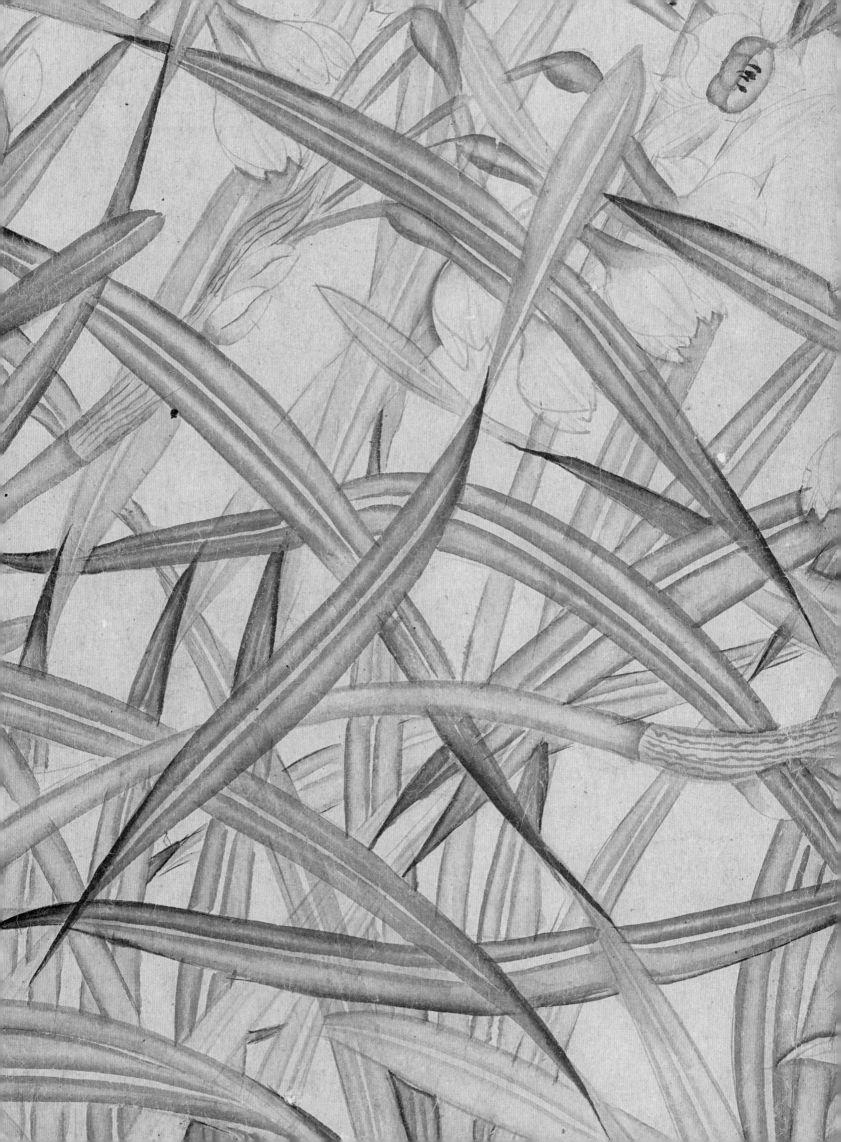

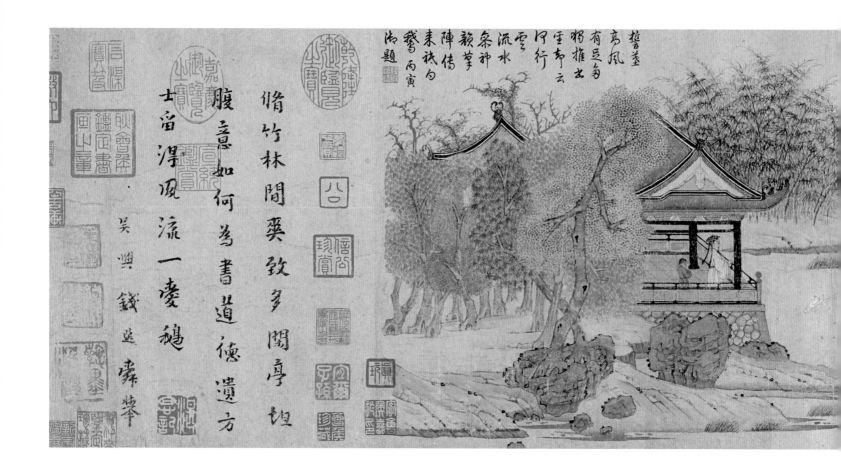

元 錢選 王羲之觀鵝圖 卷

Qian Xuan (ca. 1235–before 1307)
Wang Xizhi Watching Geese, ca. 1295

Handscroll, ink, color, and gold on paper, 9 ⅛ × 36 ½ in. (23.2 × 92.7 cm)
Ex coll.: C. C. Wang Family
Gift of The Dillon Fund, 1973 (1973.120.6)

After Hangzhou, the Southern Song capital, fell to the Mongols in 1276, Qian Xuan chose to live as an *yimin,* a "leftover subject" of the Song dynasty. In his richly archaistic "blue and green" painting style, which recalls the colored landscape manner especially popular during the Tang dynasty (618–907), the artist has deliberately employed a primitive style to allude to an idyllic time in high antiquity that could be regained only through a regimen of "internal alchemy."

Watching Geese illustrates the story of Wang Xizhi (303–361), the calligraphy master of legendary fame and a practitioner of Daoist alchemy, who was said to derive inspiration from natural forms such as the graceful necks of geese. The artist's poem reads:

> *How pleasant are the elegant bamboo and trees!*
> *In a peaceful pavilion, relaxing with bare stomach, how wonderful it must feel!*
> *Writing the* Daodejing [The Way and Its Power] *for a Daoist friend,*
> *He leaves behind a romantic image—a man who loves geese.*

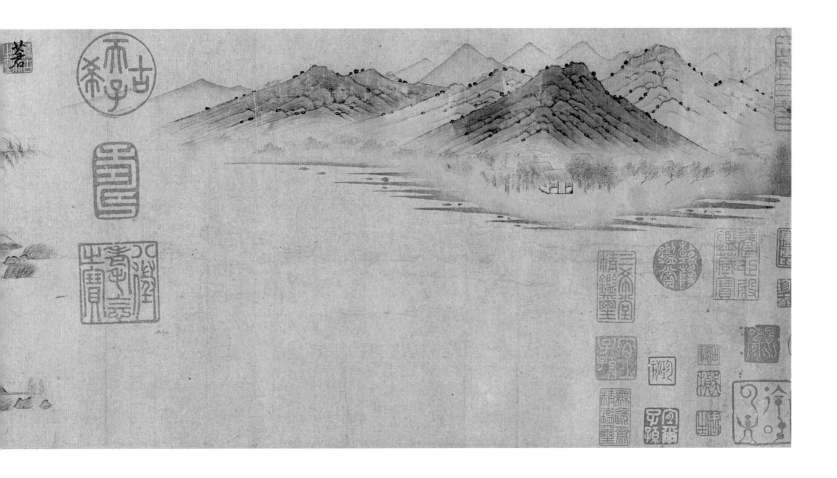

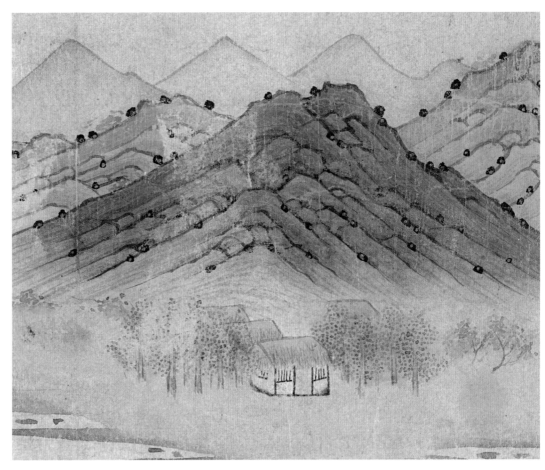

Rejecting the sumptuous realism of the Southern Song Painting Academy (a style discredited by the dynasty's fall), the artist has adopted a primitive manner—frontal, triangular mountains, cartoonlike trees and houses, and an archaic blue-and-green color scheme—to evoke a now lost golden age.

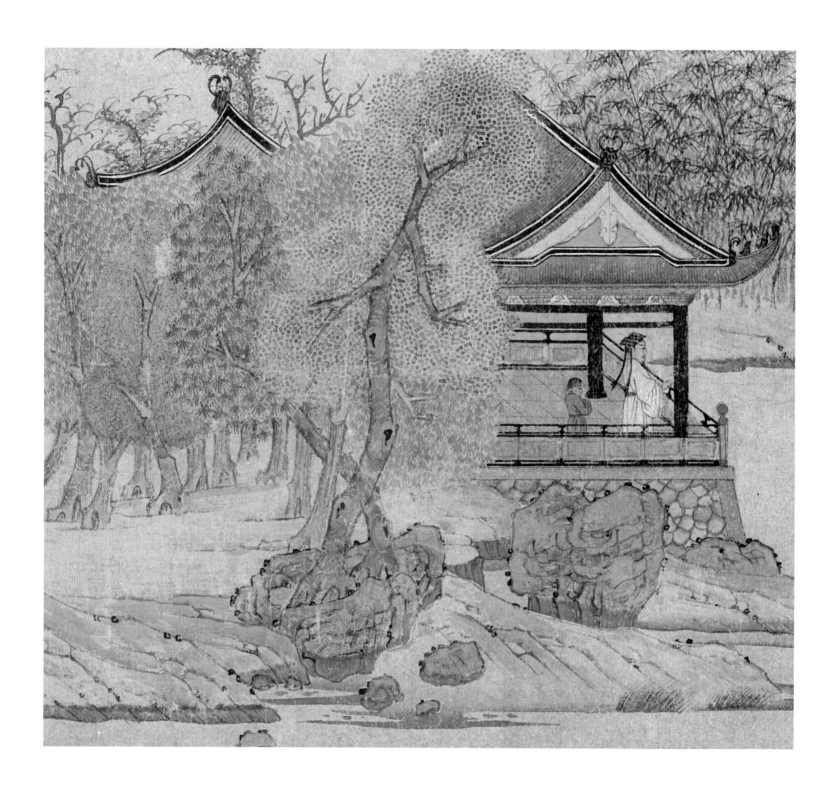

In creating a dreamlike evocation of antiquity, Qian
Xuan repeatedly confounds a realistic reading of his
picture space as a way of asserting that the times are
out of joint. His distant mountains are schematic,
his poem is inscribed on the same piece of paper as
his painting, the foliage of his trees is patternized,
and the two halves of his pavilion's roof are pulled
apart and recede at different angles—a fitting image
of the disjuncture the artist felt after the fall of the
Song royal house.

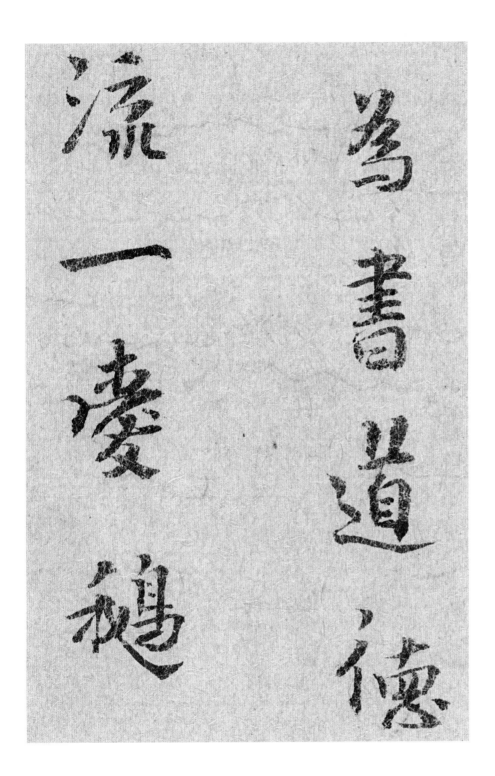

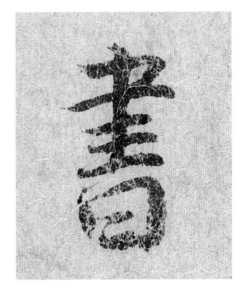

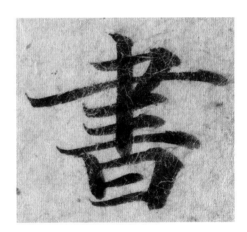

Qian Xuan's studiously unadorned writing, which exhibits neither beautifully modulated lines nor intricate brush movements, conveys an archaic simplicity that matches the pointedly antique style of his painting.

Qian's rejection of technical virtuosity is clear when his character for "writing," 書 (*shu; top*) is compared with the same character from the *Spiritual Flight Sutra* (no. 3; *bottom*).

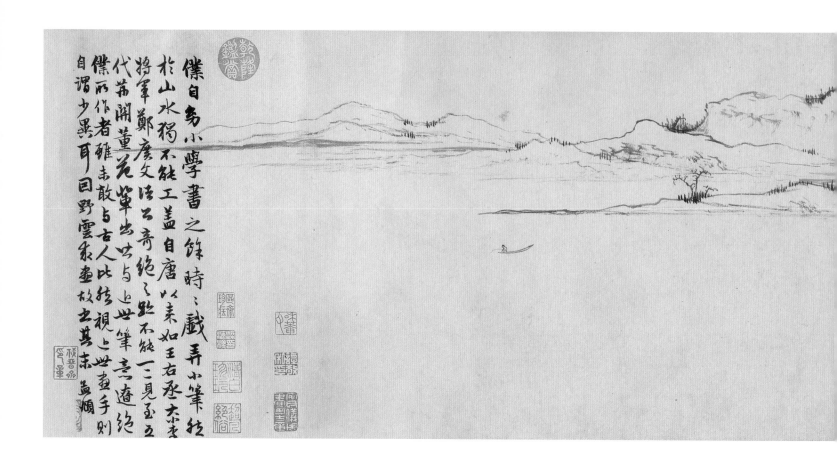

元　趙孟頫　雙松平遠圖　卷

Zhao Mengfu (1254–1322)
Twin Pines, Level Distance, ca. 1300

Handscroll, ink on paper, 10⅝ × 42¼ in. (26.9 × 107.4 cm)
Ex coll.: C. C. Wang Family
Gift of The Dillon Fund, 1973 (1973.120.5)

Zhao Mengfu, a leading calligrapher of his time, set the future course of scholar-painting by reaffirming two of its basic tenets: renewal through the study of ancient models and the application of calligraphic principles to painting. In *Twin Pines, Level Distance*, Zhao revives the classical imagery of tall trees set against an expansive level distance developed by the Northern Song masters Li Cheng (919–967) and Guo Xi (ca. 1000–ca. 1090). Indeed, Zhao's short handscroll relates directly to Guo Xi's *Old Trees, Level Distance* (no. 5), which bears his colophon: "Tall mountains and flowing rivers fill the world, / Aspiring to draw them with water and ink is difficult. / My whole life I have followed [Guo Xi's] lofty message of forests and streams; / Constrained by petty official duties, I have been unable to achieve it."

It is not clear that Zhao knew Guo Xi's *Old Trees, Level Distance* at the time he painted *Twin Pines,* but a comparison of the two works demonstrates how Zhao reinvented the Li-Guo style. Zhao makes use of a similar diagonal recession, layered distant mountains, and a fisherman, but he completely reverses the compositional flow of Guo Xi's work, placing his foreground trees at the beginning of the composition. More significantly, Zhao has eliminated the emotion-laden atmospheric and narrative details of the earlier work. Ink wash has been

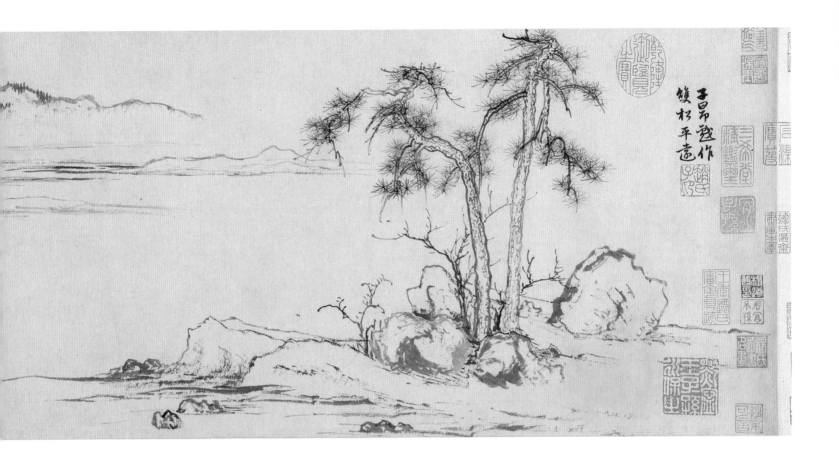

purged, content has been pared to a minimum, and the only human presence is the small figure of a fisherman in the distance. Zhao has distilled Guo's imagery; his spare, emphatically linear rocks and trees deemphasize the painting's representational function and highlight the artist's hand. Guo's landscape idiom has, in effect, become a calligraphic style. Rather than simply describing nature as it appears to be, Zhao has sought to capture its quintessential rhythms. The characteristics of rocks and trees, felt by the artist and acted out through his calligraphic brushwork, are imbued with a heightened sense of life-energy that goes beyond mere representation.

In a long inscription on the far left of the scroll, the artist expresses his views on painting: "Besides studying calligraphy, I have since my youth dabbled in painting. Landscape I have always found difficult. This is because ancient [landscape] masterpieces of the Tang, such as the works of Wang Wei, the great and the small Li [Sixun and Zhaodao], and Zheng Qian, no longer survive. As for the Five Dynasties masters, Jing Hao, Guan Tong, Dong Yuan, and Fan Kuan, all of whom succeeded one another, their brushwork is totally different from that of the more recent painters. What I paint may not rank with the work of ancient masters, but compared with recent paintings, I daresay mine are quite different."

A colophon appended to the painting by Zhao's close friend Yang Zai (1271–1323) offers a surprising commentary on Zhao's image: "As the tiny boat tries to advance upriver, / Mighty mountain trees are suddenly swept into tumult. / Swiftly heavy wind and rain pour through the night, / Clapping waves against the sky—making the oars hard to control!" Because there is little in Zhao's painting to justify Yang Zai's vivid description of a storm-wracked landscape, we must conclude that Yang was not describing the actual painting but was alluding to Zhao's tumultuous political career, in which he had to face both the dangerous intrigues of the Mongol court and the censure of Chinese who felt that his service under two dynasties was immoral.

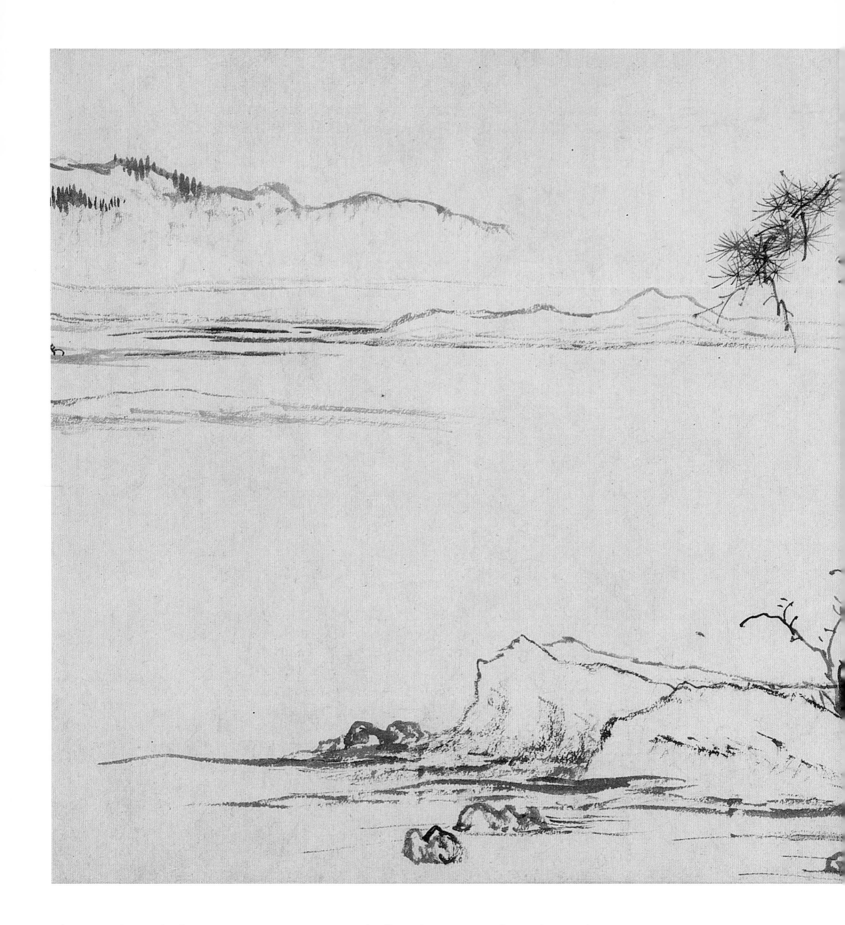

Zhao Mengfu was the first painter to equate painting and calligraphy. He wrote that to draw rocks one must use the "flying white" method of cursive script, in which the bristles of the brush separate so that lines include streaks of uninked white paper. In outlining trees, Zhao stated that one should use the unmodulated lines of seal script. To emphasize that his paintings had the same self-expressive intent as handwriting, he described his creative process not as "painting" but as "writing"; here he placed his signature in a prominent position to reinforce his point.

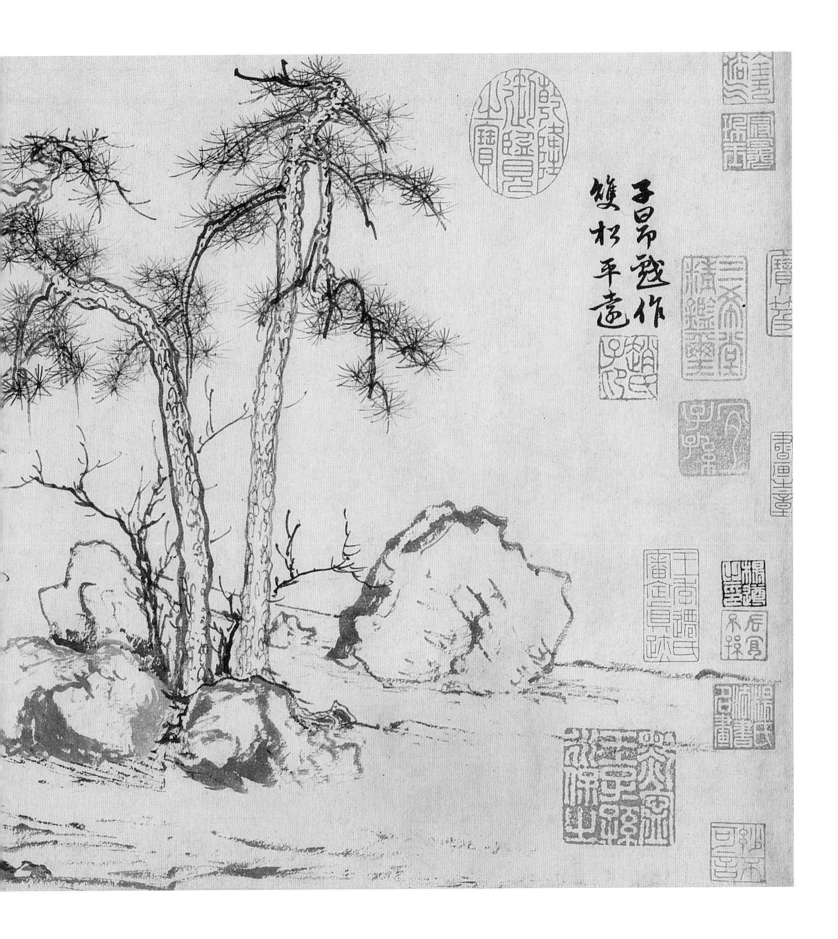

子昂戲作
雙松平遠

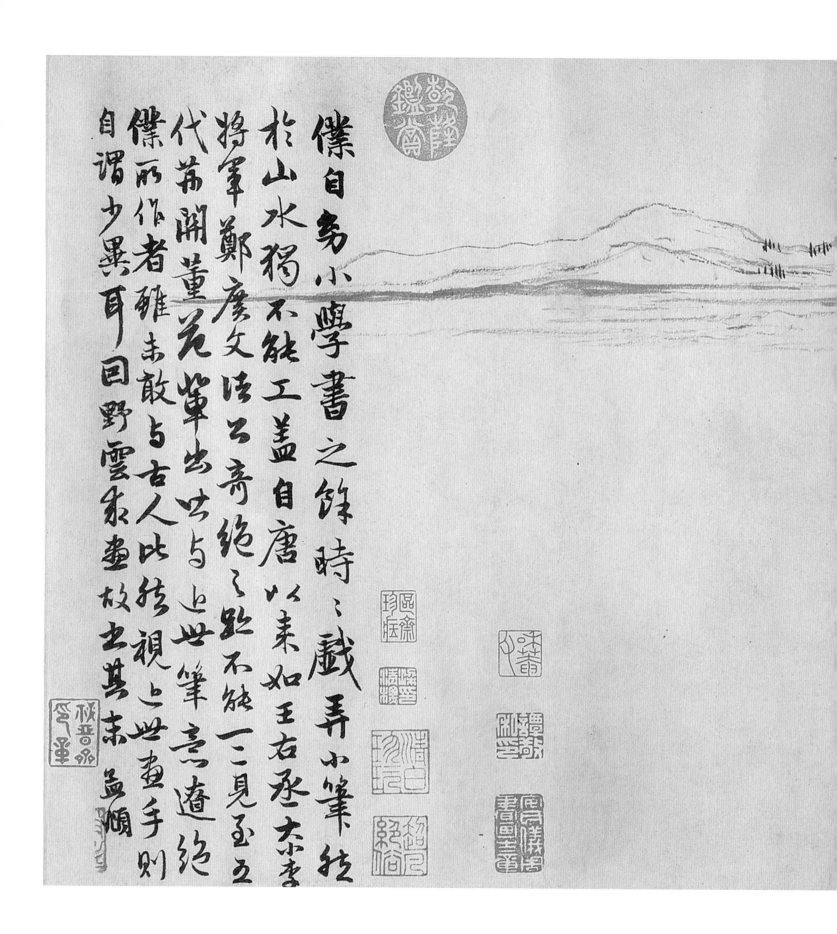

僕自為小學書之餘時戲弄小筆初
於山水獨不能工蓋自唐以來如王右丞大李
將軍鄭虔盧文活之奇絕之跡不能一見至五
代荊關董范董先筆出吃與上世筆意遼絕
僕而作者雖未敢與古人此然視上世畫手則
自謂少異耳因野雲求畫故書其末益順

Zhao intentionally added his inscription directly on top of
his rendering of distant mountains to emphasize that his
painting was not about creating an illusion of reality. By
inserting writing into the picture space, Zhao forces the
viewer to "read" his painting as a set of calligraphic brush-
strokes on a flat surface.

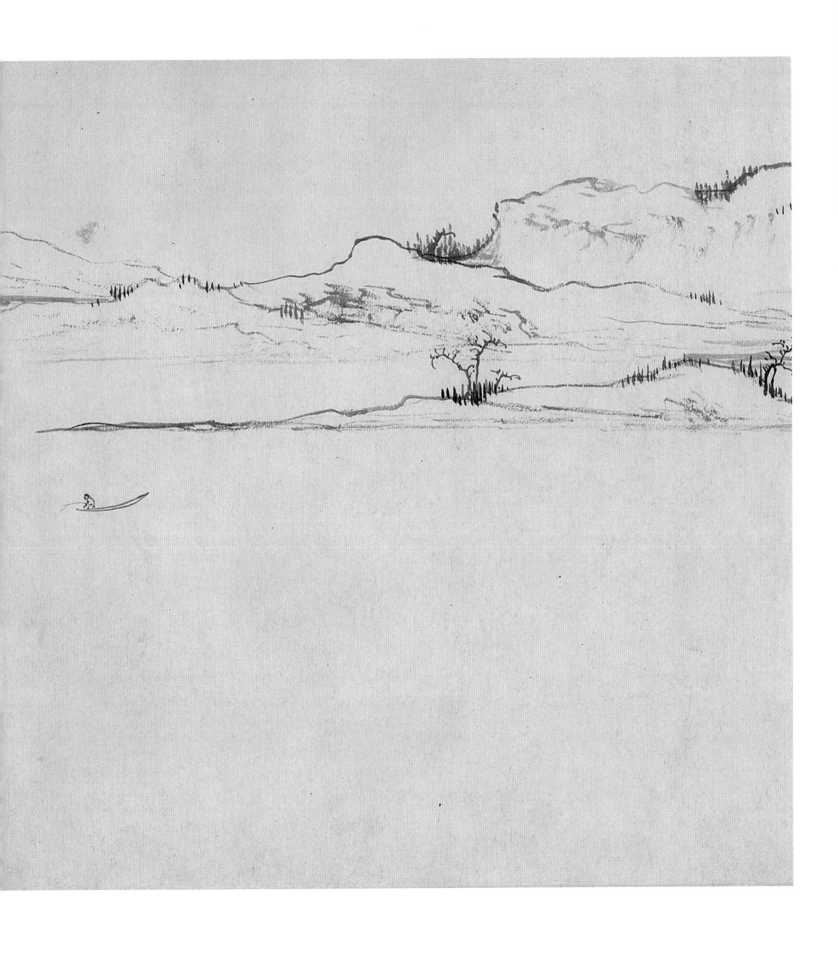

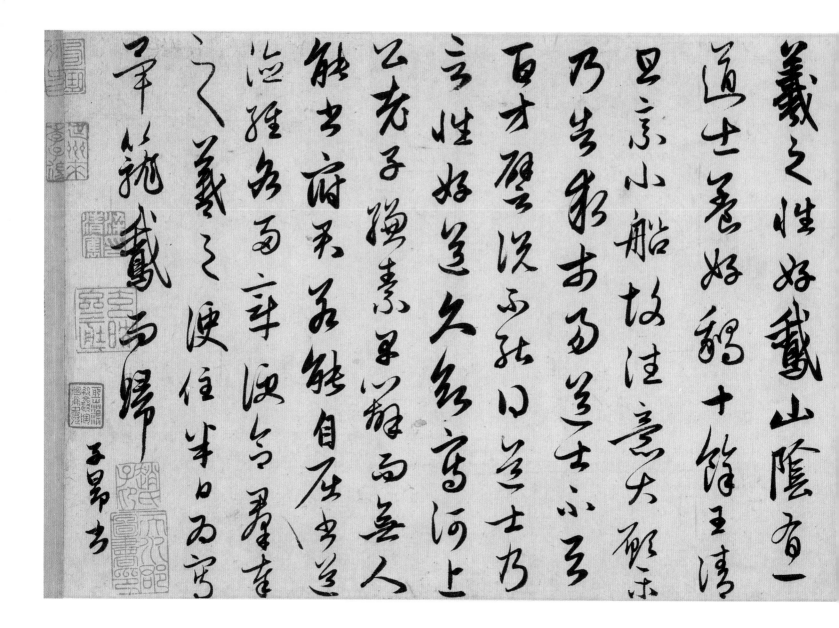

元　趙孟頫　行書右軍四事　卷

Zhao Mengfu (1254–1322)

Four Anecdotes from the Life of Wang Xizhi, ca. 1310

Handscroll (detail above), ink on paper, 9⅝ × 46⅛ in. (24.4 × 117 cm)
Bequest of John M. Crawford Jr., 1988 (1989.363.30)

The Yuan emperor Renzong (r. 1312–20) is said to have remarked that no one could compare with Zhao Mengfu (nos. 2, 17), who possessed seven outstanding qualities: Song royal ancestry, elegant appearance, wide learning, pure character and righteous conduct, literary accomplishment, skill in calligraphy and painting, and profound knowledge of Buddhist and Daoist teachings.

As the leading calligrapher of his time, Zhao advocated a return to ancient models, successfully integrating Jin (265–420) and Tang (618–907) dynasty styles to create a new synthesis in both standard and cursive scripts. During the fourteenth century, the typefaces of printed

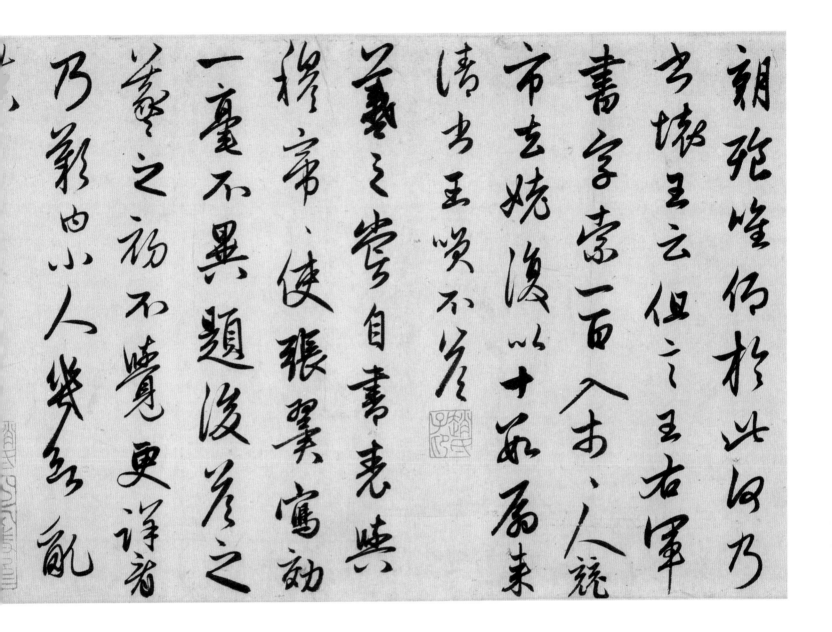

books were modeled after his standard script, while his cursive script, seen here, formed the basis for the informal writing styles of many later calligraphers.

Four Anecdotes from the Life of Wang Xizhi testifies to Zhao's devotion to the "calligraphy sage" Wang Xizhi (303–361; see no. 16), whose calligraphic style strongly influenced his own. Each of these apocryphal stories conveys a sense of how much Wang's calligraphy was valued in his lifetime. The last story is a good example:

Xizhi was extremely fond of [the graceful appearance of] geese. In Shanyin there was a Daoist monk who had raised a flock of more than ten fine geese. One morning Wang decided to take a small boat and go there. He was delighted with the geese and wanted to buy them, but the monk refused to sell. Wang tried in vain to persuade him. Finally, the monk told Wang that he loved Daoist philosophy and had always wanted a transcription of Laozi's *Daodejing* with its commentary by Heshanggong. He had already prepared the silk, but no one was qualified to write it. He asked if Wang would condescend to transcribe two chapters each from the *Dao* and *De* sections, for which he would give Wang the whole flock. Wang stayed for half a day to write out the chapters, then he caged the geese and returned home.

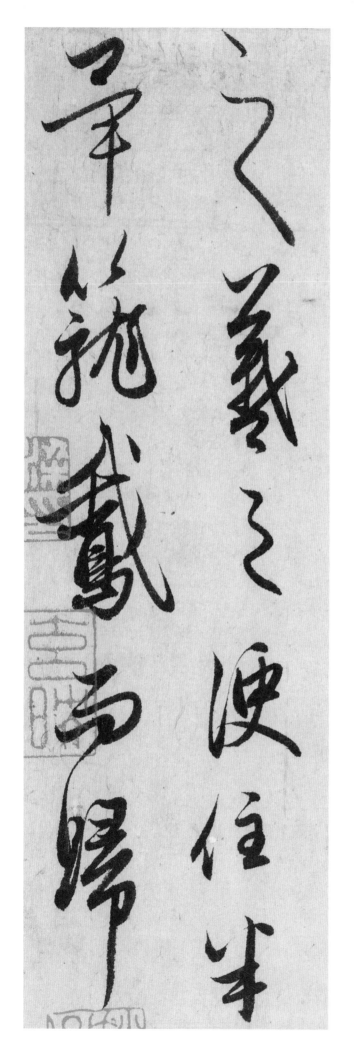

Zhao's exhilaration is conveyed by the exaggerated size of some characters. The first character in the right column, 之 (*zhi*), is the same as the third character, but coming at the end of a dramatic sentence, it has an elongated form that functions like an exclamation point: "Then the whole flock I'll give you!" The characters in the final line, at the left, are similarly emphatic: "He caged the geese and returned home!"

When Zhao's brush is fully charged with ink, his characters are denser and heavier, carrying a blunt force, as in 幾欲 (*jiyu,* "nearly"; *far left*) in the phrase "nearly confused what is authentic." Elsewhere, his lines are slender and begin or end in a sharp point, as in 道士 (*daoshi,* "Daoist"; *left*), emphasizing the resiliency of the tapered Chinese brush, which appears to dance across the surface of the paper as it responds to changes in direction and pressure. Zhao consciously manipulates the cadence of thin and thick lines and heavy and light characters to enhance the aesthetic impact of his composition.

Zhao Mengfu creatively enlivened his calligraphy by employing alternate configurations for the same character or by subtly varying the standard form. "Geese" (*e*) may be written with its two constituent components (我 and 鳥) either side by side, 鵝 (*left*), or stacked, 鵞 (*right*). Zhao uses both forms. In the stacked form, Zhao elongates the right-hand diagonal the full height of the character, dramatically tying together the two components.

元　王振鵬　維摩不二圖　卷

Wang Zhenpeng (active ca. 1280–1329)
Vimalakirti and the Doctrine of Nonduality, dated 1308

Handscroll (detail above), ink on silk, 15 ½ × 85 ¾ in. (39.5 × 217.7 cm)
Purchase, The Dillon Fund Gift, 1980 (1980.276)

This handscroll depicts an episode from the *Vimalakirti Sutra,* the Buddhist scripture in which Vimalakirti, the layman, and Manjusri, the Bodhisattva of Wisdom, engage in a theological debate. According to the sutra, Vimalakirti proved the more subtle by remaining silent when asked to explain the ultimate meaning of the Buddhist Law.

Superbly rendered in the *baimiao,* or "plain drawing," style by Wang Zhenpeng, a master known chiefly for his architectural paintings, this work disappeared after the late seventeenth century and was discovered only recently. Following the painting are two important colophons written by the artist that fully describe the circumstances surrounding its creation. It was executed in 1308 at the command of Renzong, then the heir apparent, who ruled as emperor from 1312 to 1320. The precise location in the palace where Wang received Renzong's order and even the name of the palace guard in attendance that day have been noted. The painter states that he used as his model a composition by a Jin painter named Ma Yunqing (active ca. 1230) that was itself a copy of a work by Li Gonglin (ca. 1041–1106; see no. 7). A scroll in the Palace Museum, Beijing, formerly attributed to Li Gonglin appears to be, in fact, the work of Ma Yunqing and the acknowledged model for this painting.

In China, the fluid style of depicting Indian draperies was known as "scudding clouds and flowing water." This monk's robes typify that manner. But Wang Zhenpeng's geometrically regular lines reflect the distinctly Chinese "iron-wire" (*tiexian*) style of disciplined fine-line brushwork, as does his meticulous rendering of the fabric pattern and wood grain of the couch.

Wang Zhenpeng took great license in his depiction
of this lion, reimagining a demonic beast as a playful
lion-dog. His consummate brush technique is evi-
dent in the precise curls of the animal's mane.

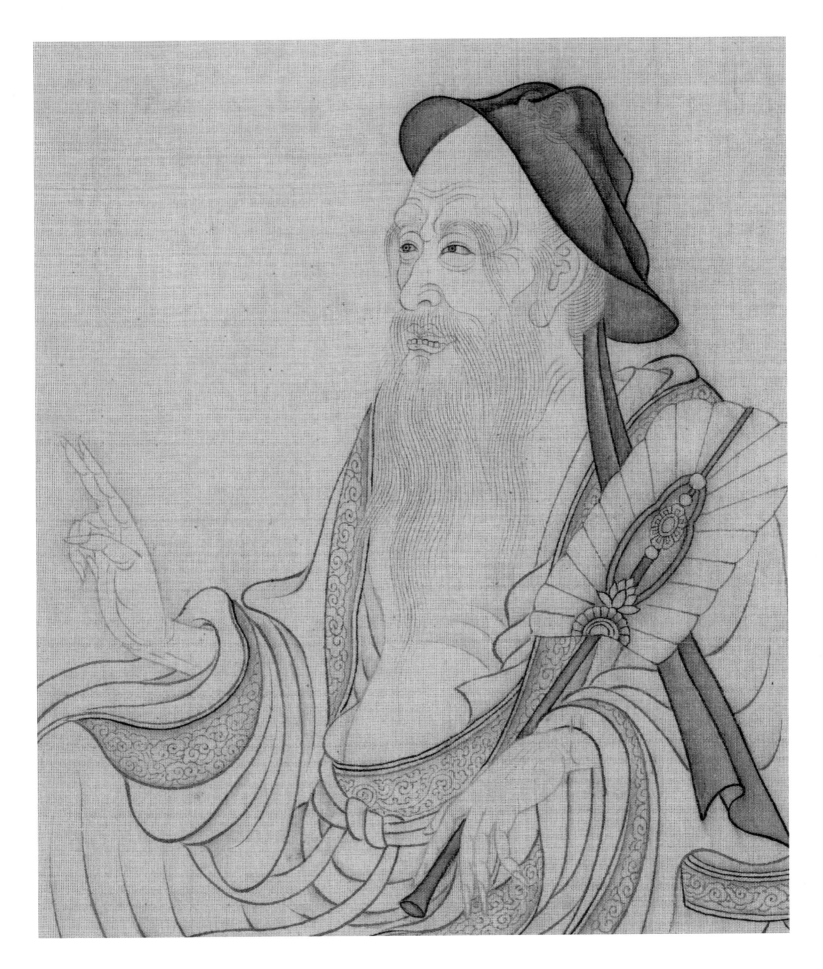

With his gauze head cover, fan, and long-sleeved robe, the Indian sage Vimalakirti is here transformed into a Chinese scholar-gentleman.

| # Meticulous Miniaturist

元　夏永　黃樓圖　冊頁

Xia Yong (active second half of 14th century)
The Yellow Pavilion, ca. 1350

Album leaf, ink on silk, 8 ⅛ × 10 ½ in. (20.7 × 26.8 cm)
Ex coll.: C. C. Wang Family
From the P. Y. and Kinmay W. Tang Family Collection,
Gift of Oscar L. Tang, 1991 (1991.438.3)

Xia Yong carried the specialty of architectural renderings in the "ruled-line" (*jiehua*) manner
to new heights of technical control. In contrast to his loosely described landscape elements,
Xia's buildings are densely detailed and meticulously drawn. This predilection for minute
scale is also evident in the artist's microscopic inscription, which transcribes "A Rhapsody on
the Yellow Pavilion," an essay by the famous Northern Song scholar Su Che (1039–1112),
younger brother of the poet Su Shi (1037–1101). That this text has special significance is sug-
gested by the figure of a Daoist immortal riding on a crane, which draws our eye toward it.

 Su Che's poem describes how the region around Xuzhou, in northern Jiangsu Province,
was flooded in 1077, following a sudden break in the dikes of the Yellow River. Su Shi, then a
prefect there, worked indefatigably to rescue the city from disaster. After the flood subsided
and the city walls were repaired, the Yellow Pavilion was dedicated in his honor. In 1344 the
Yellow River flooded again, causing widespread destruction. As Wen Fong notes, "By refer-
ring to a flood that had occurred three centuries earlier—and concealing his real message
by writing Su's text in a script so minute that few would actually have read it—Xia Yong
obliquely signaled his awareness of the momentous social changes caused by the flood of the
1340s, which would lead to the downfall of the Yuan dynasty less than twenty years later."

Xia Yong's render-
ing meticulously
describes not only
the architecture but
also details of interior
decor and activities
such as groups of
men enjoying a meal
and looking out at
the view.

| The Integration of Poetry, Painting, and Calligraphy

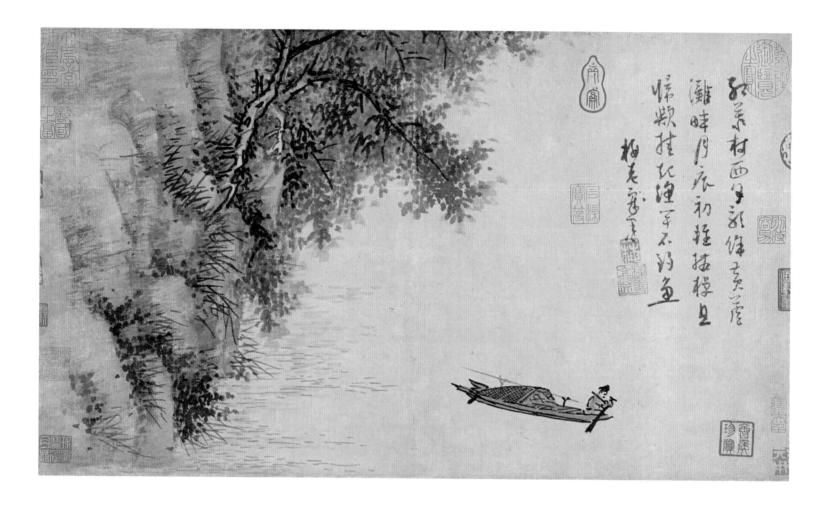

元 吳鎮 蘆灘釣艇圖 卷

Wu Zhen (1280–1354)

Fisherman, ca. 1350

Handscroll, ink on paper, 9¾ × 17 in. (24.8 × 43.2 cm)
Bequest of John M. Crawford Jr., 1988 (1989.363.33)

Wu Zhen lived the life of a recluse. He was never very famous or successful during his lifetime, but in the Ming period (1368–1644) he came to be designated one of the Four Great Masters of the late Yuan dynasty and his style was favored by many Ming painters, most notably Shen Zhou (1427–1509). Wu was fond of doing "ink-plays," the self-deprecating term used by scholar-amateur artists to describe their art, and his drawing style shows a cartoonlike simplicity and directness.

Accompanying the hermit-fisherman, a symbol of the late Yuan unemployed scholar, Wu Zhen's poetic colophon reads: "Red leaves west of the village reflect evening rays, / Yellow reeds on a sandy bank cast early moon shadows. / Lightly stirring his oar, / Thinking of returning home, / He puts aside his fishing pole, and will catch no more."

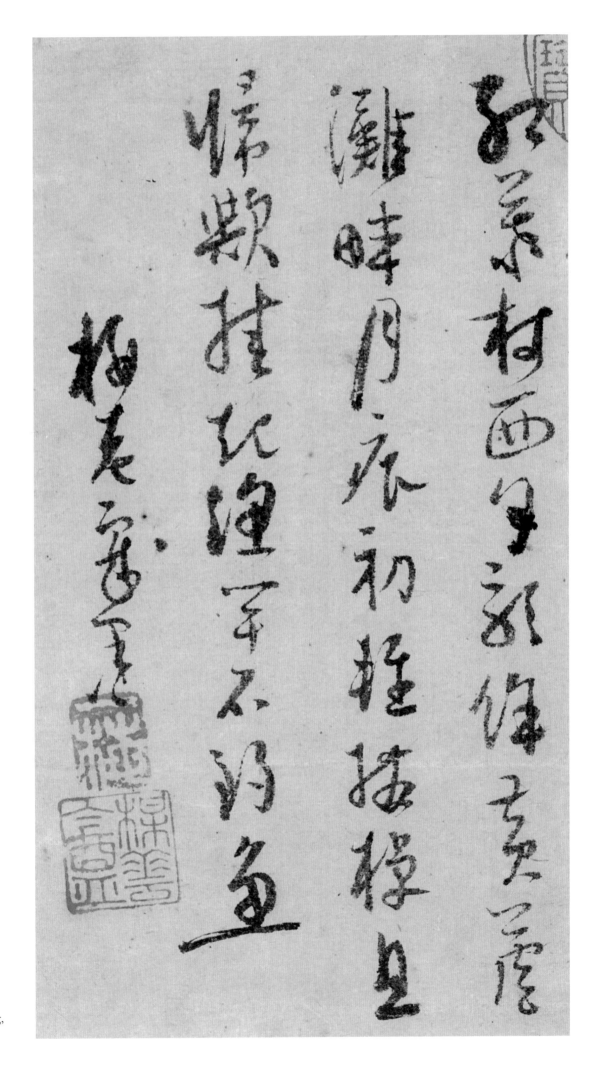

Wu Zhen's cursive writing exhibits the same informality and spontaneity as his painting, with broad, oarlike strokes contrasting with the fluid curves of his fluttering, leaflike marks.

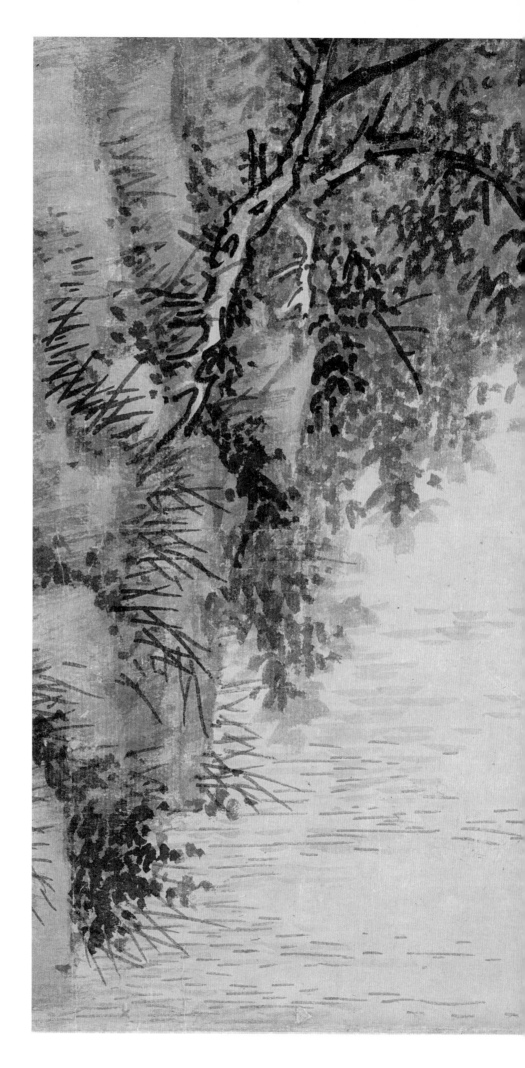

Situated halfway between the rippled shoreline and the inscription, Wu Zhen's freely sketched fisherman and boat are balanced between representation and calligraphic abstraction. Staccato blades of grass, rhythmically repeated foliage patterns, and deliberately outlined trees vividly capture the act of creation. Were it not for the graded ink tones and vague intimation of ripples, there would be little in Wu Zhen's painting to suggest three-dimensional form or spatial recession.

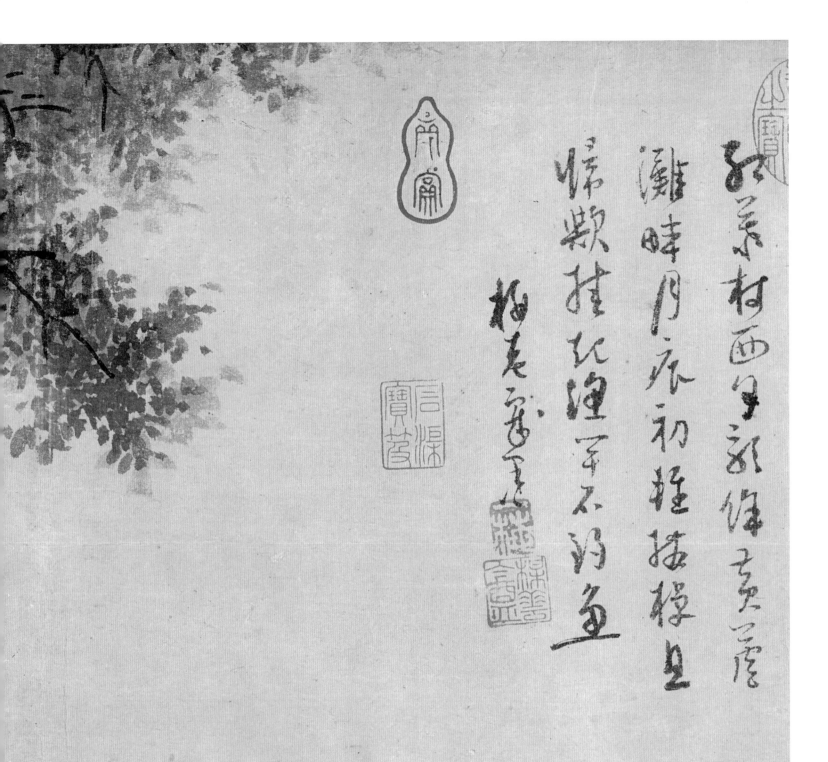

紅蓼村西夕照疎

灘晴月瓦初程掻棹歸

慣數枝花渡乎不約魚

柳岸漁家

元　倪瓚　江渚風林圖　軸

Ni Zan (1306–1374)

Wind among the Trees on the Riverbank, dated 1363

Hanging scroll, ink on paper, 23 ¼ × 12 ¼ in. (59.1 × 31.1 cm)
Bequest of John M. Crawford Jr., 1988 (1989.363.39)

Forced to flee his hometown of Wuxi in Jiangsu Province to escape extortionary tax collectors, Ni Zan led a refugee's life between 1356 and 1366, residing with his family southwest of Suzhou at a place he nicknamed Snail's Hut. Compared to his Wuxi days, this was a wrenching change, but the family was able to settle down to an existence of "simple sustenance, harmony, and happiness." Ni's paintings and calligraphy from this period are more assured and relaxed; consequently, they sometimes appear sketchy—a characteristic the artist consciously sought.

Because Ni Zan painted virtually the same composition his entire life—a grove of trees on a rocky foreground shore juxtaposed with distant mountains—the subtle variations in each iteration reveal changes in his circumstances and state of mind. This desolate landscape, done for a fellow scholar-artist, Yu Kan, undoubtedly reflects Ni's bereavement at the recent death of his wife and his growing sense of isolation. His inscription reads:

> On the riverbank the evening tide begins to fall;
> The frost-covered leaves of the windblown grove are sparse.
> I lean on my staff—the brushwood gate is closed and silent;
> I think of my friend—the glow is nearly gone from the hills.

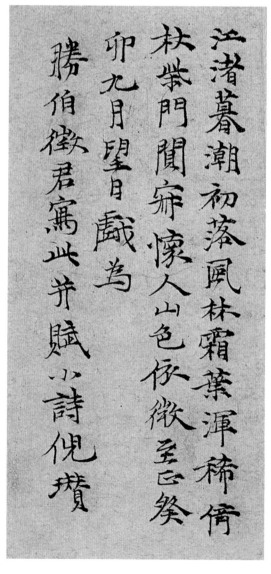

As a gentleman-recluse, Ni Zan affected a distinctive style of calligraphy based on archaic clerical script forms that give his writing a naive and rustic appearance. Characteristic features of his style are flaring diagonals and long thin horizontal strokes that broaden to the right.

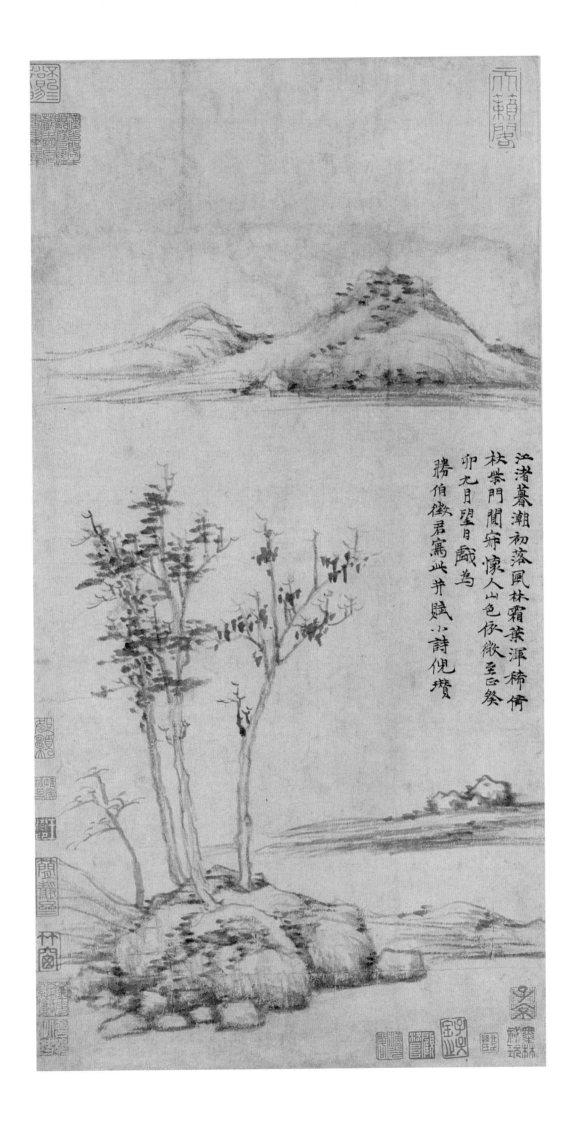

江渚暮潮初落
風林霜葉渾稀
倚杖柴門閒寄
懷人山色依微
至正癸卯九月
望日戲為勝伯
徵君寫此并賦
小詩倪瓚

99

23 | Pictorial Diary II: Contentment at Life's End

元 倪瓚 虞山林壑圖 軸

Ni Zan (1306–1374)

Woods and Valleys of Mount Yu, dated 1372

Hanging scroll, ink on paper, 37 ⅛ × 14 ⅛ in. (94.3 × 35.9 cm)
Ex coll.: C. C. Wang Family
Gift of the Dillon Fund, 1973 (1973.120.8)

In 1366 Ni Zan again abandoned his home, this time to escape marauding soldiers. Even after the establishment of the Ming dynasty in 1368, Ni continued the life of a wanderer, visiting old haunts he had not seen for twenty or thirty years. According to his epitaph writer, Zhou Nanlao (1308–1383), "In his late years, he became quieter and more withdrawn than ever. Having lost or given away everything he ever owned, he did his best to forget his worries. Wearing a yellow [Daoist] cap and country clothes, he roamed the lakes and mountains, leading a recluse's life."

Woods and Valleys of Mount Yu, executed two years before Ni Zan's death, expresses the painter's joy and contentment in the life of a recluse. The dry but tender brushwork is aloof and restrained. There is a tranquil, luminous quality about the painting that makes it one of the most fully realized works of the artist's later years. The artist's poem ends with these lines:

> *We watch the clouds and daub with our brushes;*
> *We drink wine and write poems.*
> *The joyful feelings of this day*
> *Will linger long after we have parted.*

Taut slender brushstrokes, exaggerated horizontals, and elongated characters typify Ni's mature style of calligraphy, which represents a rejection of the elegantly fluid manner of Zhao Mengfu's writing (no. 18).

100

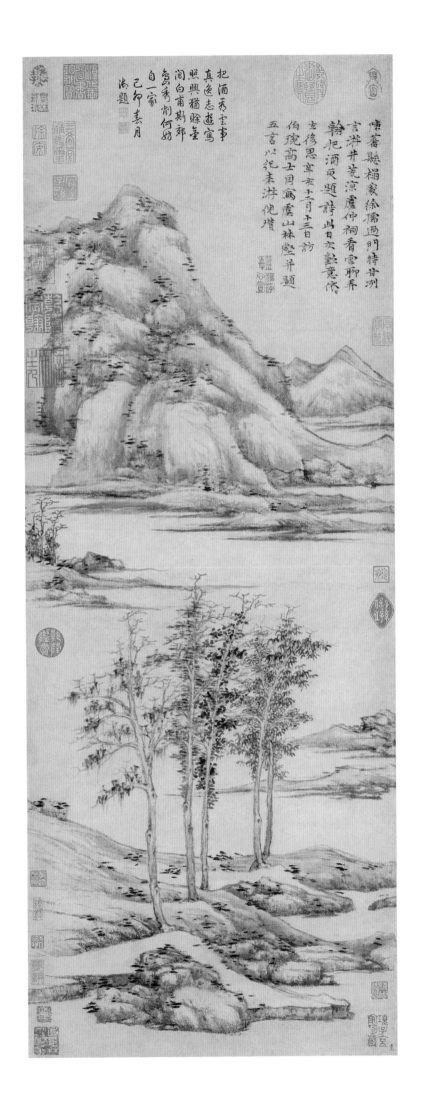

把酒秀雲事
真逸志遊寫
照興猶緜全
閒白甫期郊
竟秀削何妨
自一家
己卯春月
漫題

陳蕃懸榻宴徐孺過門特甘洌
言游井荒涼廬仲祠香雲聊弄
翰把酒更題詩此日友歡意依
左修思章在十月十三日訪
伯琬高士因寓廬山林壑井題
五言以記未游他墳

IOI

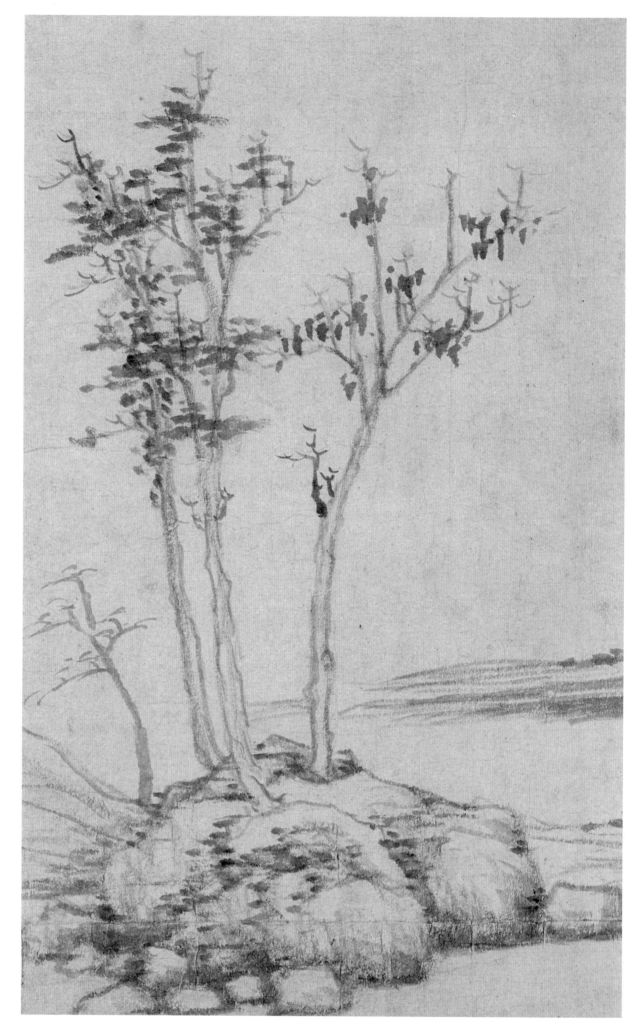

In Ni's private vocabulary, trees symbolized his circle of friends. Few in number, sparsely foliaged, and isolated from their surroundings, the trees in this wintry grove reflect the artist's bleak state of mind in 1363, as revealed in his poem.

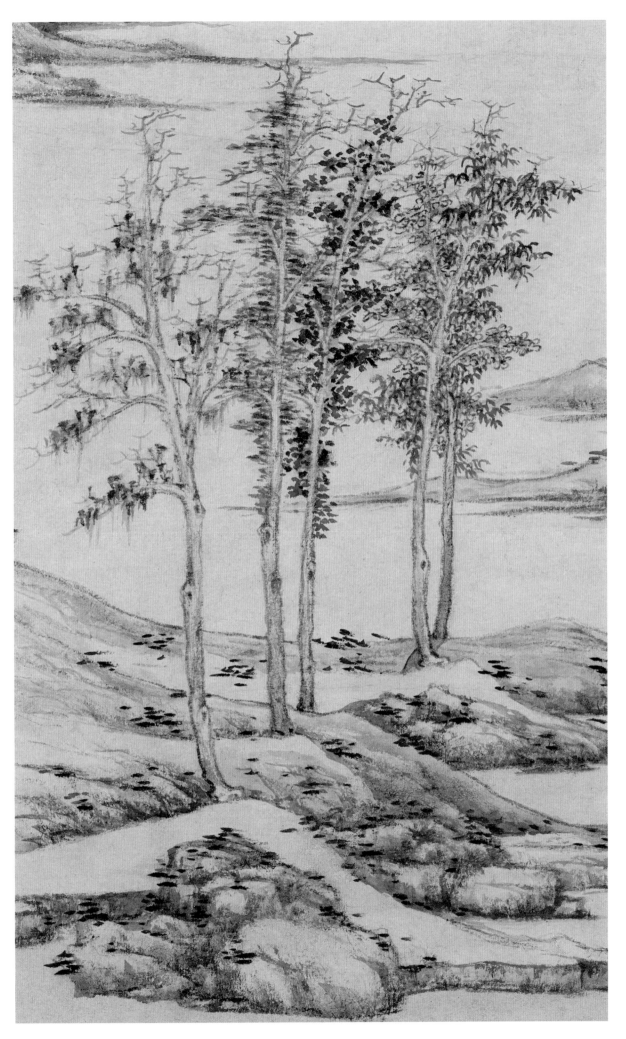

By 1372 Ni had regained his equilibrium, and his improved situation and spirits are apparent from the flourishing summertime foliage of his trees. The rich complexity of leaf patterns conveys a sense of energy and excitement.

103

Distant mountains often symbolized a refuge or paradise, but here such a retreat was clearly beyond Ni Zan's reach. The mountains appear barren and remote and are separated from the foreground trees by a wide expanse of water.

Ni Zan's enhanced sense of security by 1372 is conveyed by the substantiality of his mountains, which now appear much closer to the foreground trees. Their accessibility is underscored by an intermediate shoreline that actually intersects with the uppermost branches.

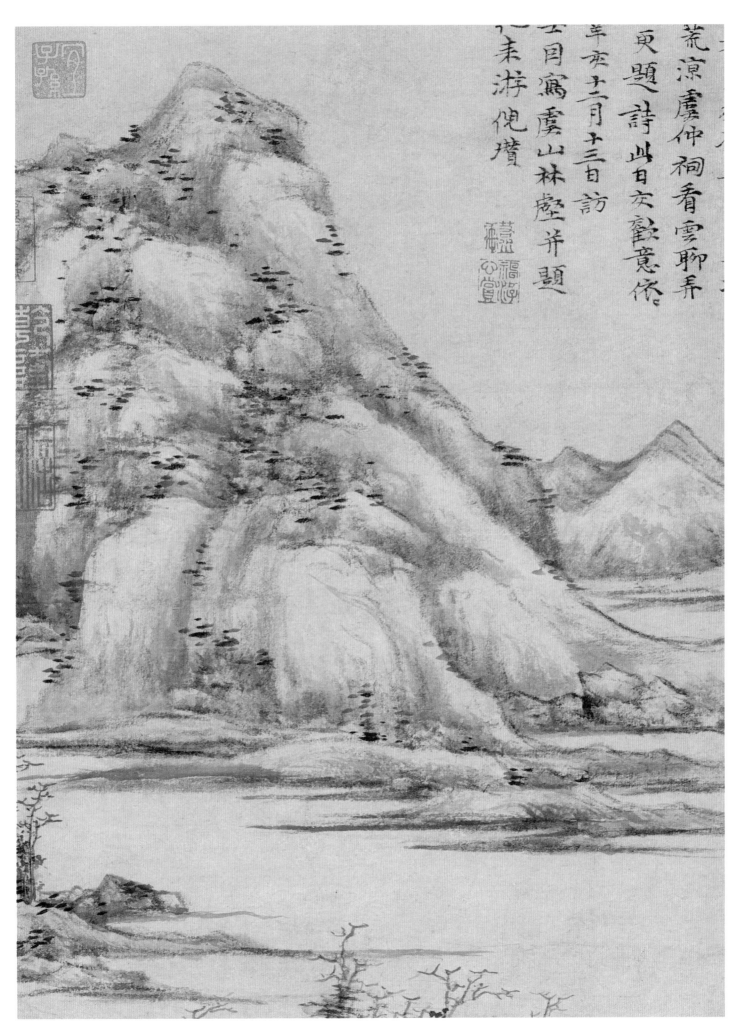

荒涼虞仲祠香雲聊弄
更題一詩此日交歡意依
辛亥十二月十三日訪
玉田寫虞山林壑並題
花来游伲增

24 | Conceptual Landscape

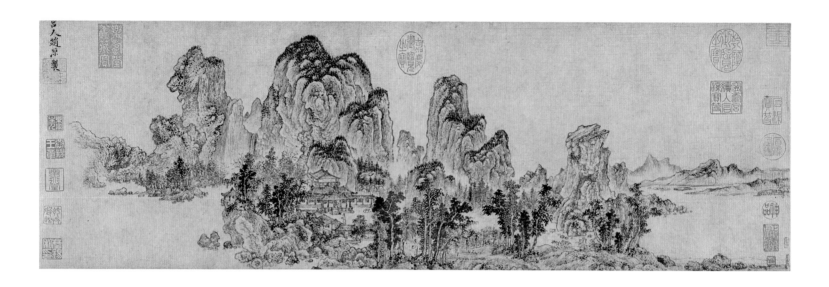

元 趙原(元) 倣燕文貴范寬山水圖 卷

Zhao Yuan (active ca. 1350–75)
Landscape in the Style of Yan Wengui and Fan Kuan

Handscroll, ink on paper, 9¾ × 31⅛ in. (24.9 × 79 cm)
Edward Elliott Family Collection
Purchase, The Dillon Fund Gift, 1981 (1981.285.15)

Late Yuan scholar-artists saw painting as a vehicle for personal expression: painting, it was said, should be like handwriting, a "heart print" of the artist. Zhao Yuan's small landscape, couched in the monumental landscape idioms of Yan Wengui (active ca. 970–1030) and Fan Kuan (active ca. 990–1030), exemplifies the scholar painting of this period, in which ancient models are transformed by calligraphic brush methods.

Executed during a period of political and social turmoil, Zhao's handscroll reflects a common theme found in paintings of his time: a life in reclusion (see nos. 21–23, 25, 26). A secluded temple complex nestled at the foot of a tall peak, with its spacious courtyard, hilltop terrace for meditation, and gazebo beside a stream, suggests a serene existence free from worldly strife.

Living in the south, Zhao Yuan recreates the towering mountains of the north through imagination. The last fantastic peak near the left end of the composition was probably inspired by a strangely eroded limestone "scholar's rock" such as those favored as ornaments in the studios and gardens of his native Suzhou.

An illusion of depth is created not through a continuously receding ground plane but through dramatic shifts in scale—from the foreground figure and trees, to the trees and figures beside the middle ground temple, to the trees around a distant mountain terrace.

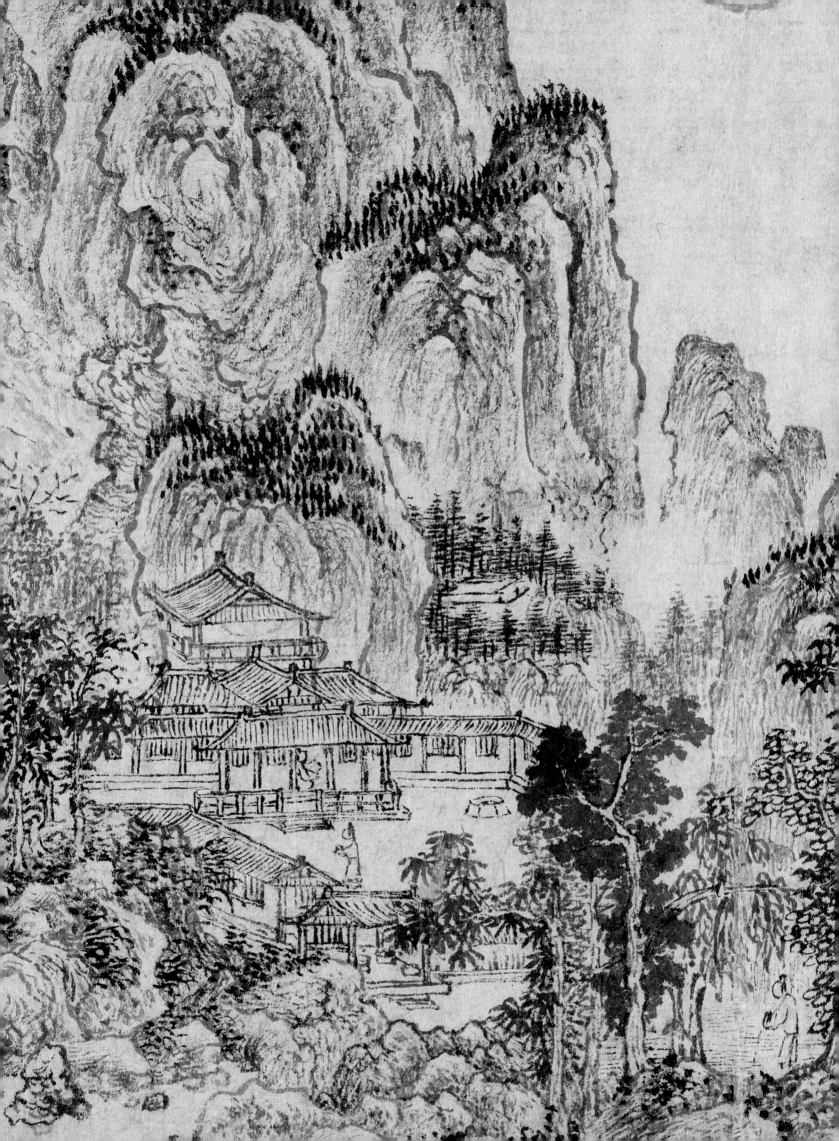

Zhao's fantastic landscape forms were likely inspired not by actual scenery but by decorative garden rocks such as those from Lake Tai in the Astor Court at The Metropolitan Museum of Art.

Expressive calligraphic brushwork rather than representational verisimilitude is the chief goal of Zhao Yuan's painting. He energizes his composition with an array of texture strokes that neither diminish in scale to suggest spatial recession nor become paler or more blurred to evoke the veiling effects of atmosphere. Instead, Zhao uses the archaic convention of overlapping ridges and contours to make his mountain appear to project forward.

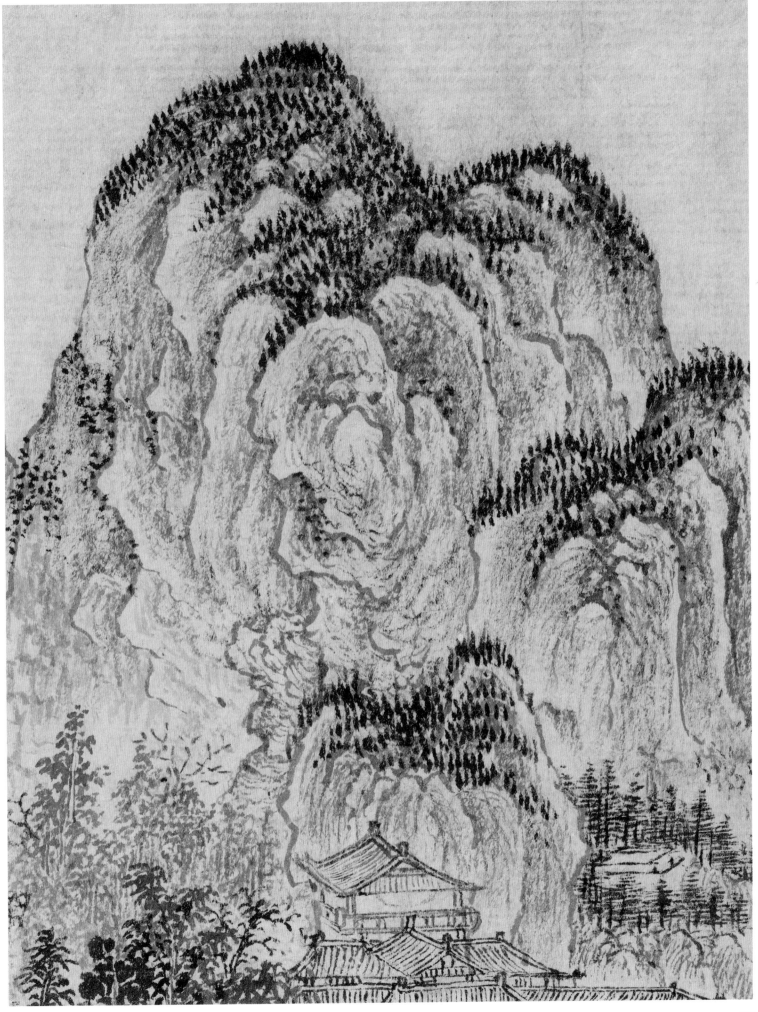

25 | Visionary Mountains

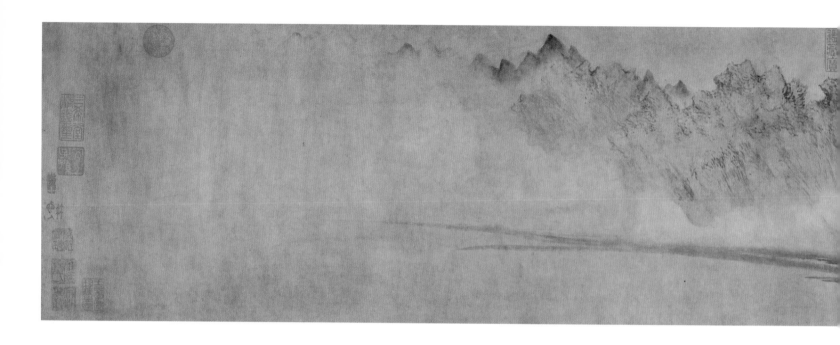

元　方從義　雲山圖　卷

Fang Congyi (ca. 1301—after 1378)
Cloudy Mountains, ca. 1360—70

Handscroll, ink and color on paper, 10¼ × 56⅞ in. (26.1 × 144.5 cm)
Ex coll.: C. C. Wang Family
Purchase, Gift of J. Pierpont Morgan, by exchange, 1973 (1973.121.4)

Fang Congyi, a Daoist priest from Jiangxi, traveled extensively in the north before settling down at the seat of the Orthodox Unity Daoist church, the Shangqing Temple on Mount Longhu (Dragon Tiger Mountain), Jiangxi Province. Imbued with Daoist mysticism, he painted landscapes that "gave shape to things that have no shape and returned things that have shape to the shapeless."

According to Daoist geomantic beliefs, a powerful life-energy pulsates through mountain ranges and watercourses in patterns known as *longmo,* or "dragon veins." In *Cloudy Mountains,* the painter's kinetic brushwork, wound up as if in a whirlwind, charges the mountains with an expressive liveliness that defies their physical structure. Weightless and dematerialized, the great mountain range resembles a dragon ascending into the clouds.

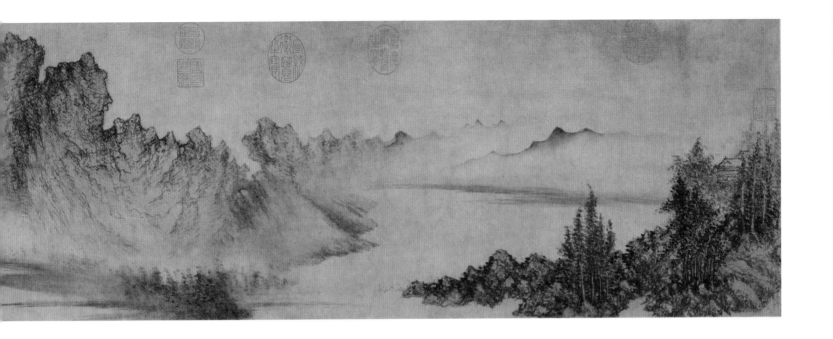

In this amorphous and transitory world, finely delineated water grasses growing at the tip of the headland not only draw attention to the artist's hand but also dramatize the enormous leap in scale from the near-ground peninsula to the mist-blurred trees and mountains on the far shore.

Overleaf: Unrolling the scroll from right to left, the viewer first encounters a foreground promontory with a half-concealed temple that serves as the "eye" of the painting, setting the scale and establishing a vantage point for the viewer. An expanse of water and a receding shoreline behind the promontory effectively convey the illusion of depth as they draw the eye into the distance. But the artist soon abandons spatial logic to animate his crenellated mountains with graphic energies that recall the elusive nature of dragons, which cannot be captured by conventional modes of perception.

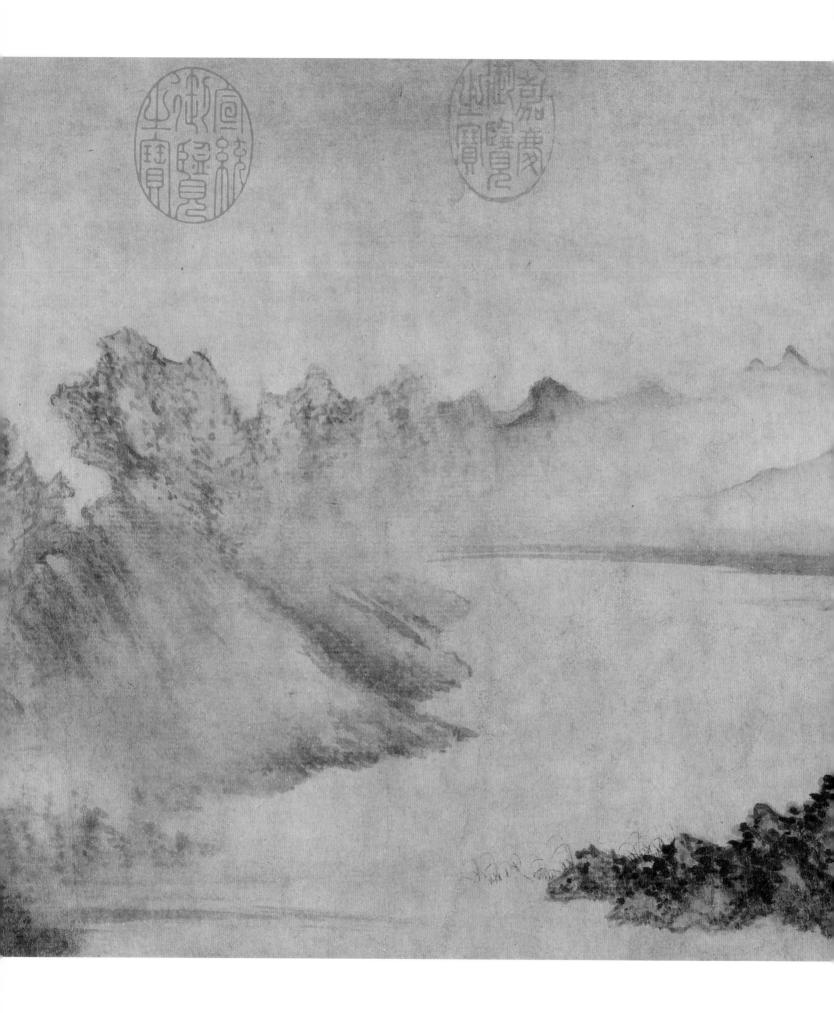

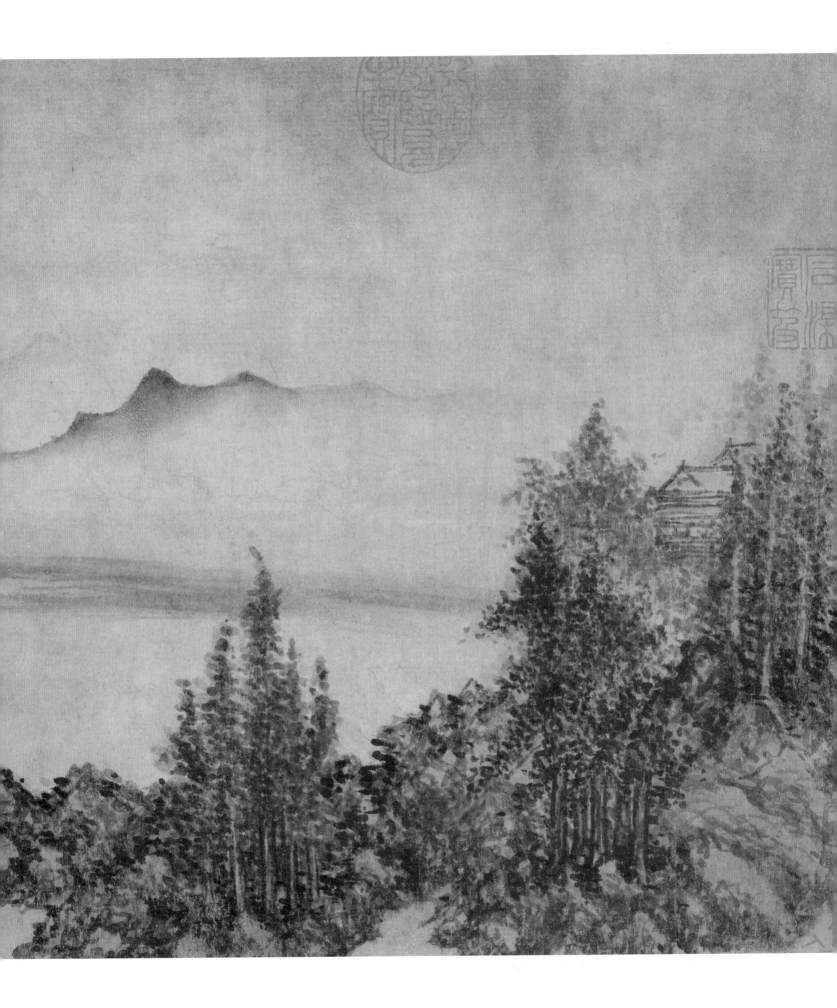

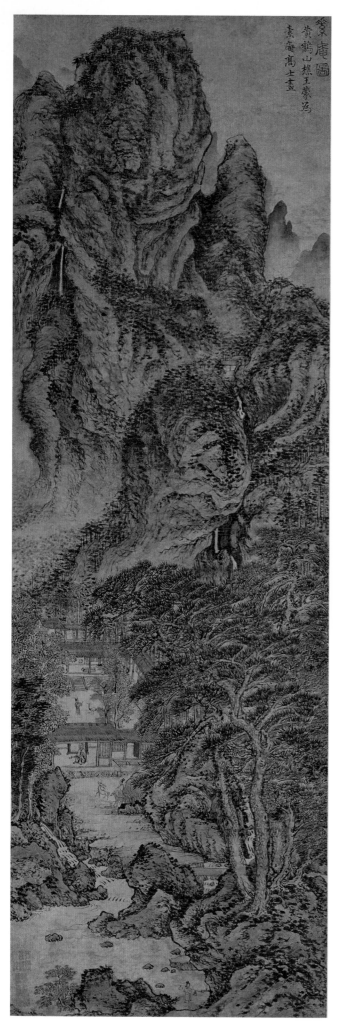

26 | Escapist Fantasy

元 王蒙 素庵圖 軸

Wang Meng (ca. 1308–1385)
The Simple Retreat, ca. 1370

Hanging scroll, ink and color on paper, 53 ½ × 17 ¾ in. (136 × 45 cm)
Ex coll.: C. C. Wang Family
Promised Gift of the Oscar L. Tang Family

During the final, chaotic years of the Yuan dynasty (1271–1368), men of learning often chose to withdraw from public life to pursue self-cultivation in retirement. Wang Meng made a specialty of depicting scholars in their retreats, creating imaginary portraits that capture not the physical likeness of a person or place but an interior world of shared associations and ideals.

Wang presents the master of *The Simple Retreat* as a gentleman-recluse. Seated at the front gate of a rustic but spacious hermitage, he is shown holding a magic *lingzhi* mushroom as an attendant and two deer approach from the woods. In the courtyard, a young boy offers a sprig of herbs to a crane. The auspicious Daoist imagery of *lingzhi,* crane, and deer as well as the archaic simplicity of the figures and dwelling, protected by overarching mountains and trees, evokes a dreamlike vision of paradise.

In creating this fantasy world, Wang Meng has powerfully transformed the substantial landscape imagery of the early Northern Song period (960–1127). Rocks and trees, animated with fluttering texture strokes, dots, color washes, and daubs of bright mineral pigment, pulse with a restless calligraphic energy barely contained within the traditional landscape structure. The blank paper of the waterways and houses acts as a counterbalance to the densely textured mountain, creating a yin-yang interplay of mass and void that further energizes the composition. Encircled by this charged landscape of mountains and water, the retreat becomes a reservoir of calm at the vortex of a world whose dynamic configurations embody nature's creative potential but may also suggest the ever shifting terrain of political power.

Wang Meng's intentionally naive, childlike style undermines the reality of his vision of paradise, where only deer and a crane come to call. For Wang, the eremitic ideal had become an unattainable dream.

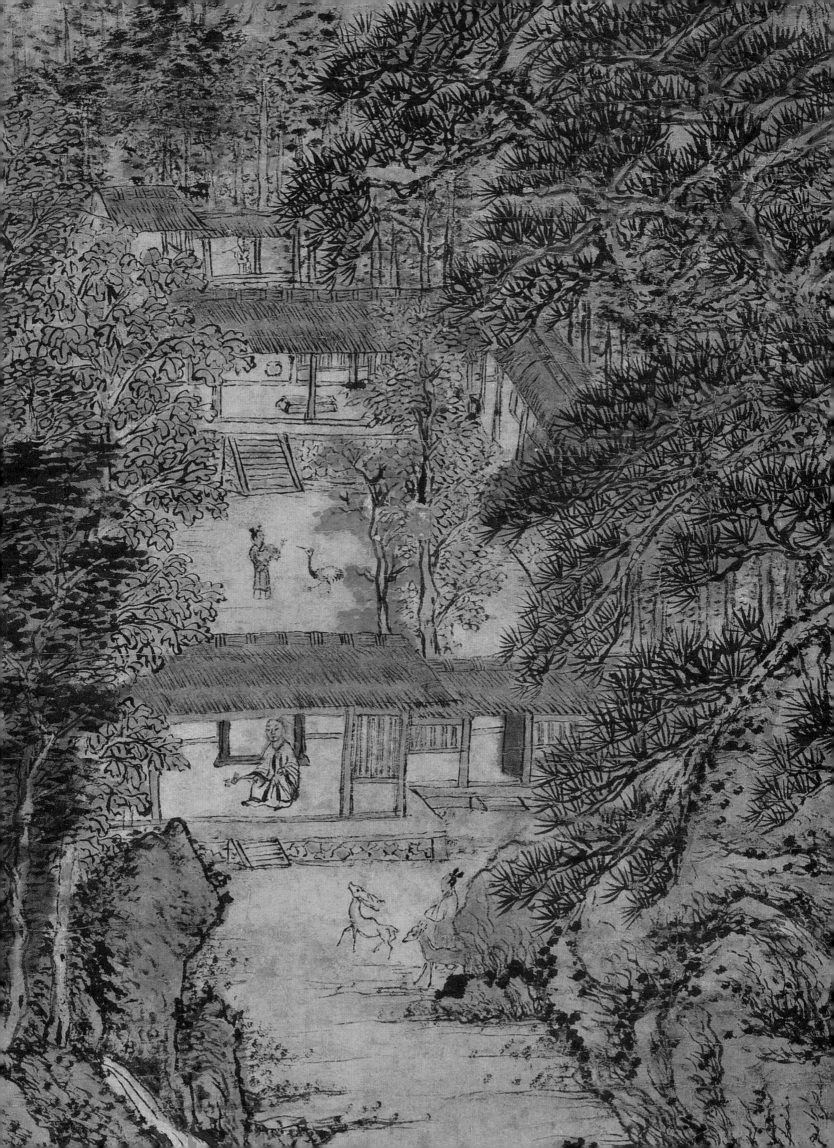

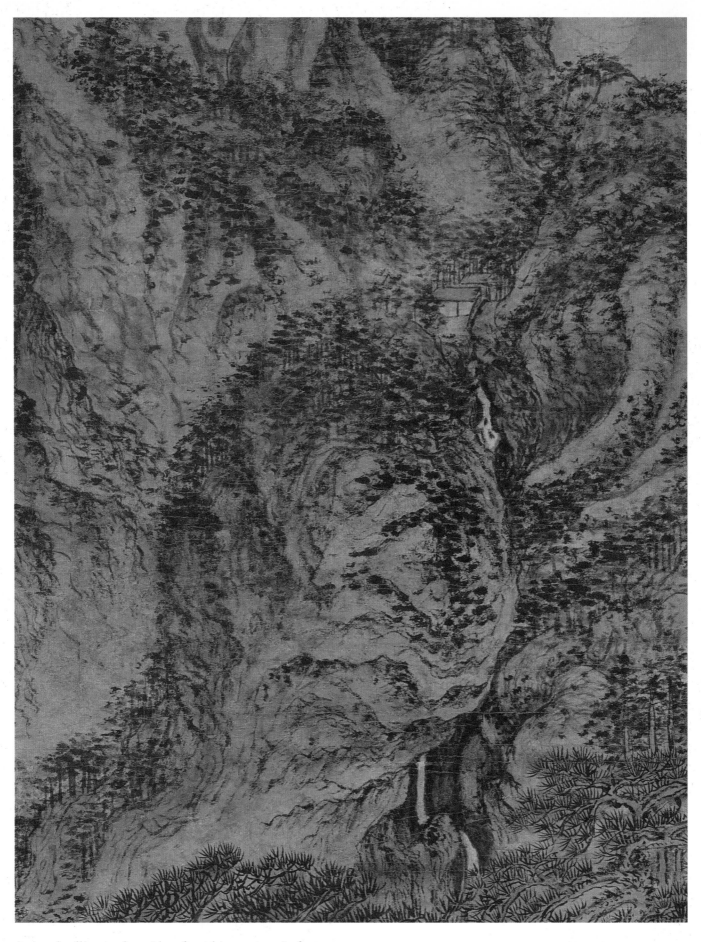

A tiny dwelling in the midst of writhing mountain forms
(*above*) is like the eye of a storm, a promise of calm in a
tempest-wracked world. From this point, water flows to
the hermitage below, encircling it and creating a serene
sanctuary protected by towering pines (*opposite*).

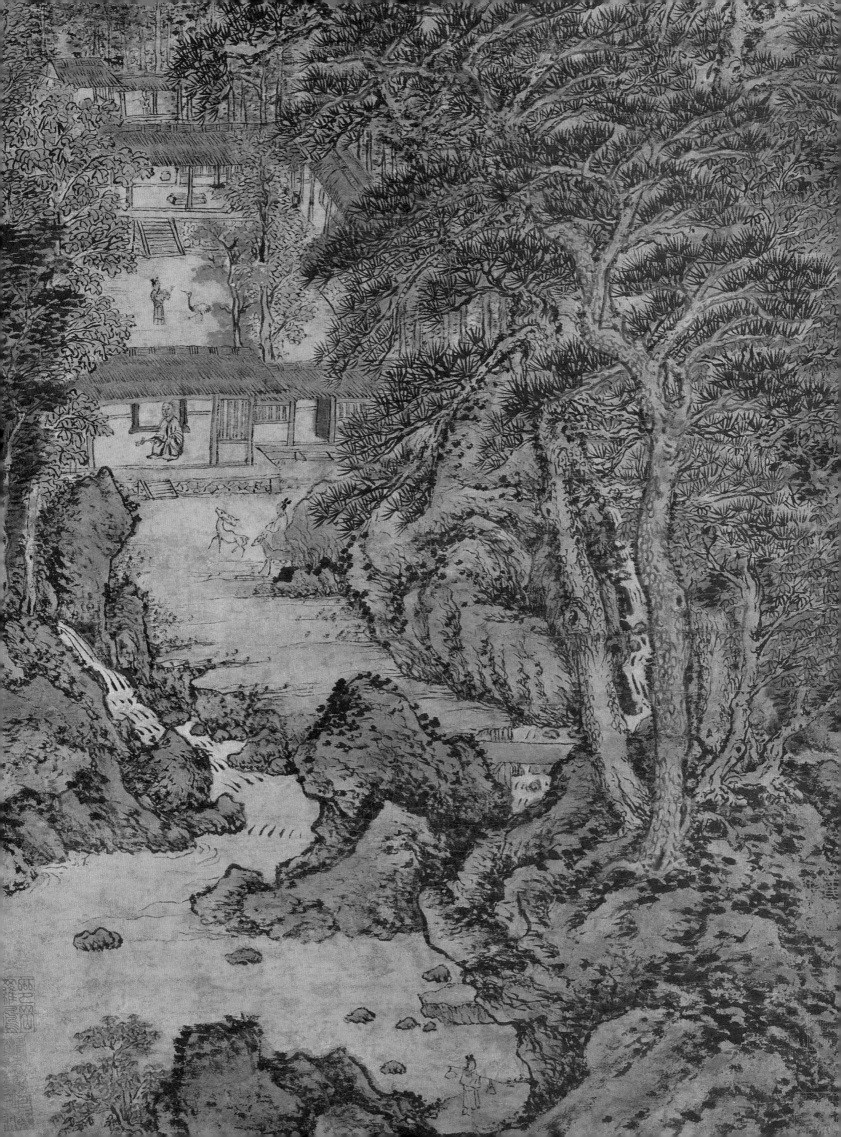

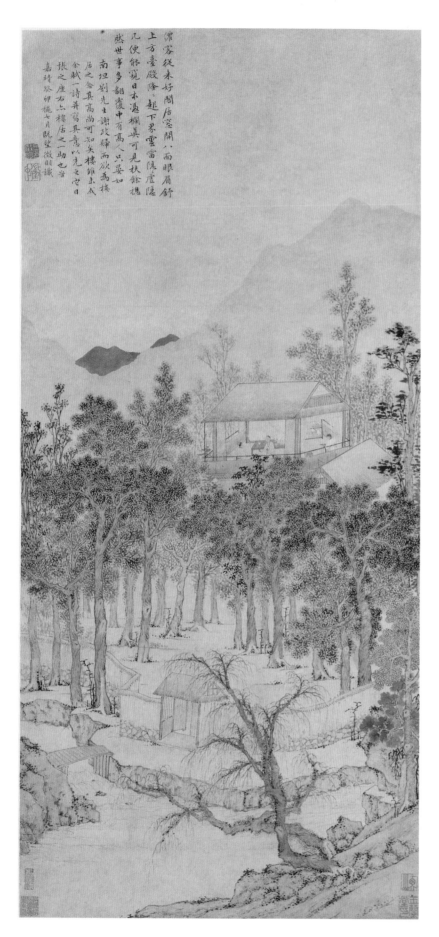

明　文徵明　樓居圖　軸

Wen Zhengming (1470–1559)
Living Aloft: Master Liu's Retreat, dated 1543

Hanging scroll, ink and color on paper, 37½ × 18 in.
(95.2 × 45.7 cm)
Promised Gift of Marie-Hélène and Guy Weill

Wen Zhengming painted *Living Aloft* for his friend Liu Lin (1474–1561), who, at the age of seventy, had retired from government service but had not yet built a home suitable for his new life. In his painting Wen presents an idealized vision of life in retirement: separated from the outside world by a stream and rustic wall, two friends enjoy each other's company in a two-story hall that is further isolated in a tall grove of trees. The studio is furnished with a red lacquer table set with an antique bronze vessel and a pile of books. More books and scrolls are arrayed on a shelf visible behind a screen as a young attendant appears bearing a tray with cups of wine or tea.

Wen elaborates on the pleasures of such a life in his accompanying poem:

> *Immortals have always delighted in pavilion-living,*
> *Windows open on eight sides—eyebrows smiling.*
> *Up above, towers and halls well up,*
> *Down below, clouds and thunder are vaguely sensed.*
> *Reclining on a dais, a glimpse of Japan,*
> *Leaning on a balustrade, the sight of Manchuria.*
> *While worldly affairs shift and change,*
> *In their midst a lofty man is at ease.*

Master Liu's retreat is no rustic wilderness dwelling; instead, it is an elegantly furnished two-story library set among a grove of ancient trees in a garden compound—an idealized vision of retired life in a time of peace.

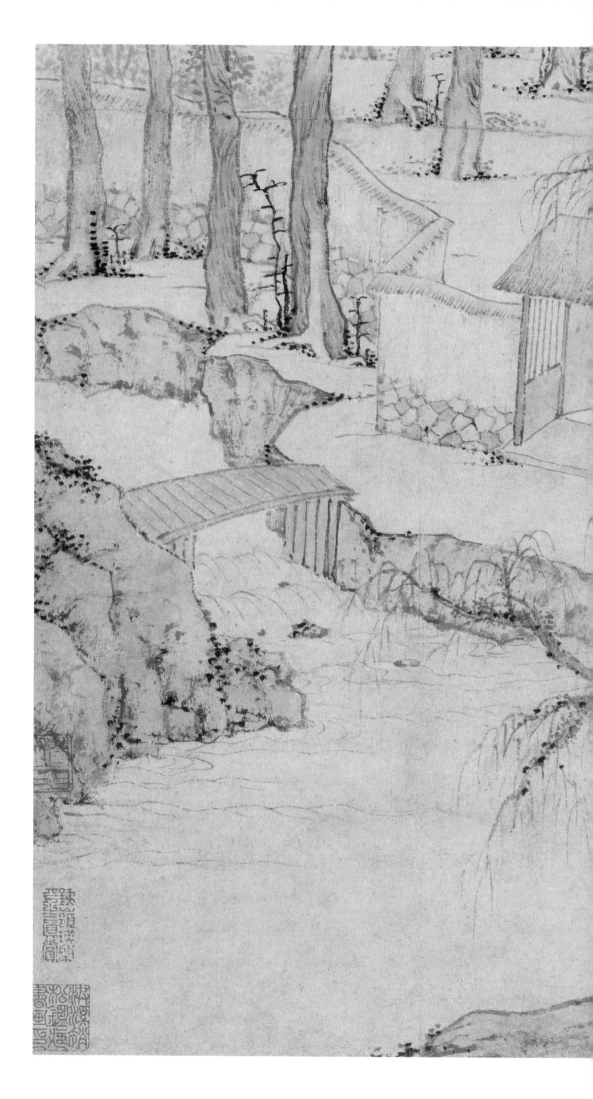

A watery moat and wall guard this verdant retreat from the wintry, mundane world beyond, suggested by the leafless foreground willows, but a bridge and open gate beckon sympathetic friends to enter.

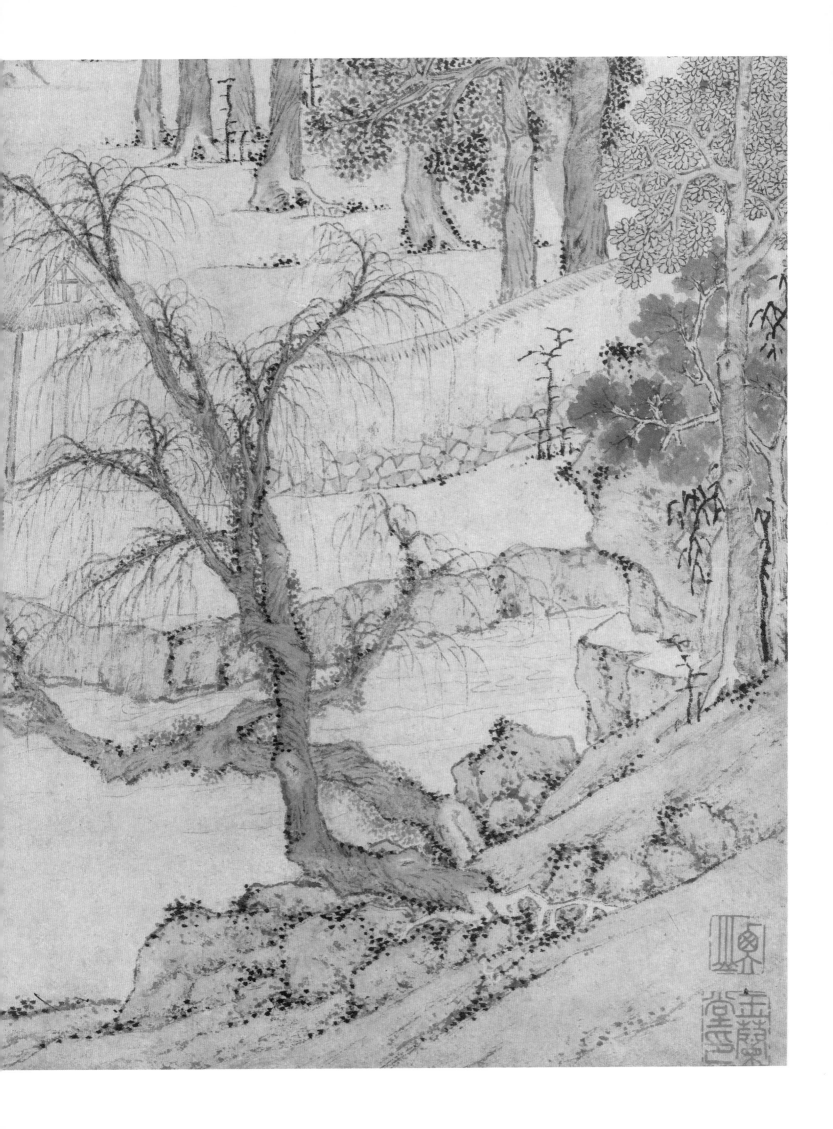

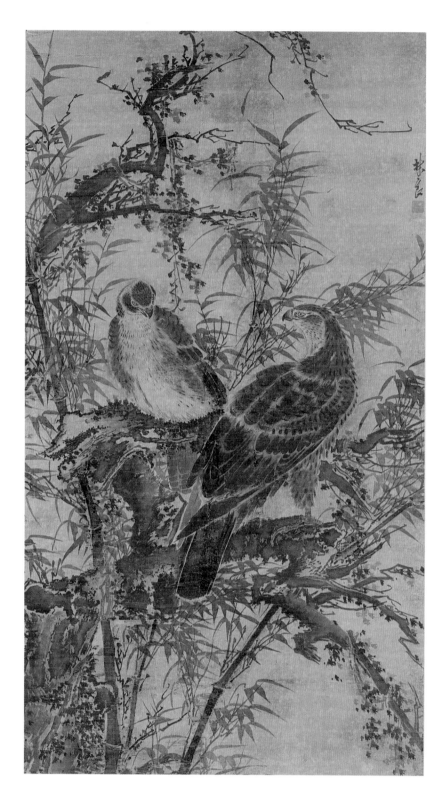

明　林良　二鷹圖　軸

Lin Liang (ca. 1416–1480)
Two Hawks in a Thicket

Hanging scroll, ink and pale color on silk, 58 ⅝ × 33 ⅛ in. (149 × 84 cm)
Gift of Bei Shan Tang Foundation, 1993 (1993.385)

One of the leading court painters of bird-and-flower genre scenes, the Cantonese artist Lin Liang specialized in bold, expressive monochrome depictions of birds in the wild. According to Richard Barnhart, "There had never before been such hawks as those painted by Lin Liang. Standing like monuments to strength and courage on the highest, frozen peaks, swept by bitter winds, living in worlds that lesser creatures could not inhabit, Lin's great birds are embodiments of heroism like no others." In contrast to his usual image of hawks silhouetted against the sky and surveying their surroundings from a high perch, however, these noble birds appear withdrawn and reclusive, "depicted as if lost in a dense forest of old trees and thick bamboo, perched on a dead tree where no one could possibly reach them, inviolable and inaccessible."

A symbol of strength and courage, this hawk is endowed with keenly observed plumage and anatomical details.

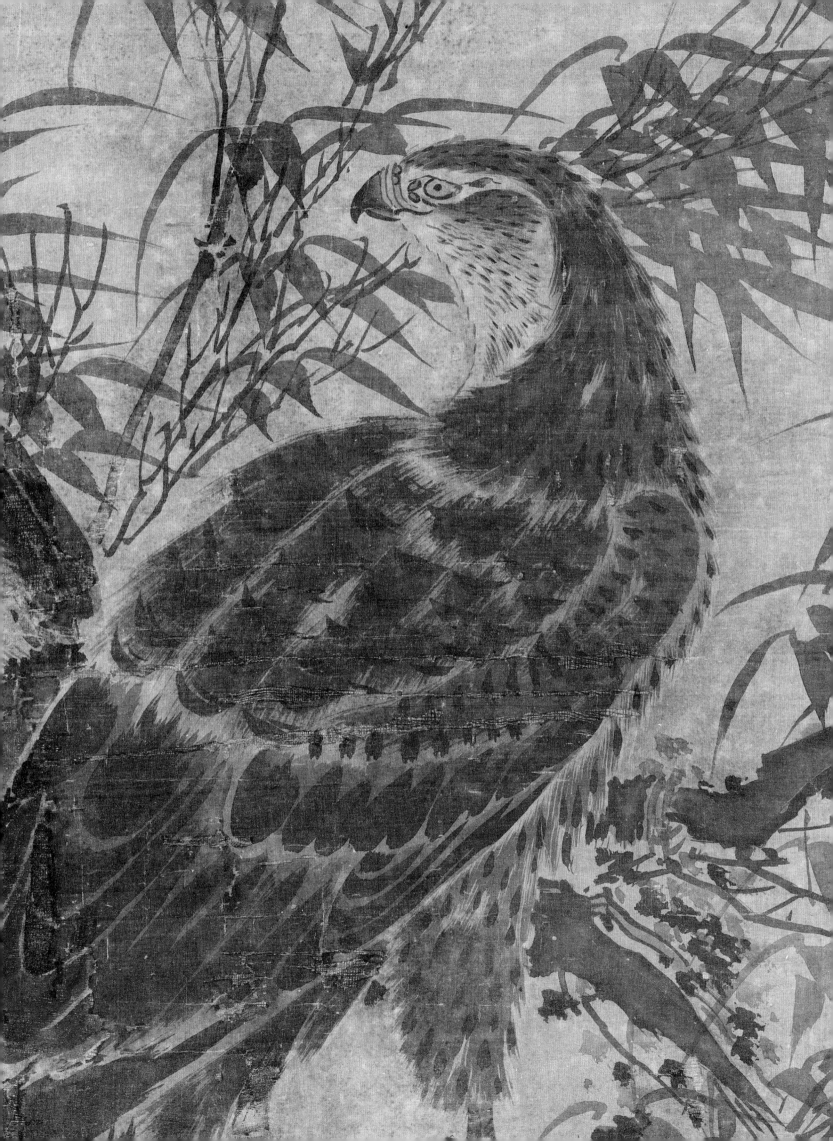

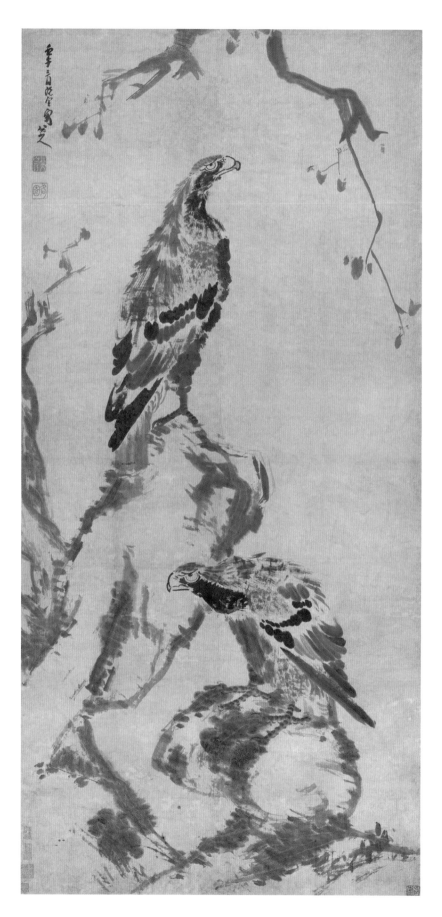

清 朱耷（八大山人）二鷹圖 軸

Zhu Da (Bada Shanren; 1626–1705)
Two Eagles, dated 1702

Hanging scroll, ink on paper, 73 × 35⅜ in. (185.4 × 90 cm)
Ex coll.: C. C. Wang Family
Lent by Oscar L. Tang

After decades spent concealing his identity as a scion of
the Ming royal house, Zhu Da, at the age of seventy-six,
seems in this forceful depiction of eagles to be declaring
his proud defiance of Manchu Qing rule. There is no
immediate precedent for such imagery; instead, the
painting harks back to the powerful representations of
eagles and hawks created by the early Ming court artist
Lin Liang (ca. 1416–1480; no. 28). Lin's heroic birds are
emblems of strength and courage suitable for presenta-
tion to censors or military officials. Zhu Da, a fervent
Ming loyalist, has personalized this imagery, transform-
ing the conventional symbolism into an expression of
brave confrontation and unfaltering loyalty, his noble
birds standing sentinel over a landscape now occupied
by foreign conquerors.

This boldly simplified rendering
transforms the earlier realistic
tradition to assert that the bird
has become a personal symbol of
defiant loyalty.

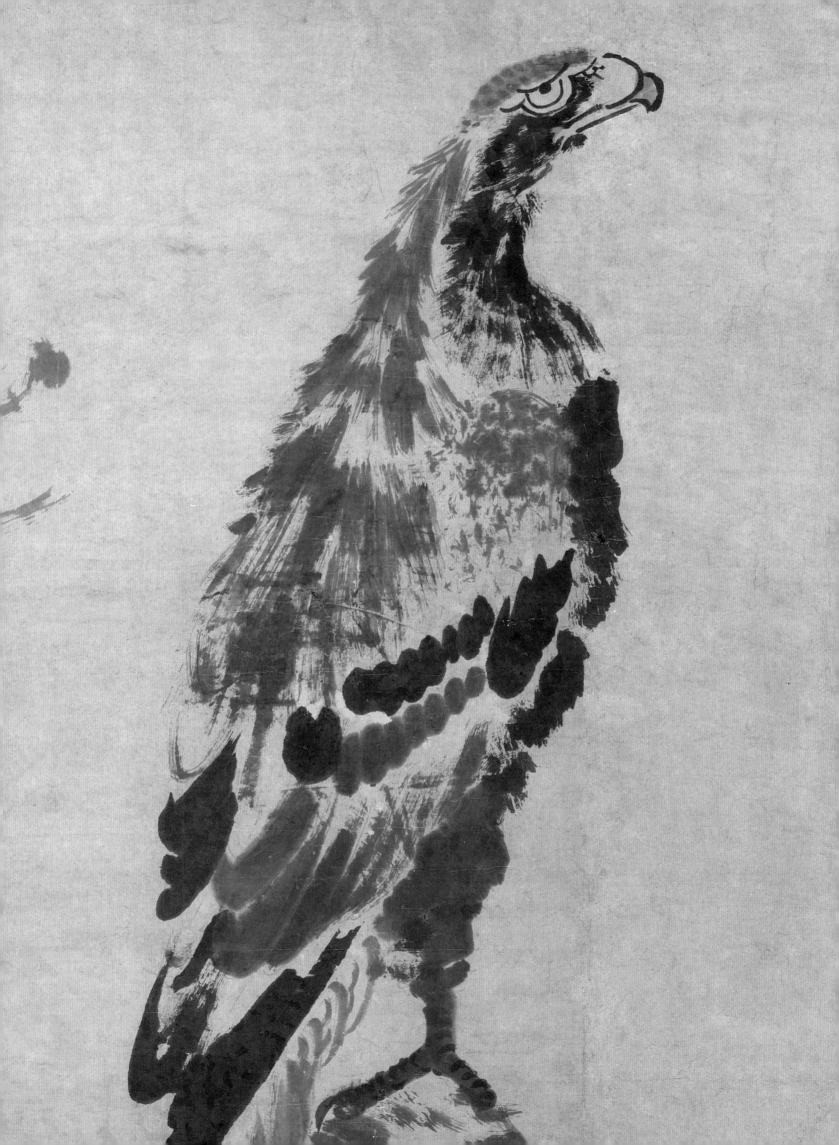

30 | Portraiture as Archetype

明 杜堇 伏生授經圖 軸

Du Jin (active ca. 1465–1509)
Fu Sheng Transmitting the "Book of Documents"

Hanging scroll, ink and color on silk, 57⅞ × 41⅛ in. (147 × 104.5 cm)
Gift of Douglas Dillon, 1991 (1991.117.2)

In his greatest act of infamy, the first emperor of Qin (Qin Shihuangdi; r. 221–210 B.C.) ruthlessly burned books and buried scholars alive to eliminate opposition. When the Han dynasty was established in 206 B.C., a program to reconstruct texts began. Fu Sheng retrieved a copy of the Confucian classic the *Book of Documents*, which he had hidden, and spent the remainder of his days lecturing on it. Here, the scholar is shown discoursing on the text to the official Shao Zuo, who had been sent by the emperor. His daughter, Fu Nu, seated beside him, was a scholar in her own right and aided by translating their local dialect into one familiar to the scribe.

Du Jin was trained as a scholar but became a professional painter after failing the *jinshi* civil service examination. Moving to Beijing, he cultivated a circle of patrons and literati friends there as well as in Nanjing and Suzhou. Through contacts such as the artists Tang Yin (1470–1524) and Shen Zhou (1427–1509), Du played a significant role in the development of a local professional painting style in Suzhou that was basically a refined version of the high academic style of the imperial court. Although this painting no longer bears a signature, it is a classic example of Du's polished academic manner.

This imaginary portrait presents an idealized image of an elderly scholar. His enlarged cranium with prominent protuberances—Buddhist attributes of supernatural wisdom—recall depictions of Buddhist sages (see nos. 32, 33), as do his bushy eyebrows and elongated earlobes. His wizened features emphasize his spiritual nature and detachment from material concerns. The open robe, a rejection of Confucian decorum, evokes the garb of free-spirited individualists of the third century. The stylized, angular drapery also derives from antique prototypes.

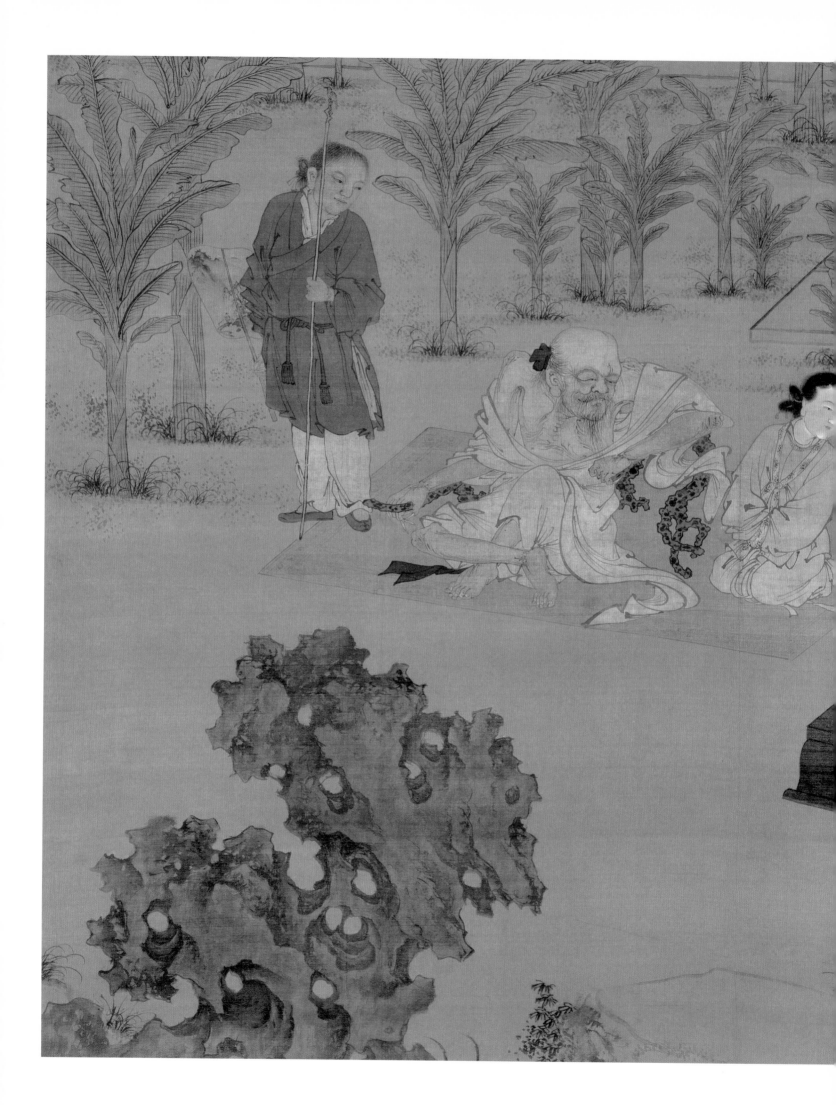

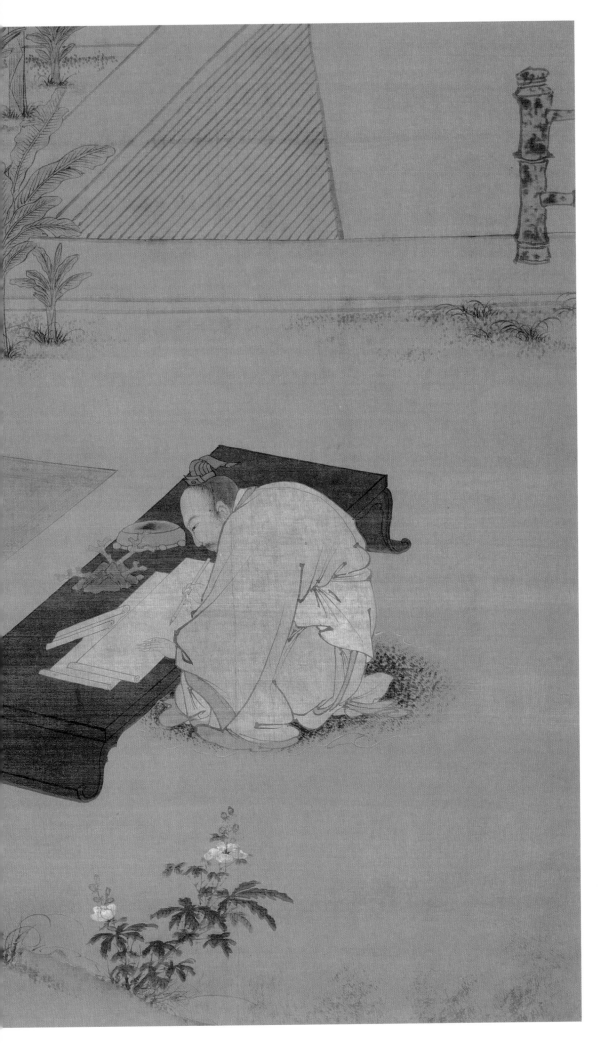

In China, gardens—idealized recreations of the natural world meant to encourage reflection and self-cultivation—have long been an important locus for cultural activities such as literary gatherings (see nos. 27, 33, 35). It is entirely appropriate, therefore, that Fu Sheng's lecture takes place in such an elegant setting. The flourishing grove of plantain suggests Fu's continued vigor, while the craggy ornamental rock is an apt symbol of his obdurate defiance of the Qin despot, who had tried to eradicate Confucian learning.

| Physiognomy as Art

明　祖德　抑齋曾叔祖八十五齡壽像　軸

Zude (surname unknown, 16th or early 17th century)
Portrait of the Artist's Great-Granduncle Yizhai at the Age of
Eighty-Five, dated *xinyou* (1561 or 1620?)

Hanging scroll, ink and color on silk, 61¾ × 37⅞ in. (156.8 × 96.2 cm)
Seymour Fund, 1959 (59.49.1)

Portraits of monarchs, used in the state cult of ancestor worship, have a long tradition in China, but private portraiture as a significant artistic genre arose only during the latter half of the sixteenth century, as a result of increased economic prosperity and a growing spirit of individualism.

This nearly lifesize image epitomizes the late Ming genre of formal portraiture, in which the sitter is depicted frontally with a realistically described face set atop a body that is largely concealed beneath the stylized folds of an engulfing robe. According to the inscription, the painting depicts the artist's relative Yizhai on the occasion of his eighty-fifth birthday. Unlike an "ancestor portrait," which was typically commissioned after a person's death and was therefore highly schematic, this portrait was painted from life. Nonetheless, the mode of representation is basically linear, with little use of light and shadow to model facial features—a Western technique that was first introduced into China in the sixteenth century and did not become widespread until the mid-seventeenth century. Yizhai is depicted in an informal hat and robe, an indication that he either never held official rank or had adopted the costume of a gentleman living in retirement.

Physiognomy, the art of discovering character from facial features, was a widely practiced form of fortune-telling in China and led portraitists to depict their subjects frontally in order to maximize the readability of their countenances. While the sitter's appearance may have been somewhat idealized, his humanity shines through. In contrast to his lifelike face, the angular drapery folds of his robe adhere to ancient conventions.

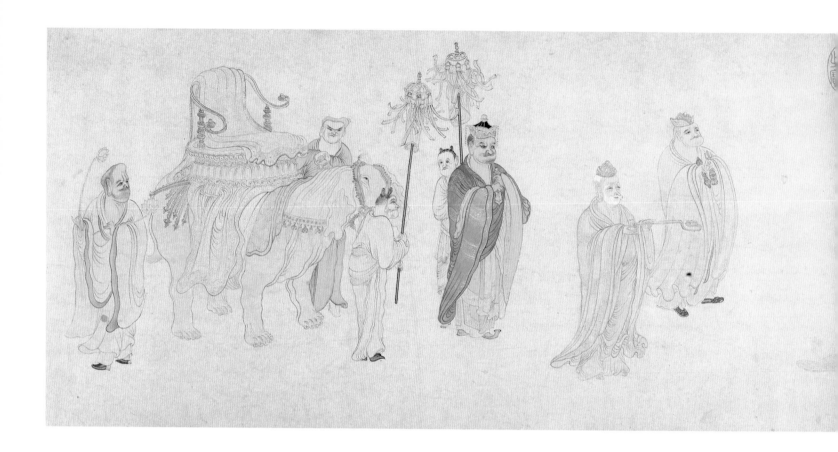

明 吳彬 十六羅漢圖 卷

Wu Bin (active ca. 1583–1626)
The Sixteen Luohans, dated 1591

Handscroll (detail above), ink and color on paper, 12⅝ in. × 13 ft. 7⅛ in. (32 × 414.3 cm)
Edward Elliott Family Collection, Gift of Douglas Dillon, 1986 (1986.266.4)

By 1600 Wu Bin, who began painting in his native Fujian Province, had moved to the southern capital, Nanjing, where he served as a court-appointed painter specializing in landscapes and Buddhist subjects. A lifelong devotee of Buddhism, Wu entered an order of untonsured monks affiliated with the Chan Buddhist Qixia Temple in Nanjing.

In Chinese popular imagination, mendicant monks, conjurors, and mysterious hermits were often thought to be disguised "living luohans," or Buddhist holy men capable of magic and miracles. When government corruption and ineptitude imperiled social order, as it did in late Ming times, such superstitious messianic beliefs became more widespread.

Reveling in oddity, Wu Bin's art represents a fin-de-siècle rebellion in painting style. In *The Sixteen Luohans,* one of his earliest extant works, the artist has already begun to invent an eccentric archaism in figure painting that was to influence late Ming figure painters, most notably Chen Hongshou (1598–1652; no. 34), as well as woodblock artists. The theatrical nature of the luohan figures suggests that the artist may have been inspired by popular religious dramas or festival processions.

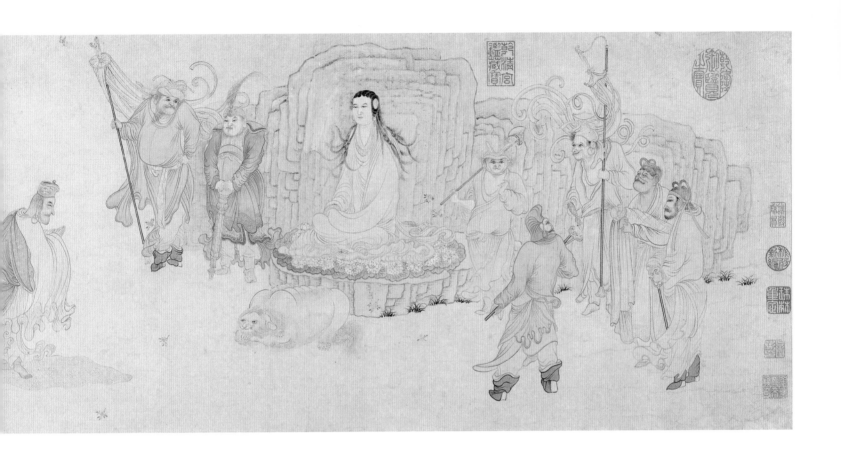

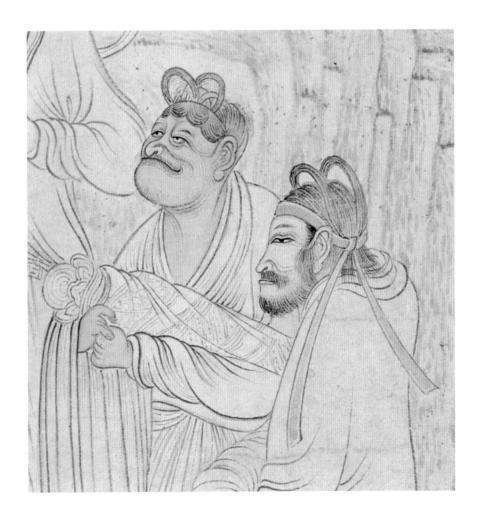

Despite his penchant for caricature,
Wu Bin portrayed his figures with
wonderful attention to detail and
even affection. In depicting these two
attendants, he lavished great care on
such features as creased flesh and bris-
tling whiskers—not to mention their
bizarre hairdos.

133

∧

Wu Bin delights in playful exaggerations.
Here, he juxtaposes a shriveled prunelike
luohan with the smooth, almost unarticu-
lated silhouette of another.

>

Wu Bin's fanciful depiction of Manjusri, the
Bodhisattva of Wisdom, lacks the descriptive
detail of Wang Zhenpeng's image (no. 19),
but the deity's visage still radiates a calm
spiritual power.

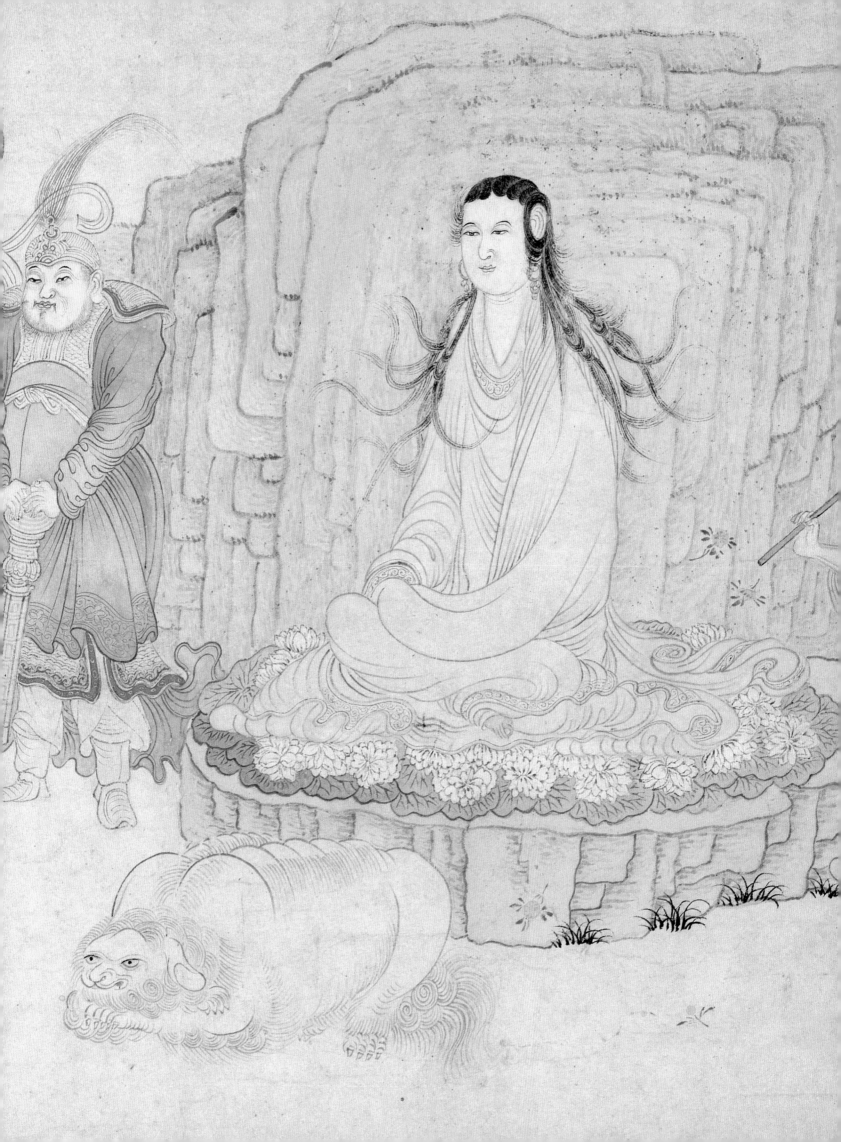

∧

Wu's humorous and grotesque figures may have
been intended to remind viewers that holiness is
an inner state and may be concealed within an
outwardly incongruous form.

>

Caricature at times borders on the freak-
ish in these three figures, whose limbs
appear unnaturally rubbery or twisted.

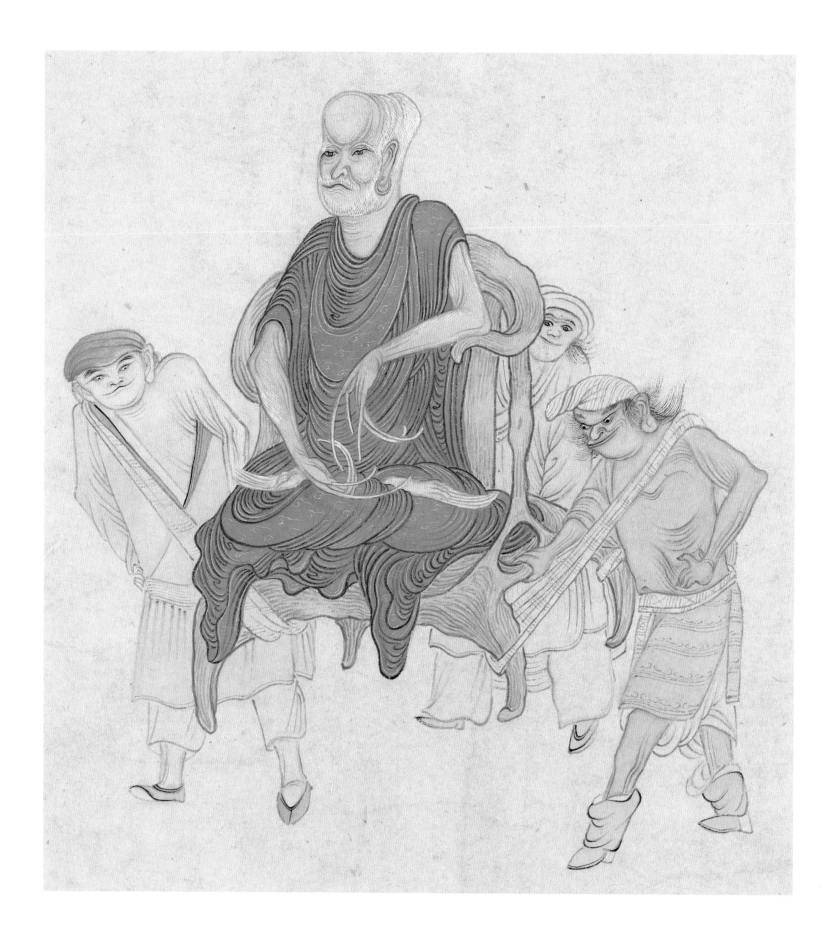

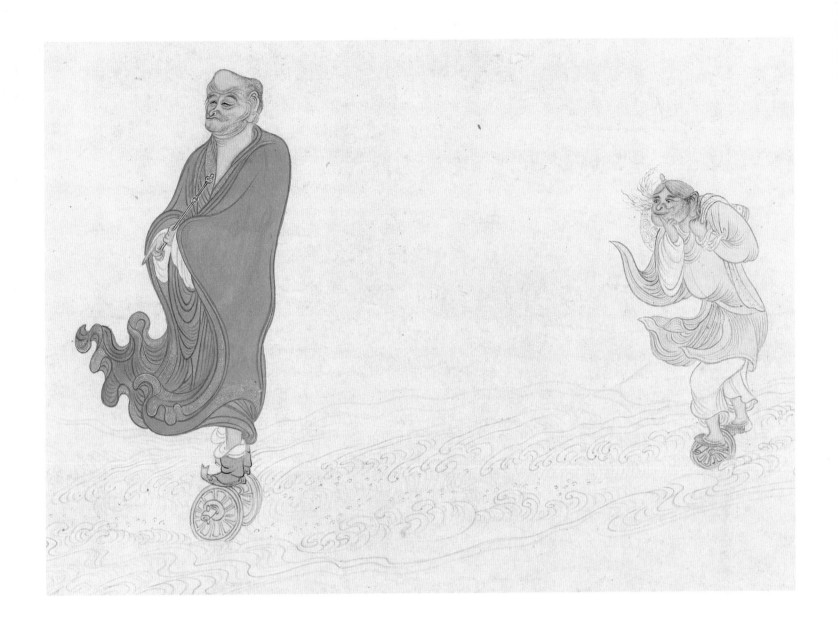

Luohans were thought to possess supernatural powers, such as the ability to tread on water. In Wu Bin's cartoonlike caricature, the luohan's indifference to this miracle contrasts with the puzzled amazement of his attendant.

<

The spiritual attributes of Wu Bin's luohans often turn bizarre. The long nails of this luohan's fingers and toes convey his complete detachment from worldly concerns.

萬曆辛亥歲於竭
陵寓舍圖 吳彬

This luohan has meditated for so long that a tree has grown up around him, its striated bark and curved roots echoing the pleats and folds of his robe. To the left of the tree, Wu Bin has cleverly integrated his signature and the date within the composition by having them appear as if carved in seal script into a rockface.

33 | A Declaration of Faith

清　石濤（朱若極）十六羅漢圖　卷

Shitao (Zhu Ruoji, 1642–1707)
The Sixteen Luohans, dated 1667

Handscroll (detail above), ink on paper, 18¼ in. × 19 ft. 7⅜ in. (46.4 × 597.8 cm)
Gift of Douglas Dillon, 1985 (1985.227.1)

Zhu Ruoji, who adopted the sobriquet Shitao (Stone Wave), was a scion of the Ming imperial family who escaped death in his youth by taking refuge in the Buddhist priesthood. In 1662 he became a disciple of the powerful Chan master Lü'an Benyue (died 1676). In the late 1660s and the 1670s, while living in seclusion in temples near Xuancheng, Anhui Province, he trained himself to paint.

In *The Sixteen Luohans,* Shitao's earliest major extant work, the young painter, then twenty-five, drew what were possibly the most effective figures created since the Yuan period (1271–1368). A rare religious subject for Shitao, who was known for his visionary landscapes, the scroll depicts the sixteen guardian luohans (in Sanskrit, arhats, or "saints") ordered by the Buddha to live in the mountains and protect the Buddhist Law until the coming of the future Buddha.

Stylistically, the immediate sources for Shitao's figures were late Ming painters, such as Ding Yunpeng (1547–ca. 1621) and Wu Bin (active ca. 1583–1626; no. 32). Unlike Wu Bin's luohans, which seem to be merely grotesque caricatures, Shitao's are carefully observed, showing thoroughly human qualities such as humor and curiosity.

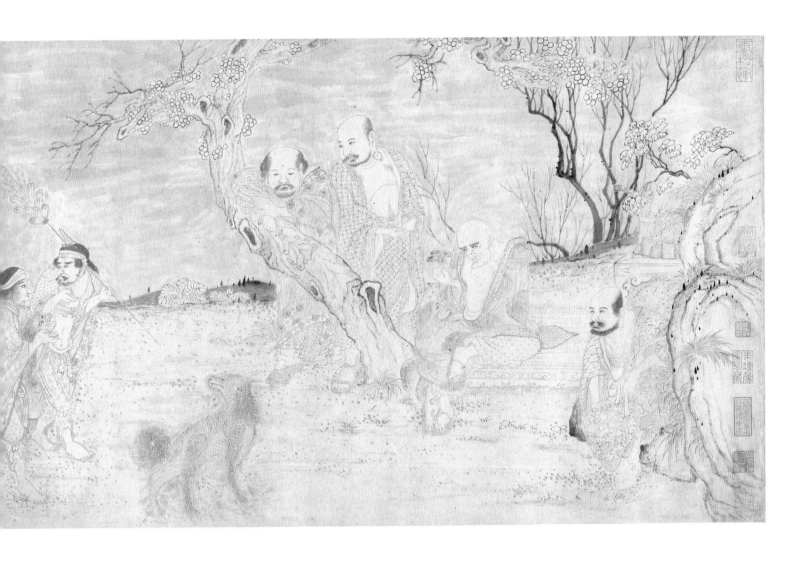

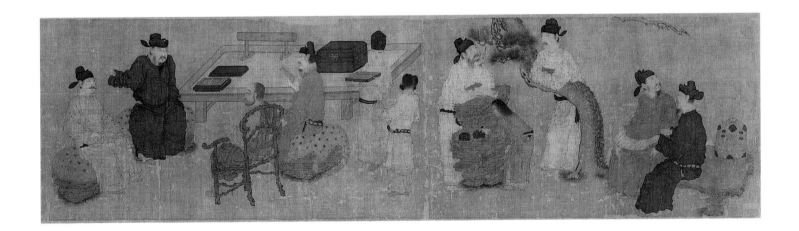

The opening section of Shitao's composition may have been inspired by *Scholars of the Liuli Hall*, which commemorates a famous literary gathering hosted by the poet Wang Changling (active ca. 713–41) that included a Buddhist monk as well as Confucian scholars. This mirror image of a thirteenth-century version of the subject points up the similarities between the two compositions.

One luohan, mirroring Shitao's own artistic mastery, demonstrates his power over the creative energies of the cosmos by releasing a dragon from a bottle. An auspicious beast able to alleviate drought or curb flooding, this dragon generates a vortex of earth, cloud, and water that transforms the land- scape's leafless trees into a flourishing profusion of vegetation.

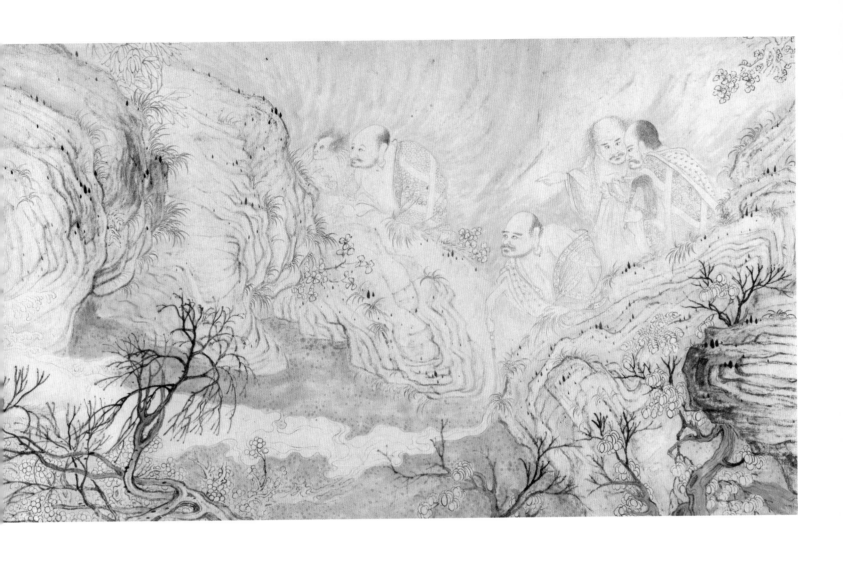

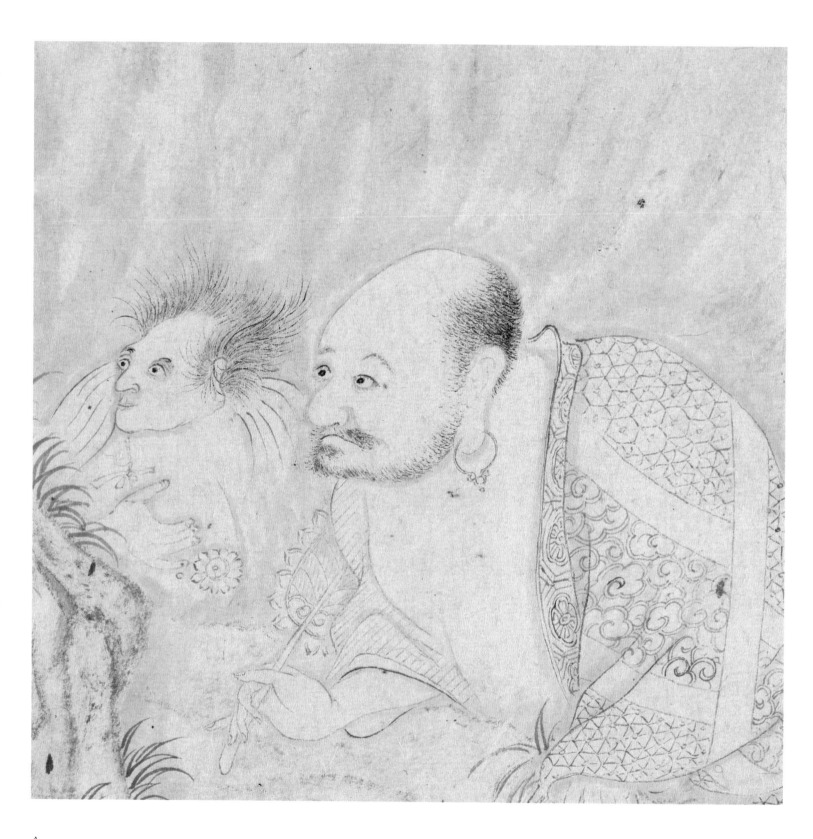

∧

This luohan and his spritely attendant are riveted
by the sight of the dragon. The radiating streaks
of ink wash behind the figures' heads, along
with the attendant's blown-back hair, suggest
the whirlwind of cosmic energy emanating
from the creature.

In this daring juxtaposition, the profile of
one luohan's head appears to define the cheek
and chin of his companion.

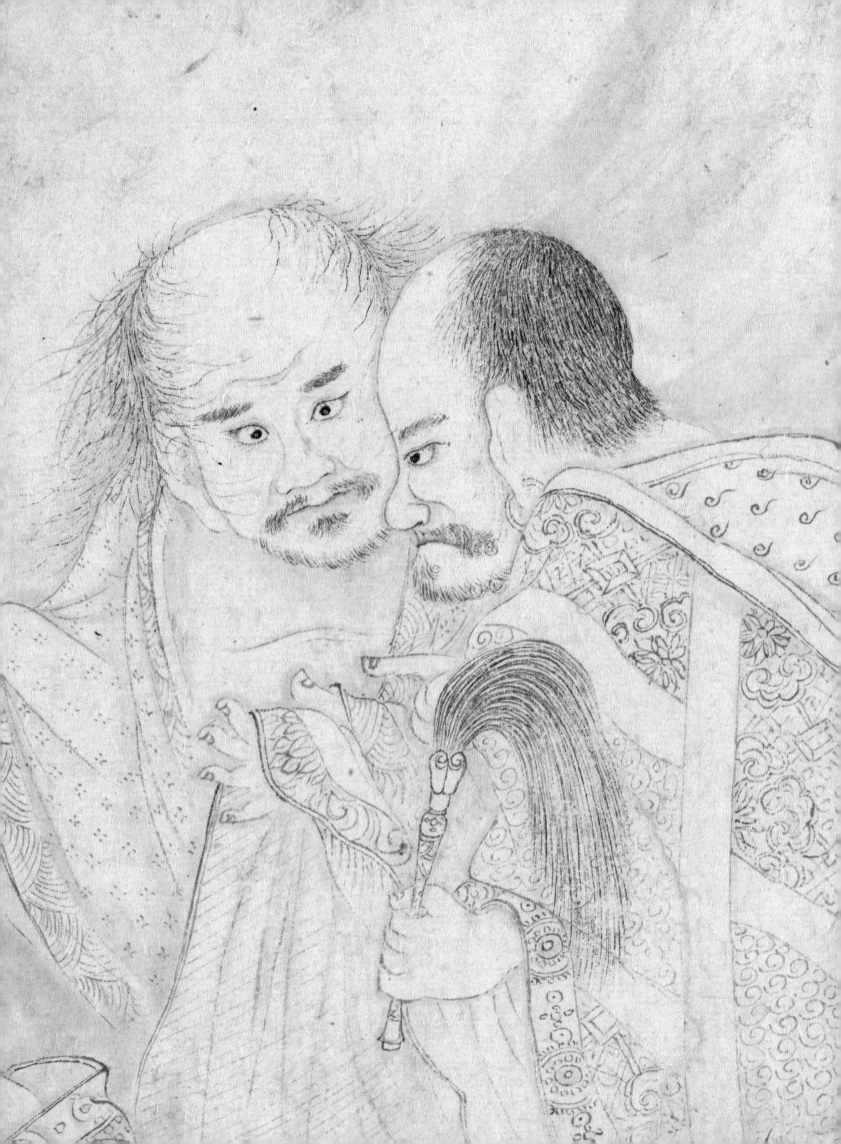

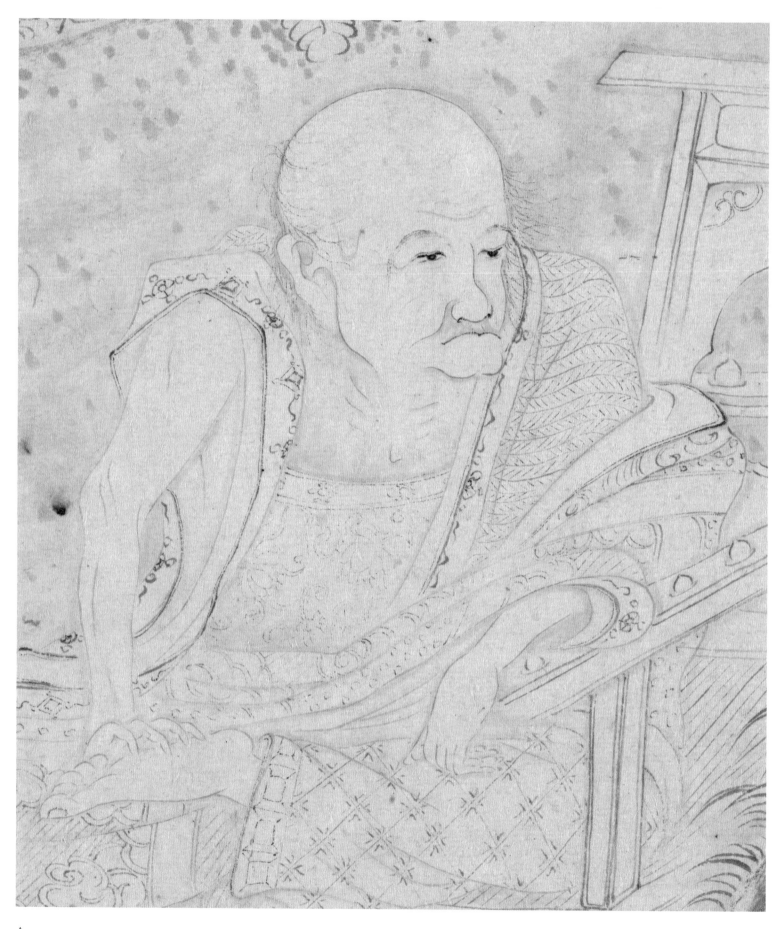

∧

This wizened luohan recalls Du Jin's depiction of
Fu Sheng (no. 30). Shitao's technical virtuosity is
apparent in the fine floral pattern, probably drawn
with a three-hair brush, on this figure's doublet.

>

The artist's sense of humor is apparent in how
the shaved head of a luohan is highlighted by
the bushy tail of the fabulous creature that
accompanies him.

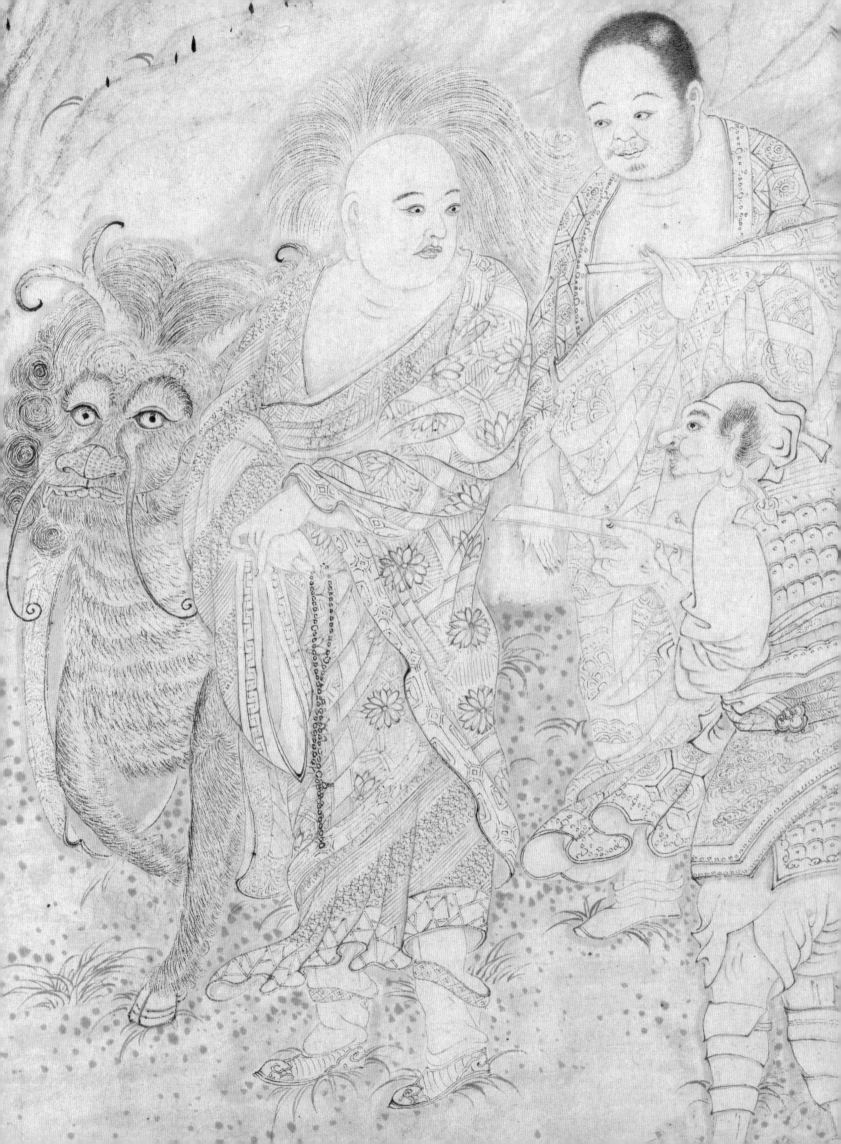

明/清　陳洪綬　撫古圖　冊

Chen Hongshou (1598–1652)
Miscellaneous Studies, one leaf dated 1619

Album of twelve paintings (four shown above and one detail opposite), ink on paper, each leaf 7 × 7 in.
(17.8 × 17.8 cm)
Ex coll.: Weng Tonghe (1830–1904)
Gift of Mr. and Mrs. Wan-go H. C. Weng, 2005 (2005. 112a–l)

This album, a tour de force by the precocious twenty-one-year-old artist, plays on the theme
of reality versus illusion: the moon is shown reflected in a basin of water, a flower next to its
image in a mirror, and a butterfly being attracted to chrysanthemums painted on a silk fan. In
the fan painting, Chen emphasizes the multiple levels of his artifice by incorporating his sig-
nature within the composition and by screening one wing of the butterfly with the fan, forc-
ing us to view the butterfly through the painting as well as through the medium of painting.
Other artful manipulations are represented by a miniature potted garden or *pencai* (*bonsai* in
Japanese), which demonstrates how human beings can transform nature, and by a twig with
worm-eaten leaves (*detail opposite*), which underscores how nature constantly transforms itself.

There is no precedent in scholar painting for such symbolic still-life subjects. Instead, these
highly sophisticated images, which relate to the ornamental designs found on deluxe crafts
of the period, including molded ink-cakes, printed stationery, and the carved decoration of
Yixing ceramics, reflect Chen Hongshou's early involvement in creating woodblock illustra-
tions for novels and dramas.

This miniature landscape is a fitting emblem of the
artistic process, which reduces the natural world to
a few select elements—here, the "three friends of
wintry weather," the pine, plum, and bamboo—
artfully composes them, and then frames them,
in this case in a ceramic basin with patterned rim
and crackled glaze.

Art has often been compared to a mirrorlike
reflection of nature. Here an ornate, water-
filled vessel—a suitable metaphor for a work
of art—captures a reflection of the moon.
Basin, water, and moon are in turn Chen's
artistic likenesses of reality.

洪綬

This image contends that Chen's flower painting is so realistic that even a butterfly is fooled. The conceit that art could be as lifelike as reality is an ancient one and common to many cultures. The Chinese artist Zhang Sengyou (active ca. 500–550) is said to have painted a hawk and an eagle on a temple wall to scare away roosting doves. Earlier, the Roman author Pliny (A.D. 23–79) recounted a competition between two artists, Zeuxis and Parrhasius, to see who could paint the most convincingly real image.

<

A mirror is often a trope for the moon, which reflects the light of the sun. Here, an eight-lobed mirror, a flower, a hairpin, and a ring suggest a lady's dressing table. The rabbit decoration on the ring further recalls the legendary hare in the moon, who prepares the elixir of immortality for the moon goddess.

35 | Landscape as Self-Portrait

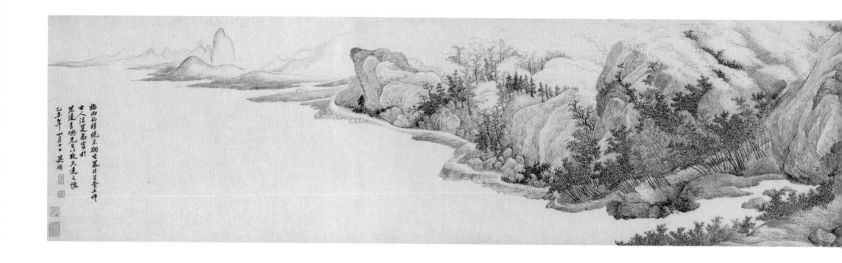

清　吳歷　墨井草堂消夏圖　卷

Wu Li (1632–1718)
Whiling Away the Summer, dated 1679

Handscroll, ink on paper, 14⅜ in. × 8 ft. 9⅝ in. (36.4 × 268.4 cm)
Ex coll.: C. C. Wang Family
Purchase, Douglas Dillon Gift, 1977 (1977.81)

In his inscription, Wu Li records that he painted this handscroll one clear morning after rainfall, sitting alone in his studio thinking of an absent friend. There is a dreamlike quality about the painting: birds, trees, bamboo, mist, and even rocks dance joyously around the hermit-scholar, who quietly reads in his idyllic domain. Although he was an ardent admirer of Huang Gongwang (1269–1354), Wu has transformed the Yuan painter's ropy "hemp-fiber" texture strokes into a distinctly personal style. Cool, pale ink textures in intricate, contrasting patterns, silhouetted and suspended in space, have been applied here with both an athlete's vigor and a poet's gentle cadence.

Wu Li named his studio the Inkwell Thatched Hall after a well that had once belonged to Yan Yan (born ca. 506 B.C.), a disciple of Confucius. Wu's hometown, Changshu, was a center of Jesuit missionary activity, and the Catholic Church occupied the traditional site of Yan Yan's home. Wu's choice of a studio name was surely meant to signify his deepening link to the church as well as his personal integration of Confucian and Catholic doctrines. In 1681, two years after he painted this work, Wu Li was baptized as a Christian, a most uncommon decision for a man of his background. Ordained as a priest in 1688 in Macao, he was sent the next year to do missionary work in Shanghai, where he died in 1718.

Robes thrown open and one foot bare, Wu Li portrays himself in the carefree attitude of an ancient sage (see nos. 16, 30). His lack of concern with worldly affairs is apparent from his rustic dwelling, with its plaster walls in need of patching.

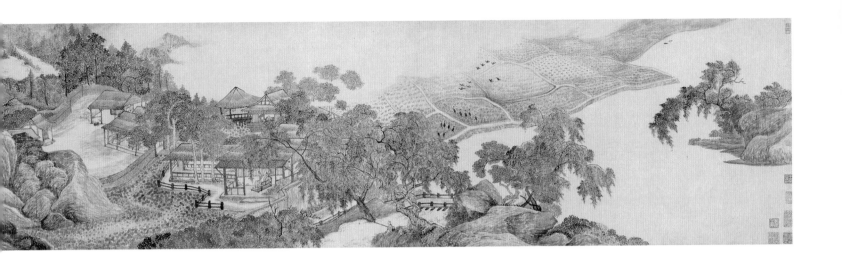

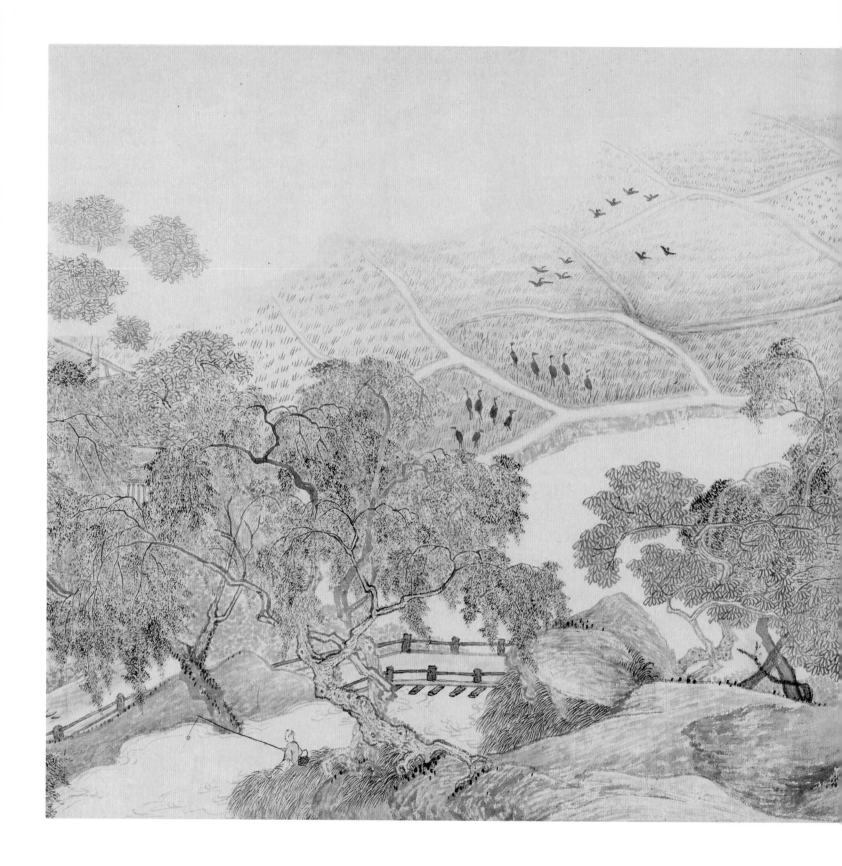

Rice paddies receding into the mist and lush willows
bent under the weight of the night's rain suggest an
early morning in summer. Only the flapping wings
of a flock of waterbirds disturb the stillness, causing
egrets standing among the paddies to raise their
heads in unison.

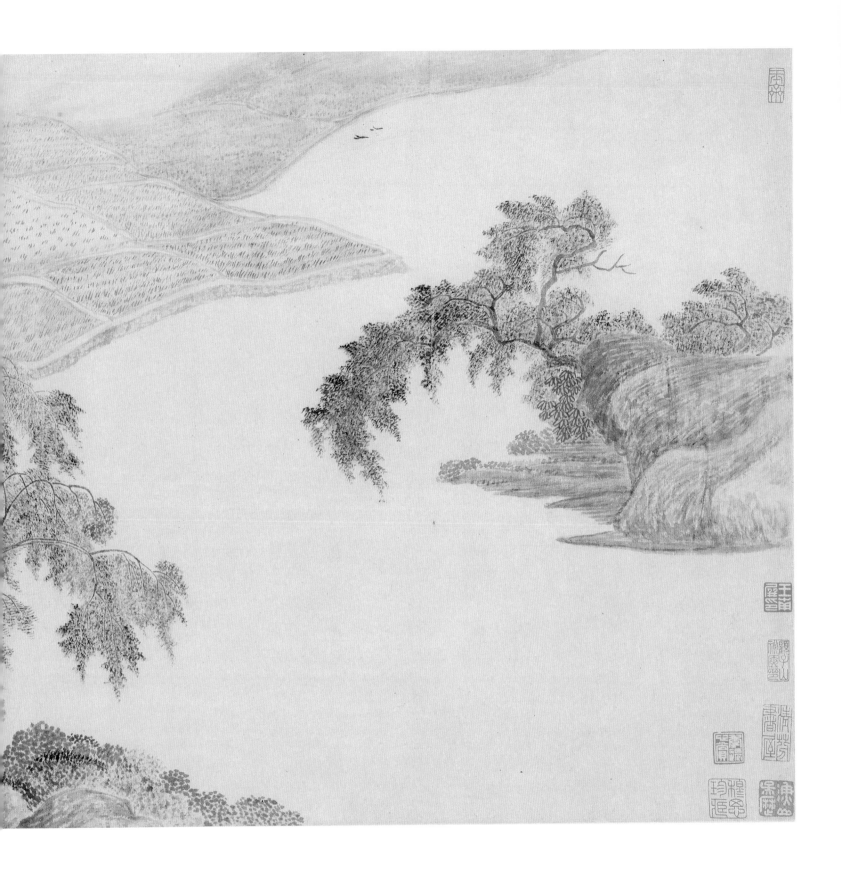

Wu Li's back gate opens directly onto a wooded moun-
tain slope, where a rock outcrop forms a natural part of
the compound's perimeter. The twisting slope, enliv-
ened by Wu's vibrant texture strokes and silvery ink
tones, forms the compositional structure known as a
"dragon vein" (see no. 25).

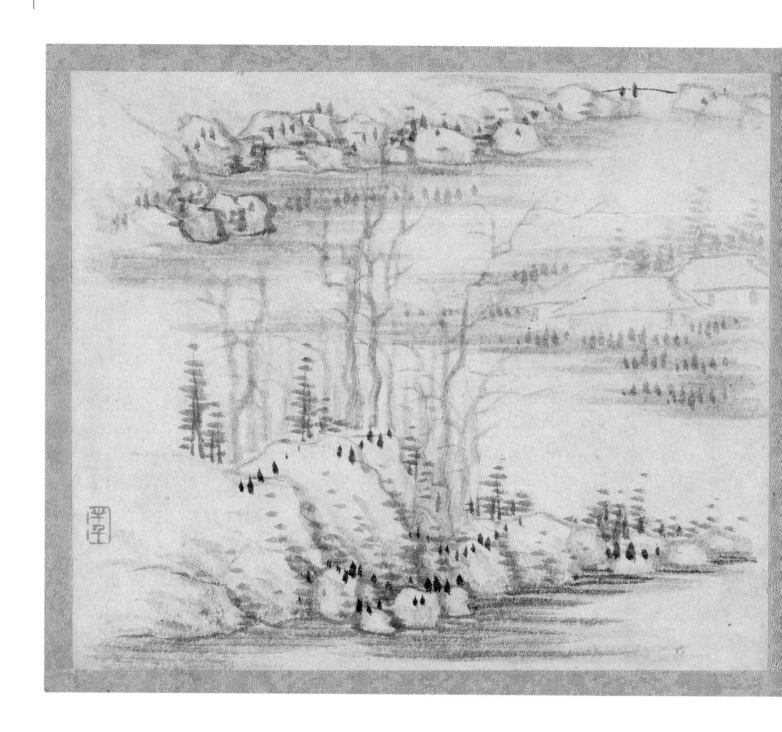

清 龔賢 山水圖 冊

Gong Xian (1619–1689)
Landscapes and Trees, ca. 1679

Album of twelve double leaves (A and AA above), ink on paper, each leaf 6¼ × 7½ in. (15.9 × 19.1 cm)
From the P. Y. and Kinmay W. Tang Family Collection,
Gift of Wen and Constance Fong, in honor of Mr. and Mrs. Douglas Dillon, 1979 (1979.499a–l)

By the mid-1670s Gong Xian's confidence as a painter had taught him to avoid an overly
skillful or popular style. In this album, he writes, "Nowadays when people paint they do only
what appeals to the common eye; I alone do not seek to please the present."

Both the paintings and the inscriptions in this album attest to Gong's striving after a spiritual communion with earlier masters while creating a pictorial vocabulary all his own. Departing from his densely textured, monumental landscape style of the 1660s, Gong moves toward a sparser manner in which each brushstroke is made to function calligraphically as well as descriptively, embodying both expressive and representational meaning. The album's format—paintings accompanied by his art historical comments on facing pages—reminds us that Gong Xian taught painting for a living.

Gong believed that in painting, less is more, as he implies in his inscription (*above*): "When you are afraid of producing too much painting, you will make a good painting." Appropriately, his image on the left-hand page is in the restrained style of Ni Zan (1306–1374; nos. 22, 23), while his calligraphy becomes increasingly faint as his ink-charged brush runs dry.

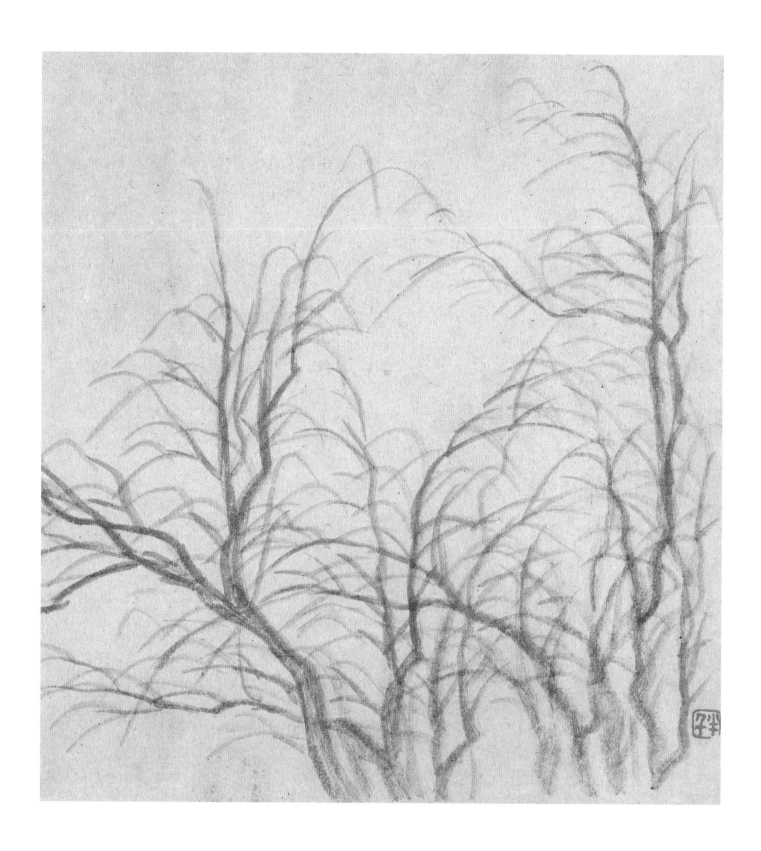

Gong Xian loved to explore contrasting
imagery and brushwork. In these two leaves
he juxtaposes pale, delicate willow whips
with craggy branches.

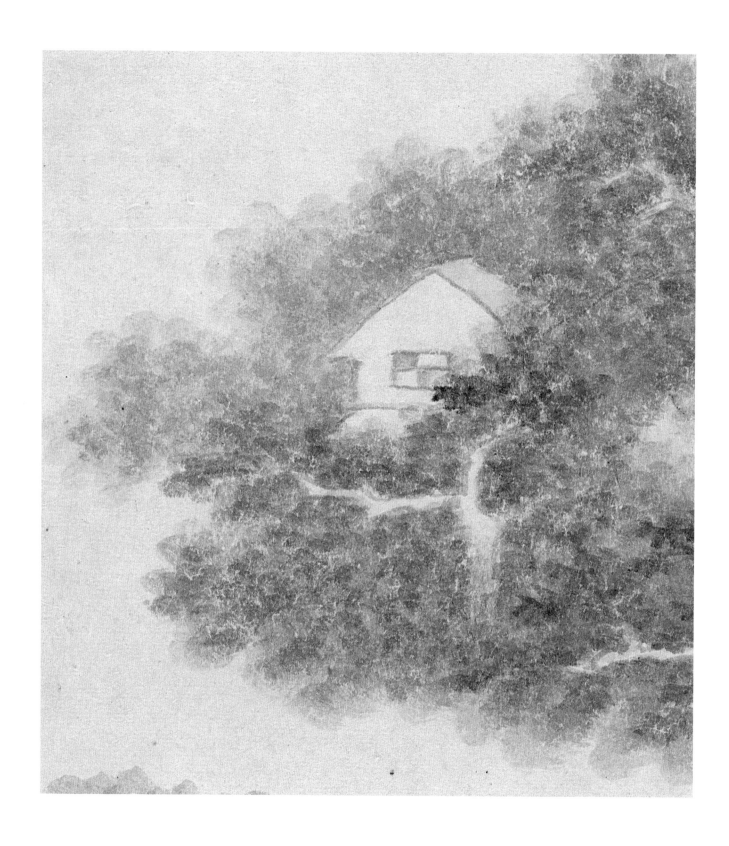

In another pair of contrasting leaves,
Gong compares a house submerged in
dense foliage with another silhouetted
against blank paper representing a
distant river.

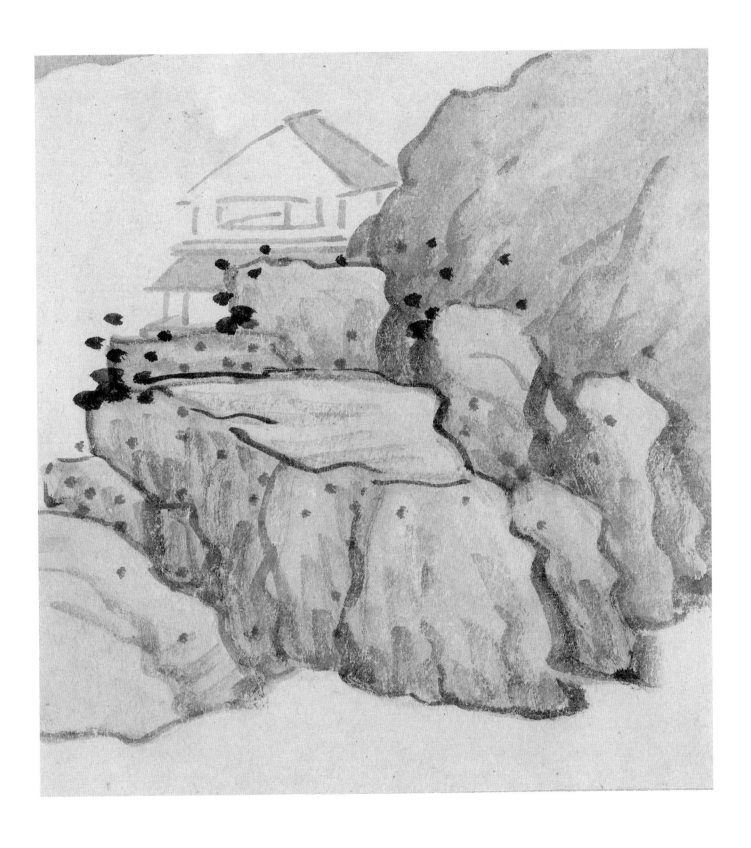

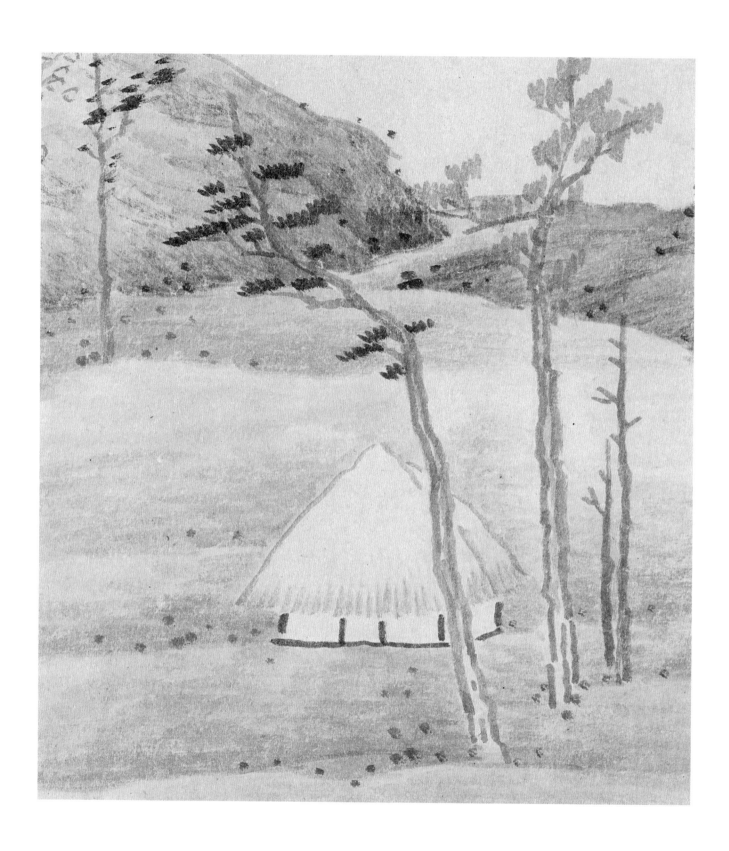

A spare landscape in dry ink tones,
with a single thatched hut at its center
and a few slender trees, contrasts with
a densely inked and textured scene
dominated by a foreground grove of
massive trees and rocks.

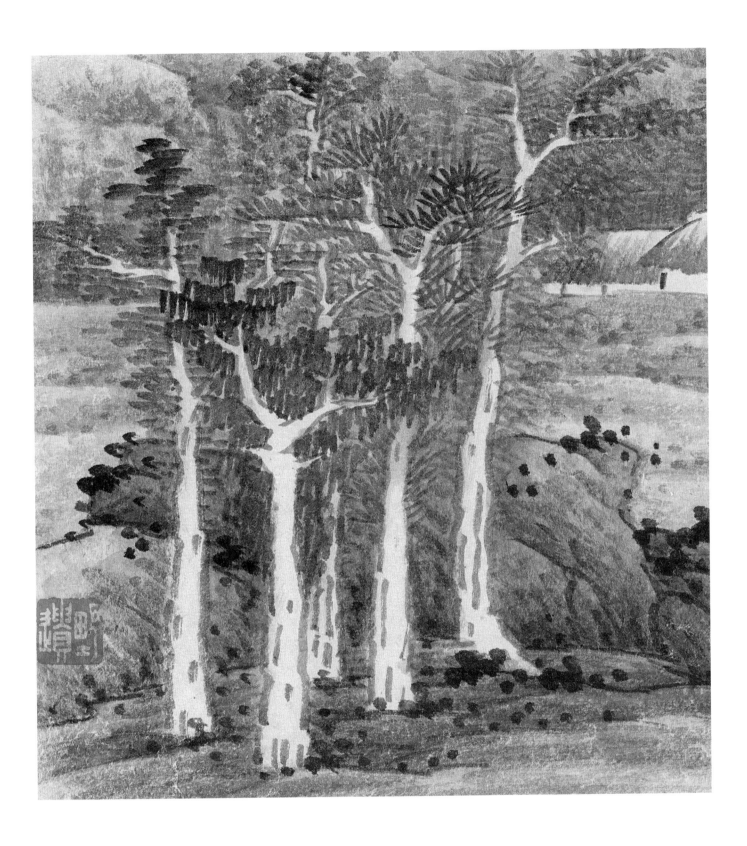

Notes

For the sake of consistency, proper names given in the Wade-Giles system in original sources have been transliterated into the Pinyin system in this volume. The Wade-Giles romanizations have been retained, however, where they appear as part of a publication title or an author's name.

Page 14: "Commissioned in 738," adapted from Wen C. Fong, *Beyond Representation: Chinese Painting and Calligraphy, 8th–14th Century* (New York: The Metropolitan Museum of Art, 1992), p. 129.

Page 20: "depicted the vastness," adapted from Fong, *Beyond Representation*, p. 82. Fong cites as his source *Kuo Jo-hsü's Experiences in Painting (T'u-hua Chien-wên Chih): An Eleventh Century History of Chinese Painting, Together with the Chinese Text in Facsimile*, translated and edited by Alexander Coburn Soper (Washington, D.C.: American Council of Learned Societies, 1951), p. 173, n. 504. Soper states that the phrase was used by Liu Daochun in his *Shengchao minghua ping* to describe a landscape by Yan Wengui. See Liu Daochun, *Shengchao minghua ping* [Commentary on Famous Paintings of the Present (Song) Dynasty; ca. 1040], in *Zhongguo shuhua quanshu* [Compendium of Chinese Calligraphy and Painting], edited by Lu Fusheng, vol. 1 (Shanghai: Shanghai shuhua chubanshe, 1993), pp. 446–59 (phrase quoted on p. 452).
"travel . . . dwell or ramble," translation from Guo Xi, *An Essay on Landscape Painting*, translated by Shio Sakanishi (London: John Murray, 1936), p. 32.

Page 28: "Landscape of Emotion" was an expression first used by Wen Fong to describe this work. See Fong, *Beyond Representation*, p. 92.

Page 29: "After the outlines are made," Guo Xi, *Linquan gaozhi* [Lofty Ambitions in Forests and Streams; 1117], in *Zhongguo shuhua quanshu*, pp. 497–502 (quotation on p. 501).

Page 31 (*top*): This interpretation of the landscape was first articulated by Ping Foong. See Ping Foong, "Guo Xi's Intimate Landscapes and the Case of *Old Trees, Level Distance*," *Metropolitan Museum Journal* 35 (2000), pp. 87–115.

Page 34: Wen Fong used the term "Magic Realism" to describe this work. See Fong, *Beyond Representation*, p. 182.

Page 40: "The rulers of states," translation by Richard M. Barnhart from Richard M. Barnhart, with essays by Robert E. Harrist Jr. and Hui-liang J. Chu, *Li Kung-lin's "Classic of Filial Piety"* (New York: The Metropolitan Museum of Art, 1993), p. 109.

Page 43: "The service which a son," ibid., p. 118; "For securing the repose of superiors," ibid., p. 127.

Page 44: "there are three thousand offenses," ibid., p. 122.

Page 47: "The two of you went off," ibid., p. 150.

Page 48: For the original text of the account transcribed in the *Biographies*, see Sima Qian, *Shi ji* [Records of the Historian] (Beijing: Zhonghua shuju, 1959), chap. 81, pp. 2439–44.

Page 49: "[When] two tigers fight," translation from Sima Qian, *Records of the Historian*, translated by Yang Hsien-yi and Gladys Yang (Hong Kong: Commercial Press, 1974), p. 144.

Page 50: "The king said," translation adapted from ibid., p. 140.

Page 55: "Killing Xiangru now," ibid., p. 142.

Page 58: For the identification of this album leaf as an illustration to one of the Eight Views, see Richard M. Barnhart, "Shining Rivers: *Eight Views of the Hsiao and Hsiang* in Sung Painting," in *International Colloquium on Chinese Art History, 1991: Proceedings*, [vol. 1], pt. 1, *Painting and Calligraphy* (Taipei: National Palace Museum, 1992), pp. 49ff., fig. 6.
"Last night's rain," translation from Alfreda Murck, "Eight Views of the Hsiao and Hsiang Rivers by Wang Hung," in Wen C. Fong et al., *Images of the Mind: Selections from the Edward L. Elliott Family and John B. Elliott Collections of Chinese Calligraphy and Painting at the Art Museum, Princeton University*, exh. cat. (Princeton, N.J.: Art Museum, Princeton University, 1984), p. 226.

Page 64: My discussion of this painting has benefited from insights offered by Frances Homan Jue of Antenna Audio.

Page 68: "Meeting the wind," translation from James Cahill, "The Imperial Painting Academy," in Wen C. Fong and James C. Y. Watt et al., *Possessing the Past: Treasures from the National Palace Museum, Taipei*, exh. cat. (New York: The Metropolitan Museum of Art; Taipei: National Palace Museum, 1996), p. 172. This poem was inscribed by Empress Yang Meizi (1162–1232) on a painting of apricot blossoms by the court artist Ma Yuan. For an illustration and discussion of the Ma Yuan painting, see ibid., pp. 172–73, pl. 79. For more information on Ma Lin's work, see ibid., pp. 194–99.

Page 70: "The shiny bronze vessel," translation from Fong, *Beyond Representation*, p. 306.

Page 74: "How pleasant," ibid., p. 319. For the *Daodejing*, the Daoist (Taoist) classic attributed to Laozi, see Arthur Waley, *The Way and Its Power: A Study of the Tao Tê Ching and Its Place in Chinese Thought* (London: Allen and Unwin, 1934).

Page 79: "Besides studying calligraphy," translation from Fong, *Beyond Representation*, p. 439.
"As the tiny boat tries," translation from Richard M. Barnhart, *Along the Border of Heaven: Sung and Yüan Paintings from the C. C. Wang Family Collection* (New York: The Metropolitan Museum of Art, 1983), p. 120.

Page 84: Renzong's description is taken from Fong, *Beyond Representation*, p. 421.

Page 85: "Xizhi was extremely fond," translation adapted from Kwan S. Wong, assisted by Stephen Addiss, *Masterpieces of Sung and Yüan Dynasty Calligraphy from the John M. Crawford Jr. Collection*, exh. cat. (New York: China House Gallery, China Institute in America, 1981), p. 73.

Page 88: For the Palace Museum painting, currently catalogued as anonymous Southern Song, see *Zhongguo huihua quanji* [Complete Collection of Chinese Painting], vol. 5, *Wu Dai, Song, Liao, Jin* [Five Dynasties, Song, Liao, Jin], edited by Zhongguo gudai shuhua jianding zu (Beijing: Wenwu chubanshe, 1999), pls. 134–36. For the attribution of the Palace Museum painting to Ma Yunqing, see Fong, *Beyond Representation*, p. 331. For a detail of the scroll, see ibid., p. 333, fig. 140.

Page 92: "By referring to a flood," Fong, *Beyond Representation*, p. 402.

Page 94: "Red leaves west of the village," translation from Fong, *Beyond Representation*, p. 450.

Page 98: "simple sustenance," quoted in Fong, *Beyond Representation*, p. 486.

Page 100: "In his late years," translation from Wen C. Fong, "Images of the Mind," in Fong et al., *Images of the Mind*, p. 112.

"We watch the clouds," translation from Fong, *Beyond Representation*, p. 490.

Page 106: For a discussion of the term "heart print" (*xinyin*, 心印) or "imprint of the mind," see Fong, "Images of the Mind," p. 3.

Page 110: "gave shape to things," Li Cun (14th century), *Si An ji* [Collection from the Waiting Studio], in *Peiwen Zhai shuhua pu* [Manual of Calligraphy and Painting of the Studio of Admiring Culture], compiled by Wang Yuanqi et al. ([Beijing], 1708), chap. 54, p. 29; translation adapted from Osvald Sirén, *Chinese Painting: Leading Masters and Principles*, pt. 2, *The Later Centuries*, vol. 4, *The Yüan and Early Ming Masters* (London, 1958), p. 58.

Page 118: "Immortals have always delighted," translation from Maxwell K. Hearn, *Cultivated Landscapes: Chinese Paintings from the Collection of Marie-Hélène and Guy Weill*, exh. cat. (New York: The Metropolitan Museum of Art, 2002), p. 22.

Page 122: "There had never before been such hawks"; "depicted as if lost," Richard M. Barnhart in Richard M. Barnhart, with contributions by Mary Ann Rogers and Richard Stanley-Baker, *Painters of the Great Ming: The Imperial Court and the Zhe School*, exh. cat. (Dallas: Dallas Museum of Art, 1993), p. 198.

Page 155 (*top left*): In *Historia naturalis* (bk. 35, chap. 36) Pliny described a competition in which Zeuxis created a picture of grapes so lifelike that birds tried to eat them, whereupon Parrhasius painted a curtain so realistic that Zeuxis asked that it be drawn aside so that his rival's picture could be displayed. When Zeuxis realized his mistake, he graciously acknowledged that while his painting had deceived the birds, Parrhasius's work had deceived an artist. I am indebted to Philippe de Montebello for this reference.

Page 156: For more information on Wu Li's conversion to Catholicism, see Wen Fong's addendum in Roderick Whitfield, *In Pursuit of Antiquity: Chinese Paintings of the Ming and Ch'ing Dynasties from the Collection of Mr. and Mrs. Earl Morse*, exh. cat. (Princeton, N.J.: Art Museum, Princeton University; Rutland, Vt., and Tokyo: Charles E. Tuttle, 1969), p. 191.

Further Reading

*An asterisk designates publications that focus on works in the collection of the Metropolitan Museum.

Principles of Style and Form

Ledderose, Lothar. *Ten Thousand Things: Module and Mass Production in Chinese Art*. Princeton, N.J.: Princeton University Press, 2000.

Rowley, George. *Principles of Chinese Painting*. 2nd ed. Princeton, N.J.: Princeton University Press, 1959.

Silbergeld, Jerome. *Chinese Painting Style: Media, Methods, and Principles of Form*. Seattle: University of Washington Press, 1982.

General Introductions

*Barnhart, Richard M. *Peach Blossom Spring: Gardens and Flowers in Chinese Painting*. Exh. cat. New York: The Metropolitan Museum of Art, 1983.

Barnhart, Richard M., James Cahill, Nie Chongzheng, Wu Hung, Lang Shaojun, and Yang Xin. *Three Thousand Years of Chinese Painting*. New Haven: Yale University Press; Beijing: Foreign Languages Press, 1997.

*Barnhart, Richard M., Wen C. Fong, and Maxwell K. Hearn. *Mandate of Heaven, Emperors and Artists in China: Chinese Painting and Calligraphy from The Metropolitan Museum of Art, New York*. Exh. cat. Zürich: Museum Rietberg, 1996.

Cahill, James. *Chinese Painting*. Geneva: Skira, 1960.

Fong, Wen C., Alfreda Murck, Shou-chien Shih, Pao-chen Ch'en, and Jan Stuart. *Images of the Mind: Selections from the Edward L. Elliott Family and John B. Elliott Collections of Chinese Calligraphy and Painting at the Art Museum, Princeton University*. Exh. cat. Princeton, N.J.: Art Museum, Princeton University, 1984.

Fong, Wen C., and James C. Y. Watt, with contributions by Chang Lin-sheng, James Cahill, Wai-kam Ho, Maxwell K. Hearn, and Richard M. Barnhart. *Possessing the Past: Treasures from the National Palace Museum, Taipei*. Exh. cat. New York: The Metropolitan Museum of Art; Taipei: National Palace Museum, 1996.

Fu, Shen C. Y., with Marilyn Fu, Mary G. Neill, and Mary Jane Clark. *Traces of the Brush: Studies in Chinese Calligraphy*. Exh. cat. New Haven: Yale University Art Gallery, 1977.

Harrist, Robert E., Jr., and Wen C. Fong, with contributions by Qianshen Bai, Dora C. Y. Ching, Chuan-hsing Ho, Cary Y. Liu, Amy McNair, Zhixin Sun, and Jay Xu. *The Embodied Image: Chinese Calligraphy from the John B. Elliott Collection*. Exh. cat. Princeton, N.J.: Art Museum, Princeton University, 1999.

Hearn, Maxwell K. *Splendors of Imperial China: Treasures from the National Palace Museum, Taipei*. Exh. cat. New York: The Metropolitan Museum of Art; Taipei: National Palace Museum, 1996.

*Hearn, Maxwell K., and Wen C. Fong. *Along the Riverbank: Chinese Painting from the C. C. Wang Family Collection*. New York: The Metropolitan Museum of Art, 1999.

*Murck, Alfreda, and Wen C. Fong, eds. *Words and Images: Chinese Poetry, Calligraphy, and Painting*. New York: The Metropolitan Museum of Art, 1991.

Thorp, Robert L., and Richard Ellis Vinograd. *Chinese Art and Culture*. New York: Harry N. Abrams, 2001.

Wang Yao-t'ing. *Looking at Chinese Painting*. Translated by the Stone Studio. Tokyo: Nigensha, 1996.

Tang, Song, and Yuan Dynasty Painting and Calligraphy (8th–14th Century)

*Barnhart, Richard M. *Along the Border of Heaven: Sung and Yüan Paintings from the C. C. Wang Family Collection*. New York: The Metropolitan Museum of Art, 1983.

*Barnhart, Richard M., with essays by Robert E. Harrist Jr. and Hui-liang J. Chu. *Li Kung-lin's "Classic of Filial Piety."* New York: The Metropolitan Museum of Art, 1993.

Cahill, James. *Hills beyond a River: Chinese Painting of the Yüan Dynasty, 1279–1368*. New York and Tokyo: Weatherhill, 1976.

*Fong, Wen C. *Summer Mountains: The Timeless Landscape*. New York: The Metropolitan Museum of Art, 1975.

*———. *Beyond Representation: Chinese Painting and Calligraphy, 8th–14th Century*. New York: The Metropolitan Museum of Art, 1992.

*Wong, Kwan S., assisted by Stephen Addiss. *Masterpieces of Sung and Yüan Dynasty Calligraphy from the John M. Crawford Jr. Collection*. Exh. cat. New York: China House Gallery, China Institute in America, 1981.

Ming and Qing Painting (14th–Early 20th Century)

Barnhart, Richard M., with contributions by Mary Ann Rogers and Richard Stanley-Baker. *Painters of the Great Ming: The Imperial Court and the Zhe School.* Exh. cat. Dallas: Dallas Museum of Art, 1993.

Cahill, James. *Parting at the Shore: Chinese Painting of the Early and Middle Ming Dynasty, 1368–1580.* New York and Tokyo: Weatherhill, 1978.

———. *The Compelling Image: Nature and Style in Seventeenth-Century Chinese Painting.* Cambridge, Mass., and London: Harvard University Press, 1982.

———. *The Distant Mountains: Chinese Painting of the Late Ming Dynasty, 1570–1644.* New York and Tokyo: Weatherhill, 1982.

Cahill, James, ed. *Shadows of Mt. Huang: Chinese Painting and Printing of the Anhui School.* Exh. cat. Berkeley: University Art Museum, 1981.

*Fong, Wen C. *Returning Home: Tao-chi's Album of Landscapes and Flowers.* New York: George Braziller, 1976.

*———. *Between Two Cultures: Late-Nineteenth- and Twentieth-Century Chinese Paintings from the Robert H. Ellsworth Collection in The Metropolitan Museum of Art.* Exh. cat. New York: The Metropolitan Museum of Art, 2001.

*Hearn, Maxwell K. *Cultivated Landscapes: Chinese Paintings from the Collection of Marie-Hélène and Guy Weill.* Exh. cat. New York: The Metropolitan Museum of Art, 2002.

*Murck, Alfreda, and Wen C. Fong. "A Chinese Garden Court: The Astor Court at The Metropolitan Museum of Art." *The Metropolitan Museum of Art Bulletin* 38, no. 3 (Winter 1980–81).

Photograph Credits

Unless otherwise specified, all the works illustrated in this volume are from the collection of The Metropolitan Museum of Art.

Page 9: *At left, above, Prancing Horse.* Western Han dynasty, 3rd–1st century B.C. Rubbing from a stamped tomb tile from Luoyang, Henan Province. From Wen C. Fong, *Beyond Representation: Chinese Painting and Calligraphy, 8th–14th Century* (New York: The Metropolitan Museum of Art, 1992), p. 6.

At left, below, and *at bottom,* Eadweard Muybridge (American, born Great Britain, 1830–1904). *Horse and Rider Galloping,* 1883–86. Collotype from Eadweard Muybridge, *Animal Locomotion: An Electro-Photographic Investigation of Consecutive Phases of Animal Movements* (Philadelphia: University of Pennsylvania, 1887; plates printed by the Photogravure Company of New York), pl. 631 (detail and full image). Rogers Fund, transferred from the library, 1991 (1991.1135.9.69)

Page 19: *Left:* Attributed to Zhong Shaojing (active ca. 713–41). *Spiritual Flight Sutra,* ca. 738 (detail, no. 3).
　　Center: Wang Xizhi (303–61). *Orchid Pavilion Preface* (detail), A.D. 359. Rubbing (Dingwu Version). From *Shodō zenshū* [Compilation of Calligraphic Works], vol. 4 (Tokyo: Heibonsha, 1960), pl. 24.
　　Right: Zhao Mengfu (1254–1322). *Record of the Miaoyan Temple* (detail), ca. 1310. Handscroll, ink on paper. Princeton University Art Museum. From Robert E. Harrist Jr. and Wen C. Fong et al., *The Embodied Image: Chinese Calligraphy from the John B. Elliott Collection,* exh. cat. (Princeton, N.J.: Art Museum, Princeton University, 1999), p. 55, fig. 36a.

Page 143: Unidentified artist (late 13th century), formerly attributed to Zhou Wenju (active ca. 940–75). *Scholars of the Liuli Hall.* Handscroll, ink and color on silk, 12⅜ × 49½ in. (34 × 125.7 cm). Gift of Sheila Riddell, in memory of Sir Percival David, 1977 (1977.49)

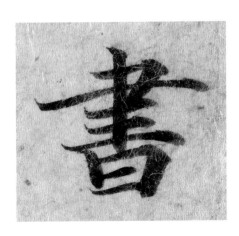